MACHINE RENDERING

Vincent Zhao

CYPI PRESS

CONTENTS

PREFACE
THE IRON BOOK

A Talk with Scott Robertson on Machine Rendering / Vincent Zhao

[The Interviewee]

Scott Robertson
/ President of Design Studio Press
/ Former Chair of Entertainment Design at Art
 Center College of Design in Pasadena, CA
/ Concept Designer/Author/Educator

[The Interviewer]

Vincent Zhao
/ Owner-Principal of Fantasy⁺Studio of Art Book
/ Art book planner
/ Former Executive Chief Editor of *Fantasy*
 Magazine and currently Chief Editor of *DICE*
 Magazine

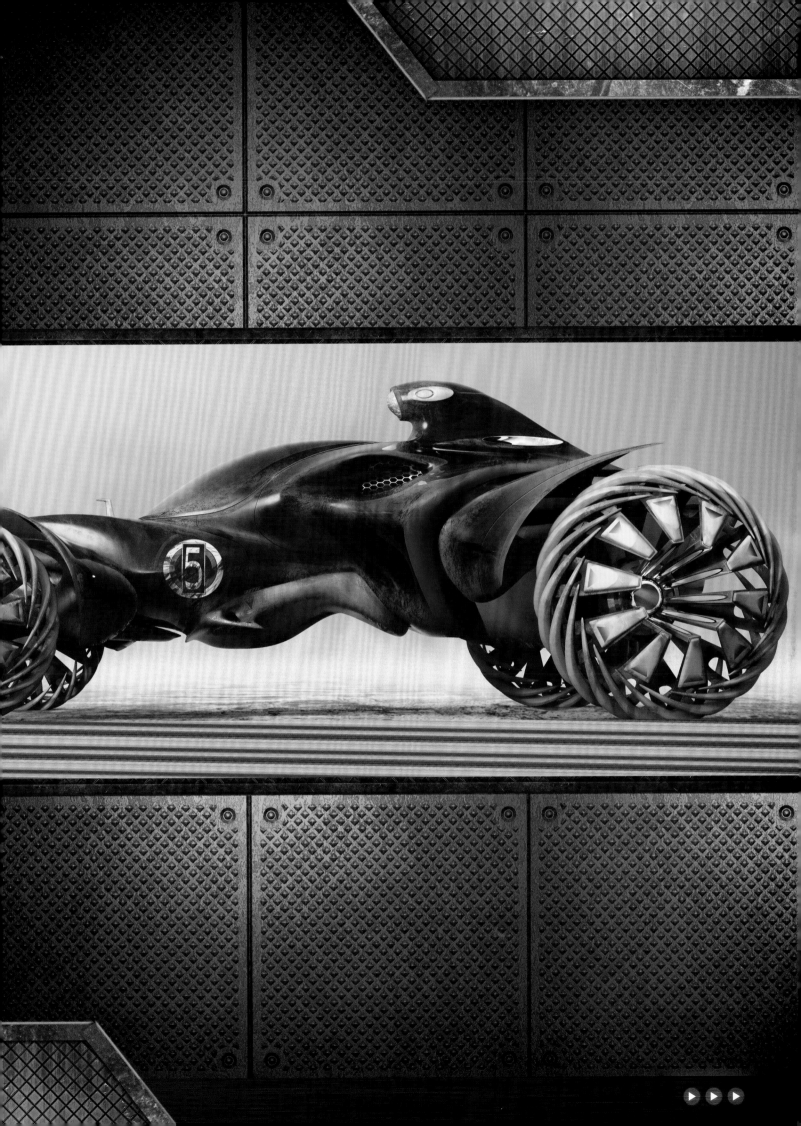

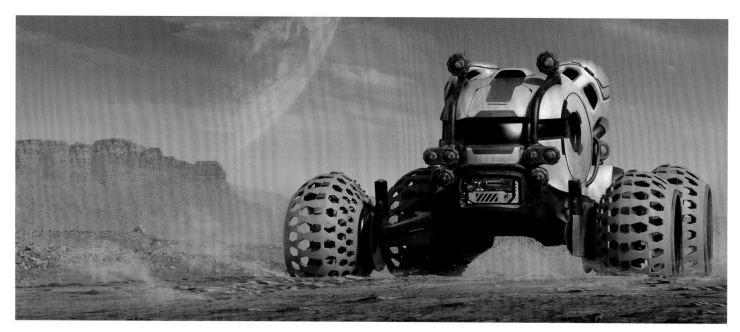

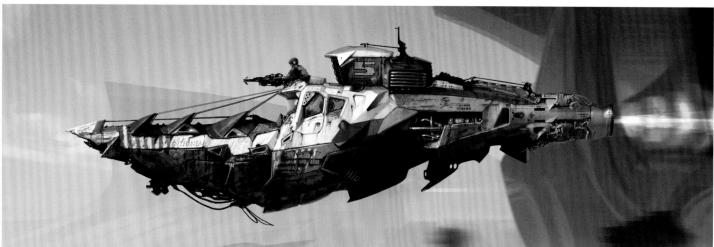

Like most boys, I was a big fan of "Transformers" and was passionate about cars. I used to fantasize about flying in the sky in a plane, and would spend money going to the cinema to watch fantasy movies. All these elements have contributed to my inspiration for this book, and helped explain why this book involves all these different elements.

Scott Robertson plans to visit China in March, 2013, and then again in June. As one of the most authoritative figures in today's machine rendering field, he is looking for a host institution for his own exhibitions, and to launch teaching projects with friends, including Neville Page and Sparth. Robertson, as the President of Design Studio Press and former Chair of Entertainment Design at Art Center College of Design, is no longer content with communicating with fans and followers through publications and online tutorials. Instead, he is taking steps to directly interact with and access the Asian market in person.

As is well known, Robertson loved making soapbox racing cars as a child so as to translate his fantasies into reality with his own hands. For this reason, his childhood dream was to be a car designer. Not many people realize their childhood dreams. Robertson is one of the lucky ones. His father was an illustration teacher, and thus could offer concrete help in terms of techniques as well as educational guidance. *"My dad taught me how to draw and build*

things and most importantly how to pre-visualize anything. He was always supportive of my creative interests but never overdid it so as to drive me away from the creative field. He passed away in April of 2001. If he were still around, I'm sure he would be proud of my pursuits and the way I live my life."

In 1990, Robertson graduated as a transportation design major, shortly after which he opened a consultancy in Los Angeles. Five years later, he took a teaching position at Art Center College of Design. From then on, education was to play a defining role in his life. From platform to graphic, and later the web, the mediums may have changed, but machine rendering has remained the unchanging subject of his courses. *"Art for industrial designers is really about giving the designer a way to communicate pleasing images of the object a company intends to build. In this case art should take a back seat to business."*

As an industrial designer, he has never identified himself as an artist. He values rationality, professionalism and industrial standards. However, after decades of experience he is disappointed by the current state of the industry. *"I feel there is a general lack of originality and fun happening with today's designs. I can understand this as there is a lot at risk if a new design fails. When*

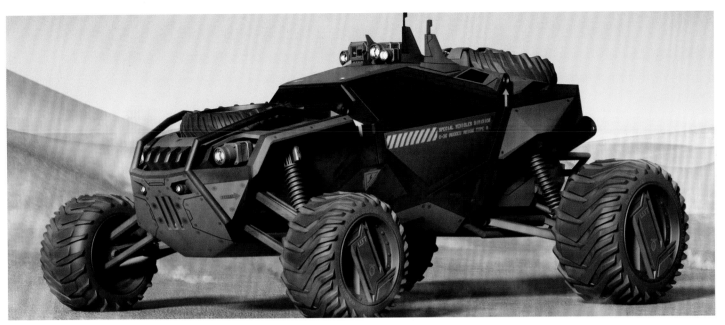

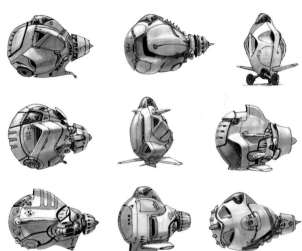

I look at the cars I do like such as the new 911 or the Audi S5 it always comes down to two main factors that influence if I like a car or not, proportion and graphic design. The ones that fall short of executing these two elements well are the ones that I find least appealing."

Drawing, rendering and design are different topics and need to be approached as such. Design should be about creative problem solving with as much creativity as the project requires. Drawing is the quickest way to explore if a creative solution will work or not and it's also the easiest way to share complex solutions with a team. Rendering is all about visually representing the finished product in full color in the proper environment and materials before the product is made. At the same time, Robertson stresses the significance of imagination, which defines those with real talent. *"I think it's more of a cultural mindset or a collective consciousness that influences a designer's mind more than being "born with it." If you are always told daydreaming is a good thing and you can do and be anything you can imagine by everyone around you, then over time you believe these things and start to excel at achieving them. I would like to think that the free tutorials I've been sharing with the world on my YouTube channel, Scott Robertson Design, are helping designers to adjust the ways in which they create by providing examples of how to infuse your workflow with more creativity."*

In order to enable professionals to better understand what he is doing and what he wants to do, Robertson has chosen educational practice as his focus. *"I'm not doing any individual tutoring other than through my online Schoolism course currently. I do teach workshops around the world and here at my studio to groups. Currently all of my workshops and online course are open to anyone who signs up. I do make recommendations as to the skills they need to have before taking one of my workshops. The only courses that are closed to the public are the ones I do for corporations."* At present, large numbers of designers visit Schoolism.com to watch online courses provided by Robertson every year. They even order Design Studio Press books on Amazon.

When working on this book, or offering editorial advice to others, I'm always confronted with a doubt: In this era of information overload on the Internet, are prints still needed? Therefore, I have intuitively avoided some potentially superfluous elements and striven to make this book irreplaceable and irreproducible as digital content. *"I think textbooks are still very valuable in that when it comes to drawings you can see and touch a better representation of the work on a printed page than on a screen. Also finding specific topics in books is much faster than scrubbing through a video. That said, we are developing an iPad app to feature the benefits of*

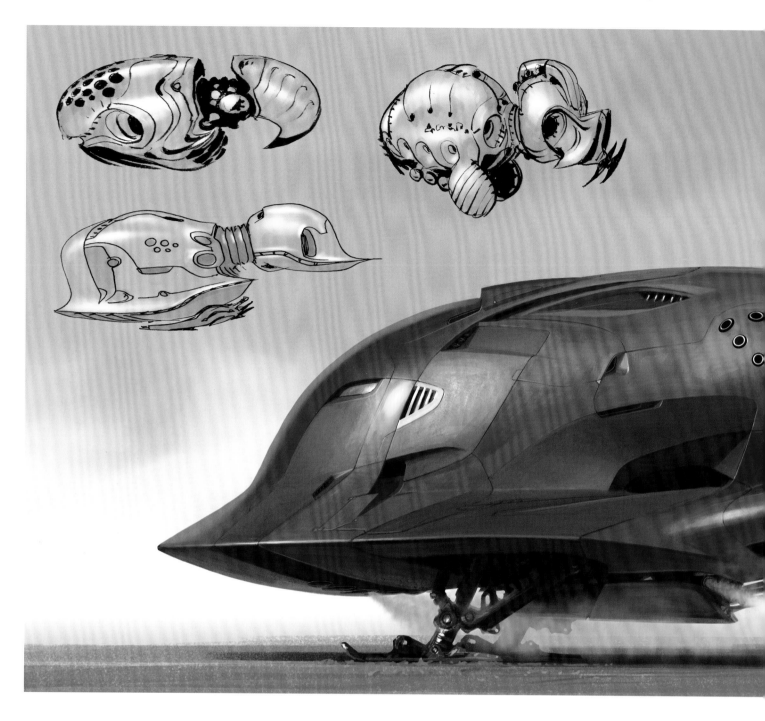

our content on a digital device. The experience will be different from that of the printed book and should ultimately add to the book experience, not replace it."

Being a publisher myself, I spoke about my doubts in my conversation with Robertson. His confident response allayed my worries. I have paid a great deal of attention to the books on design concept published by Design Studio Press since 2003. They represent a new experiment in the market and are distinctively different from other art books. They have even influenced my own editorial style. "We have some basic genres we know will be good books to publish like any well-done educational books on art and design or an "art of" book for a popular entertainment franchise. Beyond that are our artist series books, which can be hit or miss depending on how many fans an artist has. Sometimes it's not enough if I like the work, sometimes our books can have a hard time finding the right audience due to the work being too abstract or mistimed with market trends in concept art and design." These are the tenets of Design Studio Press. Robertson has great

confidence in the books produced by his press. When asked what movies or games impressed him most for their machine rendering, he replied he preferred books of his own publishing, on the basis that they have more creative freedom to give expression to the work. The role of editor frees him from the routine of typical projects by giving a different tempo, which movies and games cannot offer. Besides, books are the perfect showcase for all the outstanding work in movies or games.

This book represents my first experiment with machine design. The final product differs from my original visualization, and took a good deal longer than I initially imagined—after all, reality is not as predictable and well-controlled as machinery. Fortunately, we all evolve with the progress of age and hopefully what awaits us is a more promising future.

I hope readers enjoy this book which showcases many outstanding machine renderings. The resurgent theme which connects all the pages is not only iron and steel but also inspiration and passion.

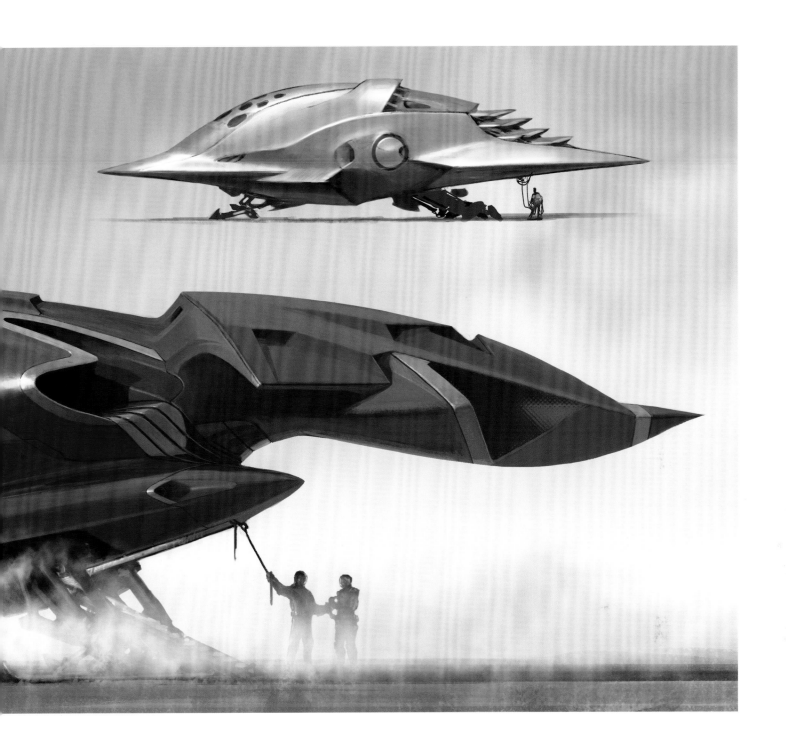

Learn or cheat! If you cannot properly render the object you need to show others in a finished form with a 2D program like Photoshop, then you will need to learn a 3D rendering program to help you with this part of the job. I now have a self-taught course with 18 hours of lectures on the subject of rendering reflective surfaces in Photoshop offered by Schoolism.com.

——Scott Robertson

SUMMARY

Whether you are fan of Japanese Anime style or more a follower of Asimov, all fans are thrilled at the idea of automatic mechanical creatures. Whether they are warriors with glittering armour or simple slaves, they represent one of the ultimate fantasies of mankind.

In this part, readers are introduced to mechanical creatures as the creation of tens of concept designers. They possess independent sources of energy and utilize artificial intelligence. These two features are indispensable factors to be considered by designers who take such commissions or machinery fans who are passionate about independent creative work. They breathe life into these mechanical creatures through feasibility of movement. They do not only visualize these creatures in their mind, but also translate them into reality. For these creators, the creatures have their own names, backgrounds, and stories. These "products" are no longer used to perform menial tasks. They may even evolve into the partners of humankind.

The science of automated robots is almost a religion. The explanations offered by their creators reveal glimpses into the mysteries of the creative process.

AUTOMATIC MACHINERY

Nickname: Nubb

Age: 27

Occupation: Concept designer/Illustrator

Email: iwo.widulinski@gmail.com

Homepage: sec.vc/iwo

IWO WIDULIŃSKI

▶ INTRODUCTION

Iwo Widuliński is a concept artist and an illustrator. He was born in 1985 in Poland where he creates and works now. He is all self-taught, and has never received any artistic education. He could not really say when he started to treat art as a career, because he has never looked at this matter in a different way. It has never been a question of what he wanted to do in his life; the question was which form of artistic expression he should choose. Along his career path, he has tried or was pretty much forced to try shirt design, web design advertising, etc., and finally he found his current area of expertise.

▶ INTERVIEW

Would you first make an introduction of yourself? How did you start to engage yourself in art?

My name is Iwo Widuliński and I'm a concept artist and an illustrator. My initial introduction to art was through comics. Since my earliest years, I went through every panel of every page with amusement. I was truly captivated. Some years later I came across "The Neverhood" game and I saw some "making of" material. Artists doodling, trying ideas, building sets, etc. From that moment I knew that this was it. That's what I want to do. I had never given it a thought before, that all those awesome creatures, characters, monster, environments presented to us in games or films were actually designed by someone. I just took it as given. Somebody actually had to sit down and draw all that magnificent stuff. I wanted to be that somebody, so I went to fine art high school (from which I was kicked out by the way) but I was too immature to appreciate the program. After high school I went straight to work and since then I've pursued an art career.

In addition to machine rendering paintings, you are also engaged in other varieties. Does painting account for a big proportion of your work? What benefits have these paintings brought to you?

Painting and imagining dominate my time. I never stop sketching or writing down ideas. I like that state of panic that a vision will be lost. I've always wanted to draw and paint fantasy. My portfolio was full of orcs, elves and all the fantastic folk. At some point, despite all the content included, I started to get sci-fi commissions. I actually once replied to a company that there must be some sort of mistake. I couldn't understand what just happened. After viewing pages and pages of ghouls and dwarves a company said, "Ok, so we want you to

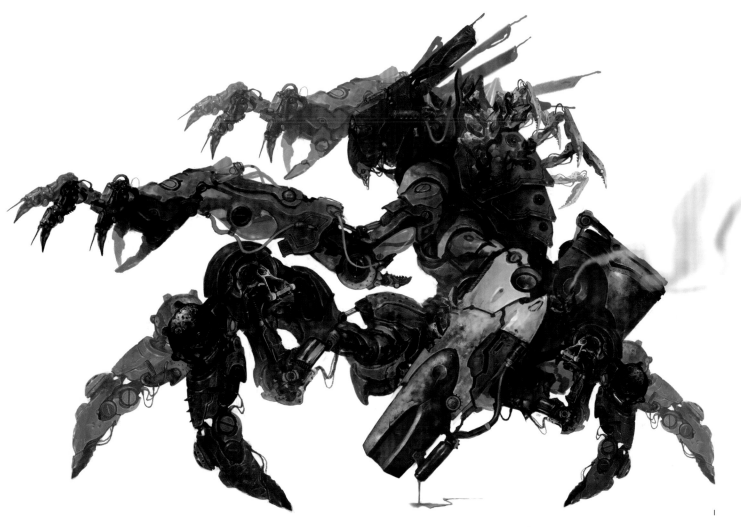

Robot | 2011 | Commercial work

This unit was designed to gather human
flesh at the battlefield to use it for
research purpose

design combat armour for a space trooper." The challenge pushed me
to meet expectations and finally enriched my art. Those experiences
help me now to mix styles and genres. I like breaking from convention.
Working in different fields makes the pool of the visual library deeper.

I can draw from fantasy when creating robots or bring sci-fi or cyber-
punk elements to my fantasy designs. It's a nice way to keep things
fresh for both the client and me.

When did you start to engage in machine rendering? Was there any opportunity?

There were a few small opportunities to design some robot characters
or armour elements but my first huge thing was to come with the

robot fraction for Dark Age Games. They wanted to introduce a new
force to their game and thought my style would fit their world.

Most of yourworks on display are themed on "Dark Age"? Would you please share something more with us about this project?
What role do you play in this project?

As I've mentioned, that was my first big sci-fi commission. My job was
to create a whole line of robots. The great guys at Dark Age Games
found a robot sketch I posted on forums and thought that it was just
the style they were looking for in their project. I was a bit nervous at
the beginning because those robots were for a miniature game. Units

varied in level of advancement, function and their importance within
the fraction and they had to be easily distinguishable on the battlefield.
There are lots of things to think about, but that is one of the most
enjoyable experiences I've had.

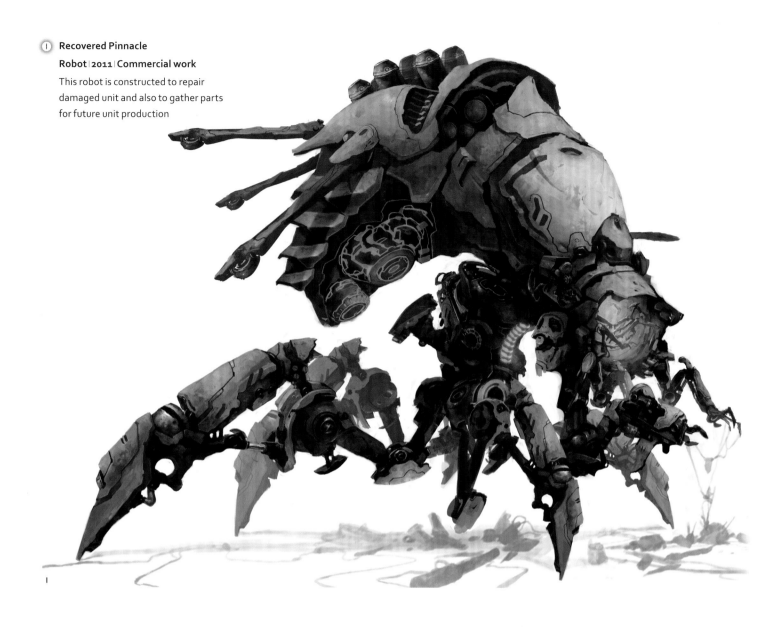

Recovered Pinnacle

Robot | 2011 | Commercial work

This robot is constructed to repair damaged unit and also to gather parts for future unit production

I

What's the defining characteristic of "Dark Age"? Has Gerald Brom brought any dark and gothic elements into this project?

"Dark Age" is a gritty, post-apocalyptic miniatures game, and yes, Brom had a huge impact on the overall style. There are many visual clues of Brom's art all over the place. That fetish tortured soul vibe adds great spice to the mix of this twisted world.

Some works on display belong to the "Galaxy Saga" Series. Would you please tell us more about the characteristics of this project and your role in it?

"Galaxy Saga" is a new game from Applibot Inc. It's a sci-fi turn on the card game for tablet devices. Applibot team invites artists from all over the world to participate and I was one of those lucky people. The setting is very futuristic, hard sci-fi. I think that it's the furthest I ever went into the future with my designs.

All the robots you have designed share something in common: They have relatively more parts and joints, and thus do not look so firm and stout. Are you trying to capture some robot features in this way?

That's actually my taste in mechanical design. I really like to turn robots inside out. Make all the joints visible, move covering plates aside, and expose the structure. I'm a huge fan of the steam-punk way of depicting machinery and I try to push it—regarding the specification of the project I'm currently working on—further into the future or bring it back into the past.

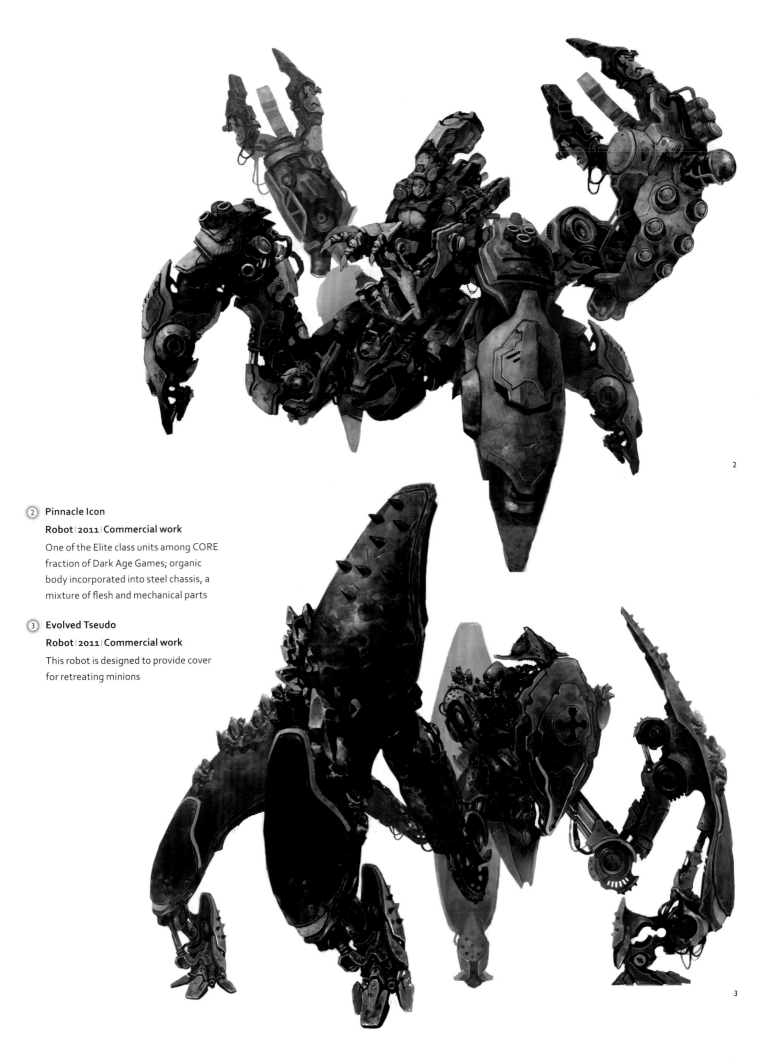

2 Pinnacle Icon

Robot | 2011 | Commercial work

One of the Elite class units among CORE
fraction of Dark Age Games; organic
body incorporated into steel chassis, a
mixture of flesh and mechanical parts

3 Evolved Tseudo

Robot | 2011 | Commercial work

This robot is designed to provide cover
for retreating minions

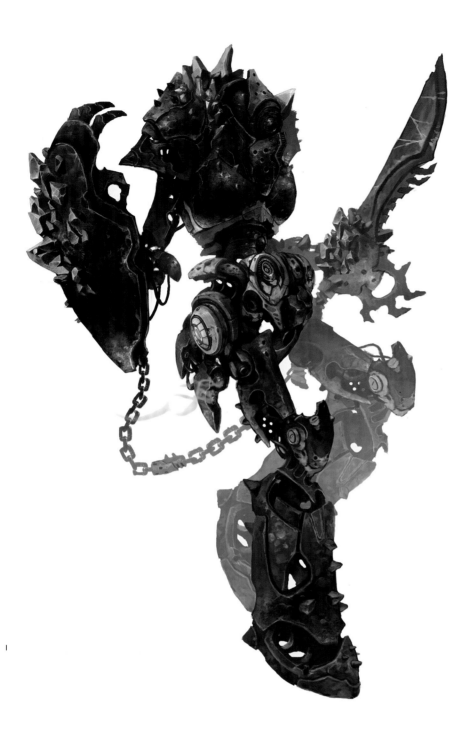

(i) Evolved Legionary

Robot | 2011 | Commercial work

Close combat standard war robot

I

What preparations do you think a machine renderer or an artist should make to finish a machine rendering project? Do they need to learn more in their spare time?

Gathering references is always my way to start. Even if I end up using just a few pictures, I will spend a day looking through my image library (power tools, industrial parts, motorcycle frames and gears, rigs, WWII tanks, rusted vehicle cemeteries, plane wrecks..., pretty much anything that can give me an idea of texture, structure, ways of bringing static and movable parts together) and things I come across while designing a robot. I believe that having some hobby grounded in machines somehow could help. Engineering or mechanical repairs could also help, but I don't have the foggiest idea about these things.

Would you please share with us some experience you have gained from these machine rendering projects?

Oh, I've gained a lot! I've learned to think about more things during the design and rendering process. I think about how gravity would affect the model, how the model would bend or raise an arm and turn its head. I've also spent time studying materials, and the way light brings out unique qualities. Also I pay attention to the big shapes that build up form before I go wild with the detail, and try to check if added elements make the overall silhouette easier to read or weaken it.

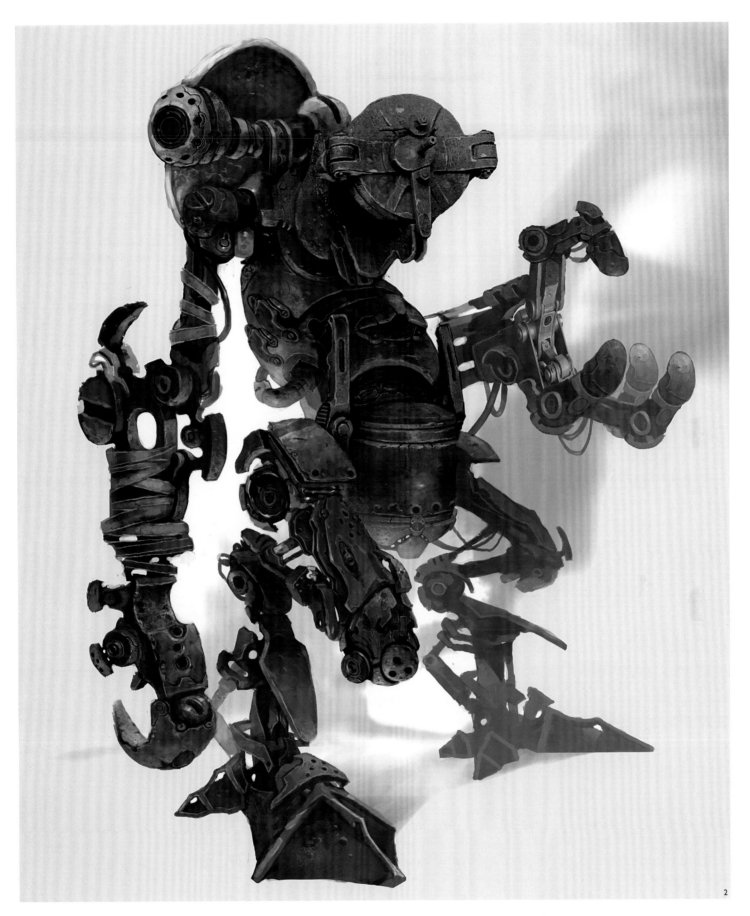

2

Robot | 2011 | Commercial work

Menials are the lowest class robots. This
is the first generation, mainly serving in
battle after being modified. This was a
standard melee close combat unit

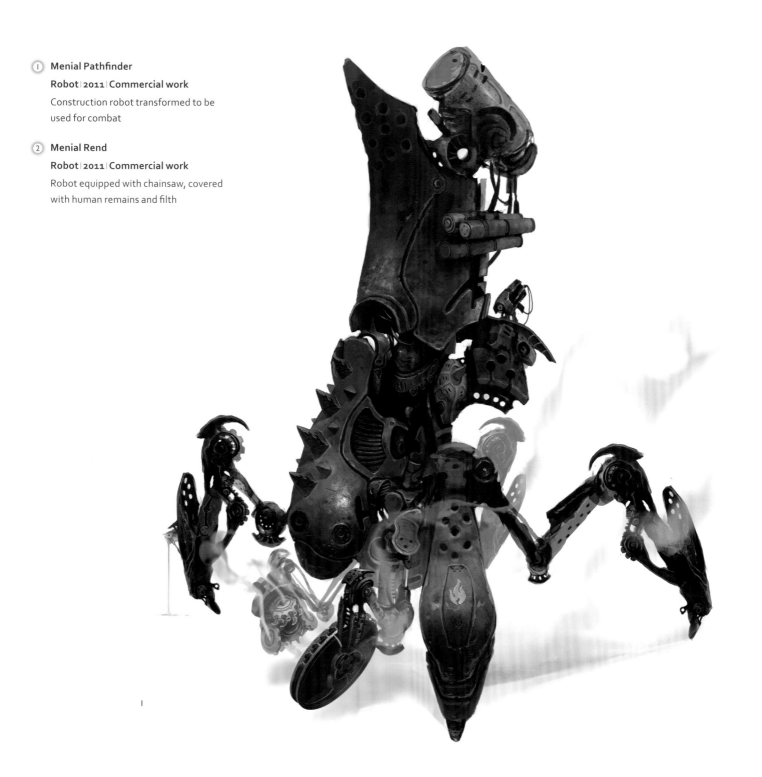

① **Menial Pathfinder**
Robot | 2011 | Commercial work
Construction robot transformed to be used for combat

② **Menial Rend**
Robot | 2011 | Commercial work
Robot equipped with chainsaw, covered with human remains and filth

Whose works have inspired you? Do you like any movie or game for its machine rendering?

There are armies of artists who inspire me. In robot tech design I look up to Ashley Wood, Vitaly Bulgarov, James Hawkins, Ruan Jia, Allessandro Taini, and John Park. I also admire Laurel D. Austin, Dermot Power, Rob Bliss, Iain McCaig, Cole Eastburn and many, many more. It's very motivating to live and create with such talent all around. As for films, my all-time favorite is "Aliens," which I've actually watched a few dozen times, and also "Moon," "Avatar," "District 9," and "The Matrix." I get goose bumps every time I watch that defending dock in Zion scene in "The Matrix." The list goes on and on. There are a lot of sci-fi movies that are just stunning from technical or design standpoints, but the story itself isn't great. I like to freeze footage and analyze what makes it so wonderful. How the lights build up the mood, how some areas are just hinted at and not fully fleshed out. Tons of information is there.

Do you have any plans for machine rendering? Will you dig more in this field?

I never suspected that I'd like machine rendering and design so much. I'm currently working on a project with a few guys that involves mecha design and I'm just loving it. It's my baby project and I can't wait till we are able to show it to the world. I would also like to include more mechanical elements in my fantasy work as I learn more ways to enrich the overall design.

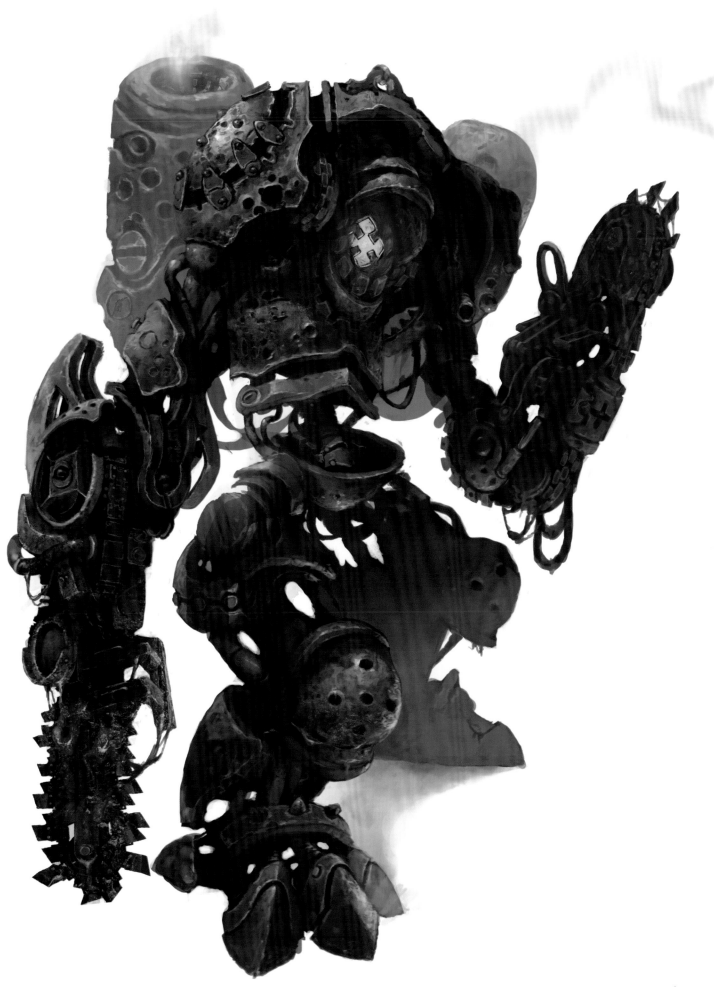

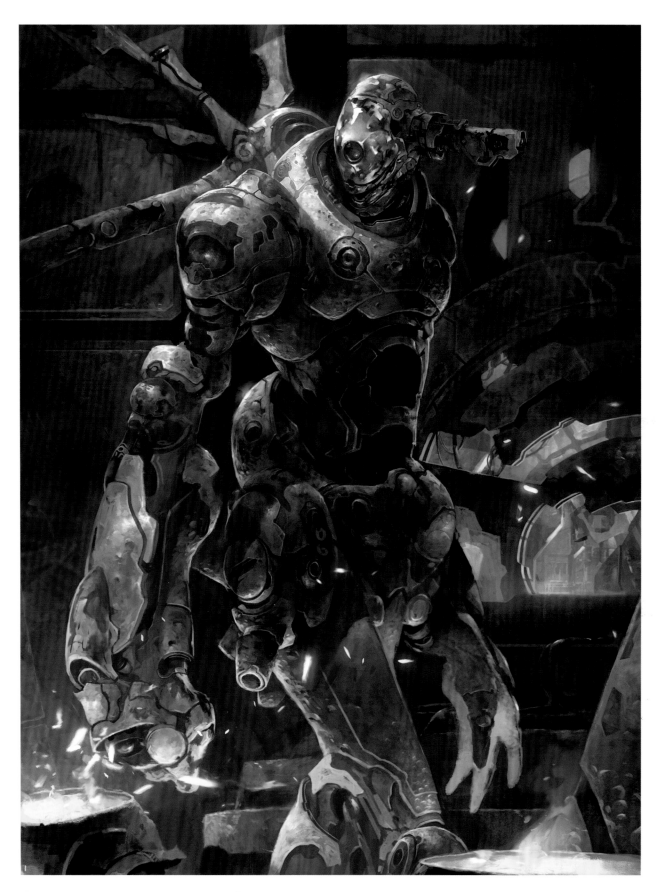

① **Demon Droid Reg**

Robot | 2012 | Commercial work

This is a design for deadly and intelligent combat droid Reg. The silhouette should be quite slim and not so bulky to indicate its fast movement and more tactical approach

② **Demon Droid (advanced version)**

Robot | 2012 | Commercial work

AppLIbot projects require a standard and advanced version of illustration design, so this is the evolved version of Demon Droid unit. The idea behind all the advanced versions is to show the darker, stronger side of a character

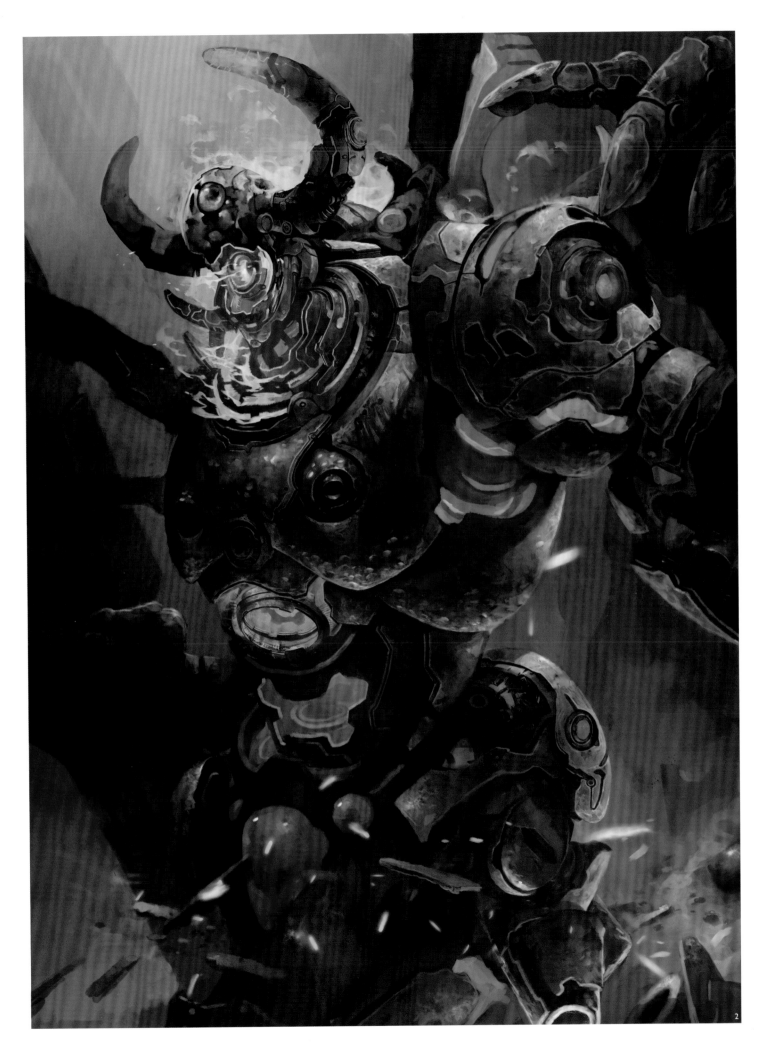

Nickname: Ben Mauro
Age: 28
Occupation: Concept designer
Email: Benmauro@gmail.com
Homepage: www.artofben.com

BEN MAURO

▶ INTRODUCTION

Ben Mauro is a US-born concept designer and digital sculptor. He studied industrial design and entertainment design at Art Center College of Design in Pasadena, California. He has been working in Wellington, New Zealand at Weta Workshop since 2009 and over the past few years has contributed to a vast array of film, television and videogame projects such as "The Hobbit" trilogy, "Elysium" and "Valerian" among many others. Before coming to Weta Workshop he worked as a freelancer for various clients including LucasFilm, Rhythm & Hues, Activision, EuropaCorp, Universal Pictures, Sony Pictures Animation, Insomniac Games, Design Studio Press and Vishwa Robotics. While most of his time is taken up by his duties at Weta, he continues to offer his design services to clients around the world.

▶ INTERVIEW

How did you embark on the path of artistic creation?

It has been about 10 years since I decided to become a designer. It was a lot of work, and it has not been easy but has been very rewarding. Initially I thought I wanted to be a level designer in the game industry creating environments and architecture. That took me to a school in Seattle called DigiPen where I studied for a few years, but after meeting many local concept artists like Kekai Kotaki and other ArenaNet artists they convinced me there would be a much more creative and rewarding future being a concept designer. So after much research and thought I decided to change school and move to Pasadena, California to attend Art Center College of Design where I got a strong foundation in industrial design and entertainment design with some incredible instructors like Scott Robertson and Neville Page among many others. I studied there for a number of years learning a lot and making many good friends, which led me to meet Richard Taylor at Comic Con, who after seeing my portfolio asked me to keep in touch with him because he wanted me to come to Weta Workshop when they had work for me. About a year later the opportunity came up and in 2009 I made the move to New Zealand where I currently live and work.

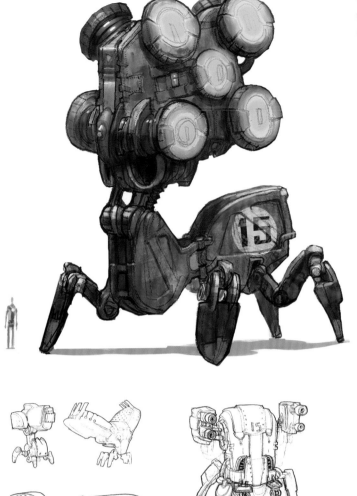

1 Maladroit Mech

2 Mechanical creature | 2008 | Personal work

3 This is probably one of the earliest designs included in my portfolio. This was created when I was still in college. I imagined there could be a whole series of these robots that would harness and release energy in a more whimsical videogame environment. As the players' vehicle needed recharging, you could stop near these robots and they would fill up your batteries

Since when have you started doing machine rendering? Was the initial rendering required by the clients or did you do it out of interest?

I have always loved robots and machines, all of the work presented in this book from me is personal work that I came up with exploring different ideas I had at the time outside of any work-related project. If you look at much of the early work I did you can see more playful, colourful and more stylized types of designs that look more illustrated and painted. Later on when I start integrating photography and 3D into my design process, everything gets more serious and realistic, losing a bit of its charm and less colourful, but feels more believable.

You have participated in designing many films and videogames. Which project do you think is the most unforgettable one?

By far my favourite design experience on a project was working with Neill Blomkamp on "Elysium." It was one of the first projects I worked on when I got to Weta Workshop straight out of college and was working with amazing designers like Aaron Beck, Greg Broadmore and Christian Pearce, so every day was a huge learning experience as I worked with very experienced designers and also a very talented director who has very good sense of design. Overall that was a huge learning experience that changed my art and my thinking forever.

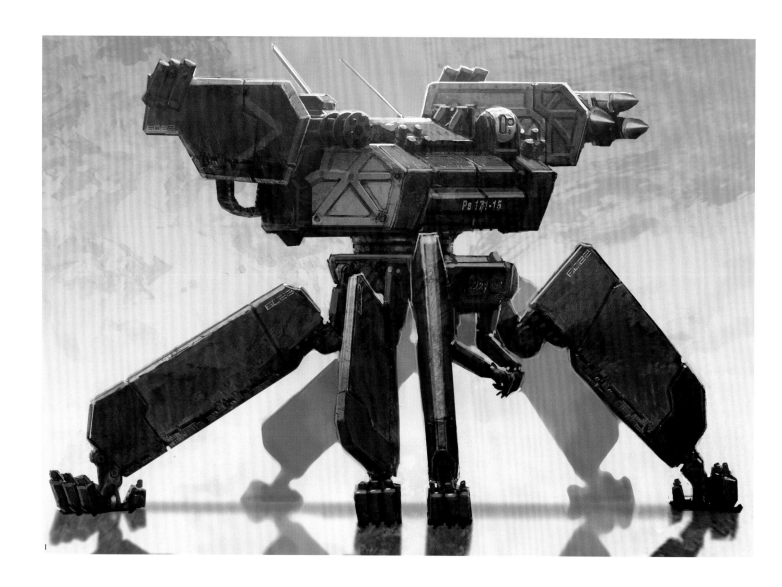

What kind of interesting experience do you have at Weta Workshop?

Some of the big experiences for me were just learning from some incredibly skilled senior designers. I learned a lot in school, but I feel like Weta Workshop was my real education. I saw the importance of 3D and digital sculpting which is a skill set I picked up here as well along with learning and growing as a designer in every way imaginable. Being surrounded by so many physical sculptures, designs and film history really sink in whether you know it or not. Just being involved in a project from start to finish is a very important experience to have as a designer, working back and forth with people building your design and the issues that you need to solve to make a design work from a 2D drawing to a 3D prop that an actor needs to use in a film. All of those experiences have been really essential to my understanding of design and how I approach creating things.

Many of your machine renderings are personal works but not for completing projects. Why?

I always make time for personal work. On a job you are always creating someone else's vision, which sometimes is very fun and sometimes is not. Personal work is a way for me to show my ideas and my own personal vision that make me a unique designer. This extra effort into personal work allows you to make a name for yourself outside of big jobs and the company you work for so that hopefully one day you can create your own films with your own vision instead of working for other people the rest of your life.

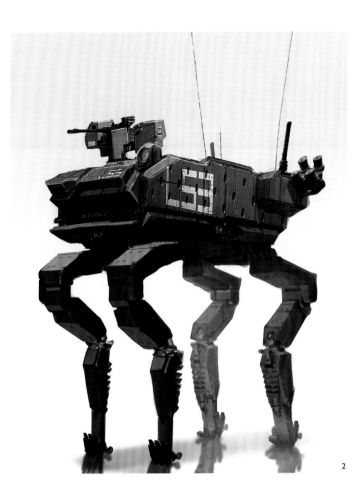

① **AMP Mech (Autonomous Military Patrol)**

Robot | 2010 | Commercial work

This design was created as a demo for the magazine *ImagineFX* creating realistic military robots. I showed my process of gathering natural and military reference as a starting point, initial design drawings, then a final design and rendering. The idea with the legs and arms was that this robot could fold up into a very box-like form, which could be easily stacked into a transport vehicle and shipped all over the world

② **Big Dog LS3**

Robot | 2010 | Personal work

This was purely a design exercise for myself, at the time when Boston Dynamics' "Big Dog" robot was a working real design and I had just read that they won the contract to develop a militarized version of the design called the "LS3" for "Legged Squad Support System." So being really interested to imagine what a military version of the "Big Dog" robot would look like, I did this drawing for fun to visualize it

③ **Big Spider LS6**

Robot | 2010 | Personal work

After completing the Big Dog LS3 design I decided to follow that logic and push it even further into the future and create what could possibly be another design in the same product line, a sort of militarized spider mech. This autonomous robot would be a sort of mini "walking tank" that could scout ahead and give support to troops on the field in combat

2

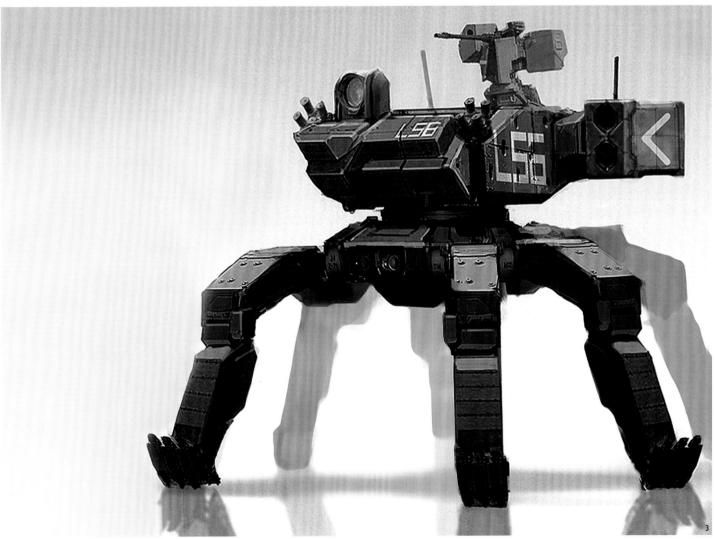

3

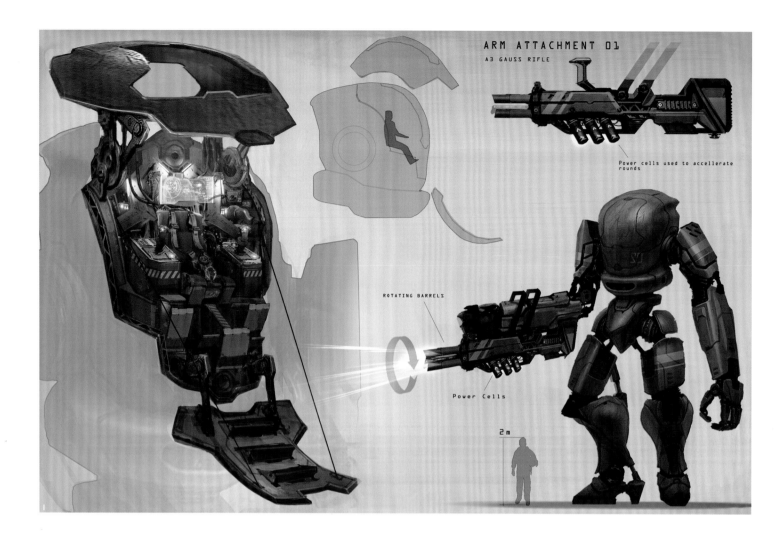

ARM ATTACHMENT 01
A3 GAUSS RIFLE

Power cells used to accellerate rounds

ROTATING BARRELS

Power Cells

2 m

Some Chinese characters appeared in some of your works. Are these works part of a series? Why did you bring in this kind of design?

These originally showed up in some images because they were relevant to the story I was trying to create. The first image was of an old Chinese farmer in the future with cybernetic implants in his eyes and brain. The idea was that in the future human consciousness could be transported to multiple different bodies, so this person is maybe on the run from criminals and has gone way out into the country and is hiding in this old farmer's mind while he waits for people to stop pursuing him. This initial series of images showing the futuristic Chinese farmer leads to a second series seen in the "Grey Fox"

images, which could maybe have been the same person's mind many, many years in the future where human bodies no longer exist and only robot bodies occupy the earth. On top of those reasons it makes sense to me that the Chinese language would be prevalent in the future as the country will become the dominant superpower as the years go on and will have a very large cultural influence on the rest of the world, so adding that element to my work makes it feel more authentic as a piece of futuristic design.

What features do your machine renderings have? Which aspect of the machine do you mostly like to deliver?

I think my machine renderings at the moment have a very broad range of design aesthetics; I have always been interested in machine rendering over the years, which hopefully is reflected in the work presented in the book. Right now my favourite part is to create

something that feels and looks realistic even though the design might be something not seen before, making something look like it is real and can function even though it is just a drawing.

Which machine rendering in videogames or films is your favourite so far? Why? What do you learn from that?

My favourite machine rendering film would probably have to be the original "Ghost in the Shell" anime. The level of design in that film is still pretty unmatched in any other movie. The level of realism in the designs and the way weapons, combats or actions is handled is

still really incredible by today's standards, and there is still a lot to be learned from that film and from the designer Masamune Shirow who created the designs and the Ghost in the Shell universe.

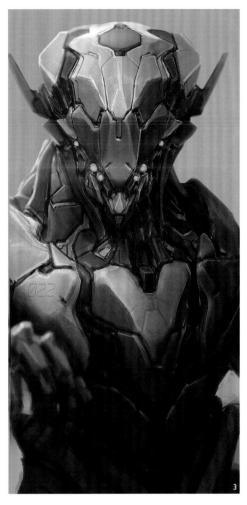

① **K.I.W.I. Cockpit**

Robot | 2009 | Personal work

This is showing the interior view of what I thought the cockpit would look like on the K.I.W.I. robot, imagining how the front plating would fold out and down so the pilot could get out, adding steps into the main plate so the pilot would have more footing exiting the vehicle

② **GREYFOX**

Mechanical creature | 2011 | Personal work

This design was created for the book *Nuthin But Mech* published by Design Studio Press. I imagine this character to be some high-tech robot that works in an advanced intelligence facility in Neo Shanghai. The AI that runs the facility would download part of its consciousness inside the robot to interact with objects in the physical world

③ **220**

Mechanical creature | 2012 | Personal work

I imagine this character to be some sort of higher-level alien robot "king" in the world it lives in. The sort of technology I am playing with here is a combination of hard surfaced armoured areas with flexible synthetic muscle type structures in between to allow for a full range of motion in the joints and legs

What to start with when a concept designer prepares to create a set of machine renderings?

I think having a strong idea is the most important thing, and then asking yourself as many questions as possible will give you a good starting point. Is it based on current day technology or is it in the future? What type of function does this machine have? Is it built for war? Is it built for manual labour? Where is the machine used? Is it manned or autonomous? Asking yourself all these questions will allow you to start gathering relevant reference to use as a starting point before you start sketching out ideas that can be developed into more refined designs.

With regards to the creation of machine renderings, what further plan do you have for the future?

My plans for future machine rendering art would be to push more realism and more originality in my work. Much of my journey so far, the first 10 years of my career, has been learning so many techniques, foundation skills and learning so much about the world and how machines work. I feel like I am finally at a point where I can express visually the things in my head to a competent level and now it is time to focus more on really high-level conceptual development, as I don't need to worry as much about technical skills. The first 10 years feel like a big warm-up and now I am finally ready to push myself to create "real" art.

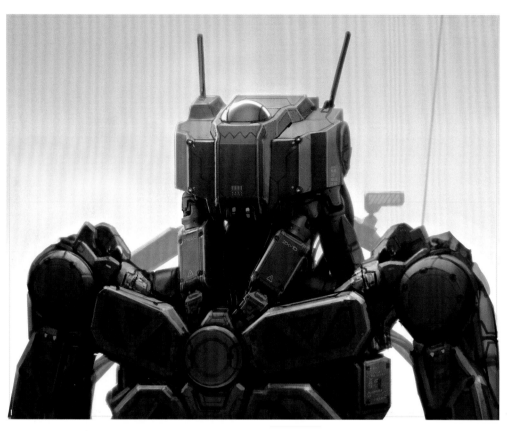

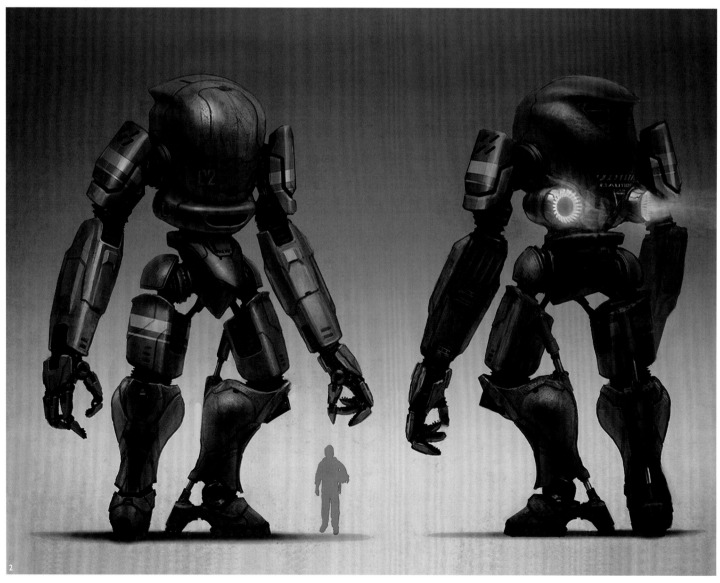

① **X7**

Robot | 2008 | Personal Design

I imagine this character to be a more developed Boston Dynamics "Petman" type robot that could be used for the military

② **K.I.W.I Mech**

Robot | 2009 | Personal work

This image showcases some sort of future military robot that could be piloted for exploration or combat in some future warzone environment

③ **330**

Mechanical creature | 2012 | Personal work

I imagine this guy would be from some sort of lower level troop that would go out and fight wars or carry out tasks for the 220 character. It is of similar design elements described for the 220 in the overall aesthetic and the specialized foot design

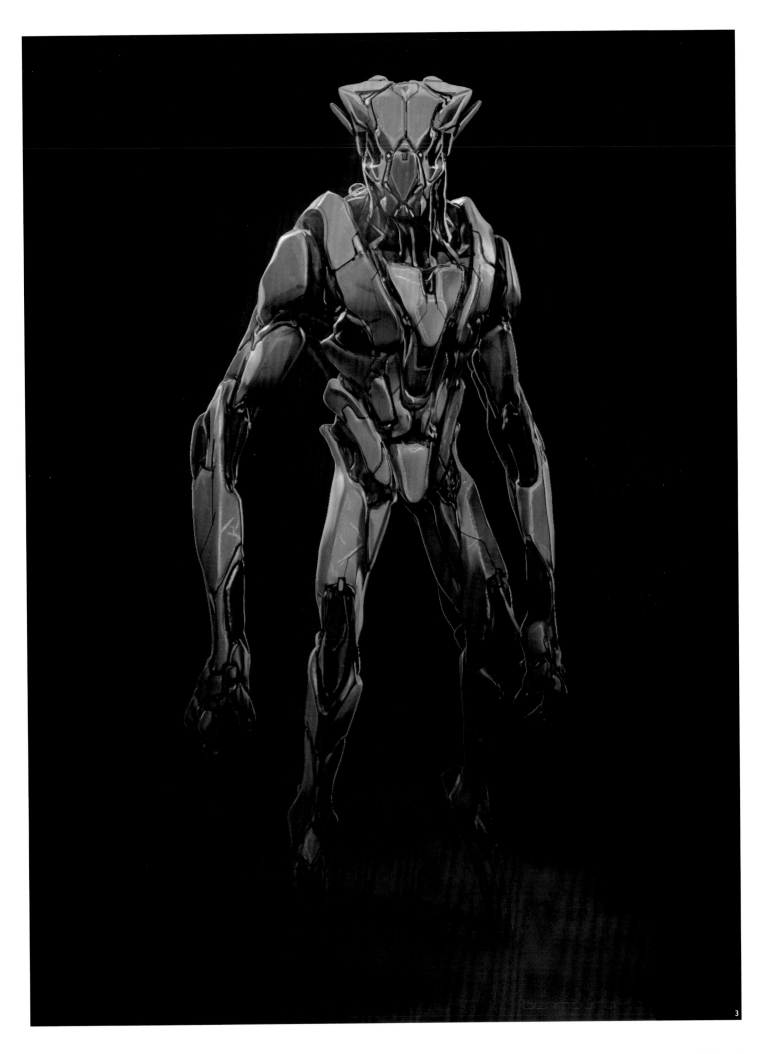

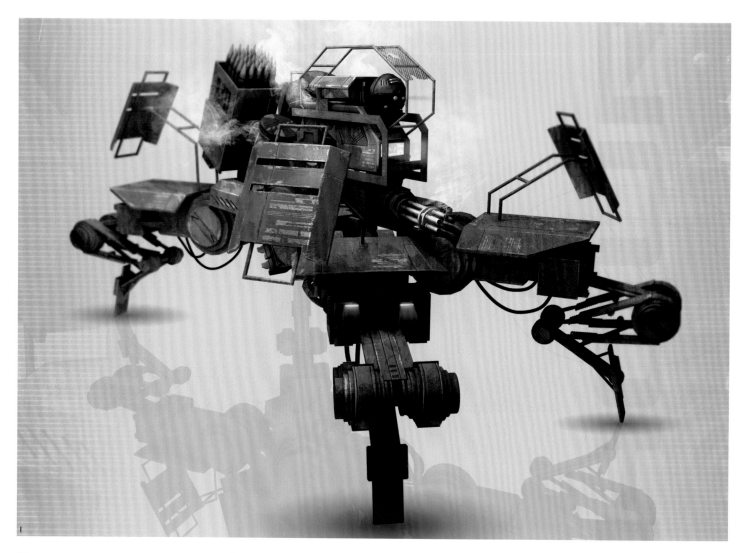

(1) **Salvaged Robot**

Iwo Widuliński | Robot | 2011 | Personal work

It was built from scraps in some post-apocalyptic world to act as a sentry

(2) **Mechanical Hanger**

Iwo Widuliński | Robot | 2011 | Personal work

It is a hanger bay, ready to launch the elite mechs. It drops robots at high altitude

(3) **Grunt Robot**

Brad Wright | Robot | 2011 | Personal work

A multi-purpose grunt of a robot; whatever the situation, they can be sent to deal with it

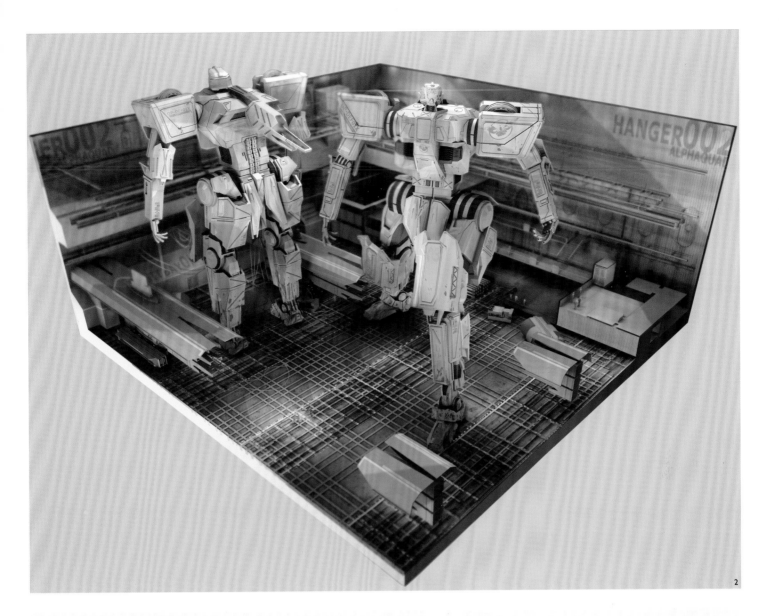

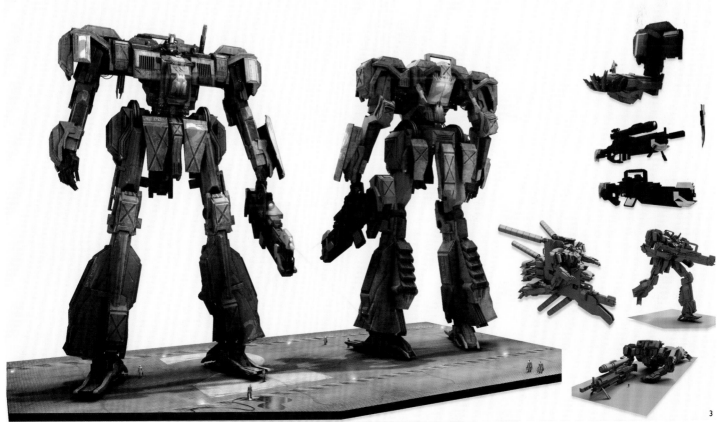

1. **The Magi**
Iwo Widuliński | Robot |
2011 | Personal work
The Magi is a protector,
a travelling holy man,
defending those
that cannot defend
themselves. He wears an
archaic mechanized suit,
millennia old

2. **God or Mecha**
Iwo Widuliński | Robot |
2011 | Personal work
I wanted to create a more
organic mecha, as well as
an illustration that would
bring all the drama and
atmosphere that I felt
watching anime

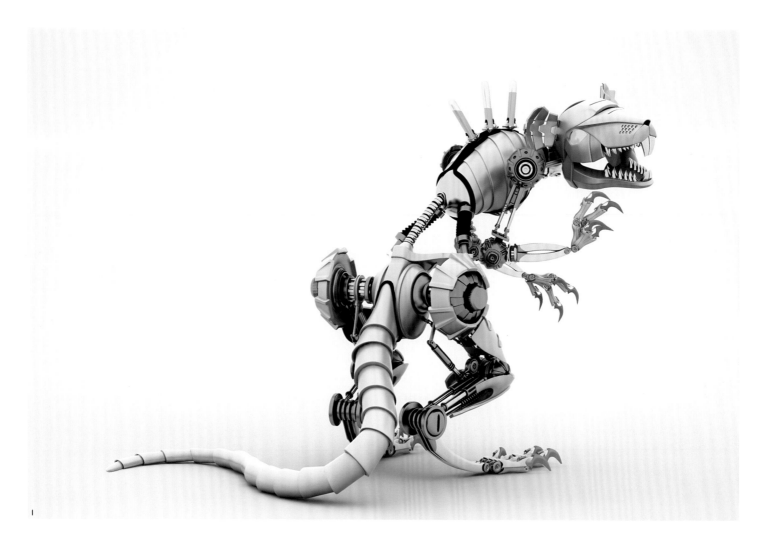

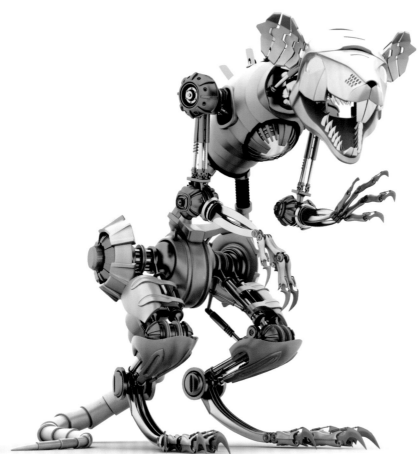

① R.A.T.

② Benjamin Parry | Robot | 2010 | Commercial work

The R.A.T was designed to be a high-tech robotic rat that is as much a rat as an advanced bipedal machine. I found a good blend in the design between the rat form and a robot by keeping as much of the animal shape as possible

③ Cyborg

④ Benjamin Parry | Robot | 2010 | Commercial work

This is a model designed for Mad Cats Inc. for their line of Cyborg Gaming products. The look of the Cyborg had to fit in with the key design elements of my R.A.T. model that was already being used for a product in this same product line

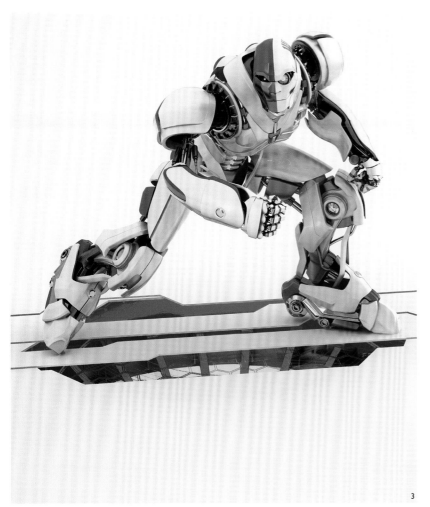

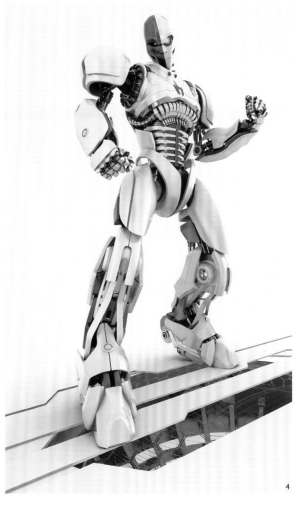

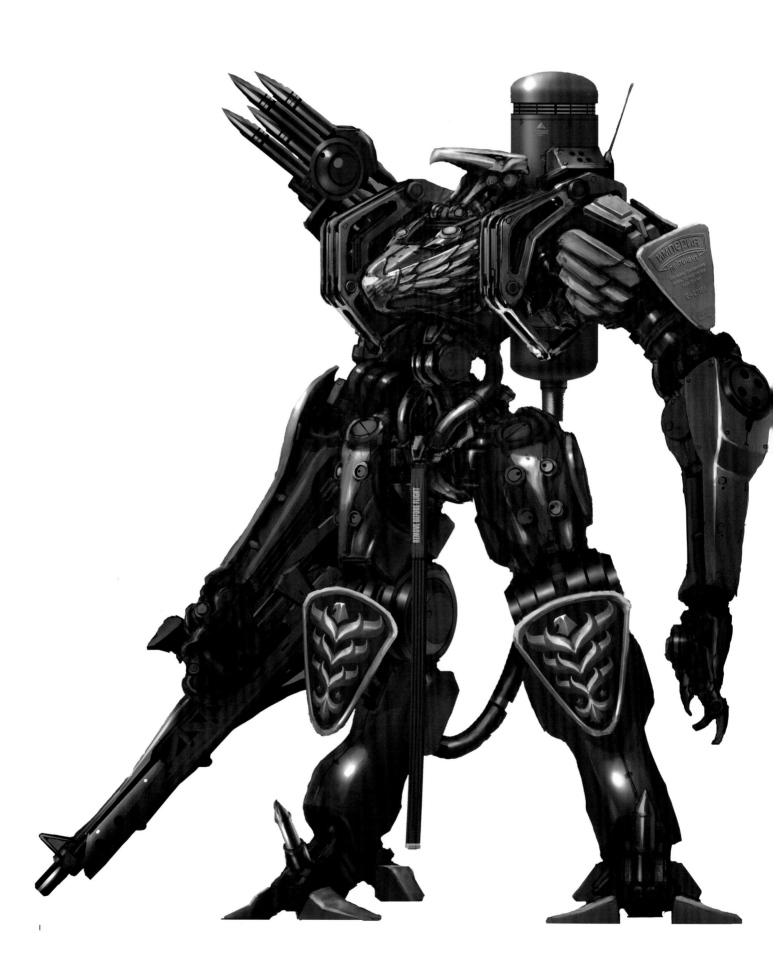

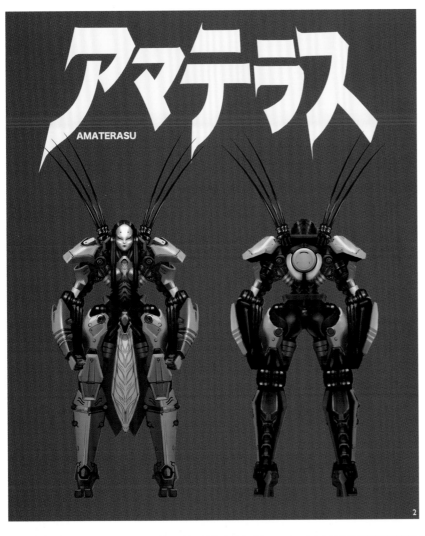

アマテラス

AMATERASU

① Elite Guards
Thom Hoi Mun | Robot | 2012 | Personal work
I was trying to work within the same design language as Lt. Gustav, giving it a less subordinate look

② Amaterasu
③ **Thom Hoi Mun | Robot | 2012 | Personal work**
I was trying to build a robot with more conventional joints and mechanism

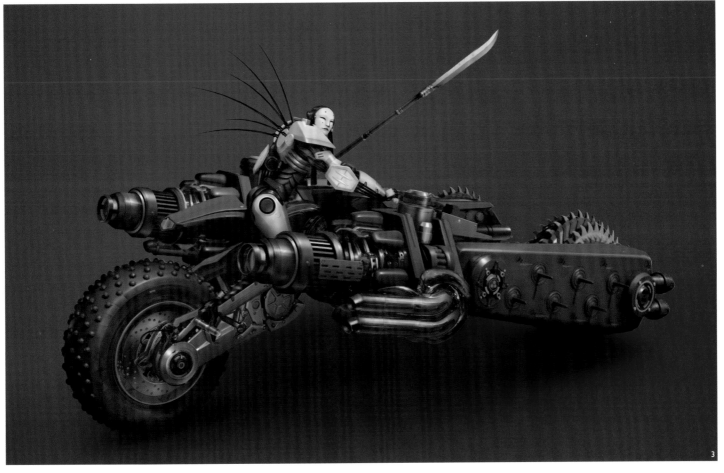

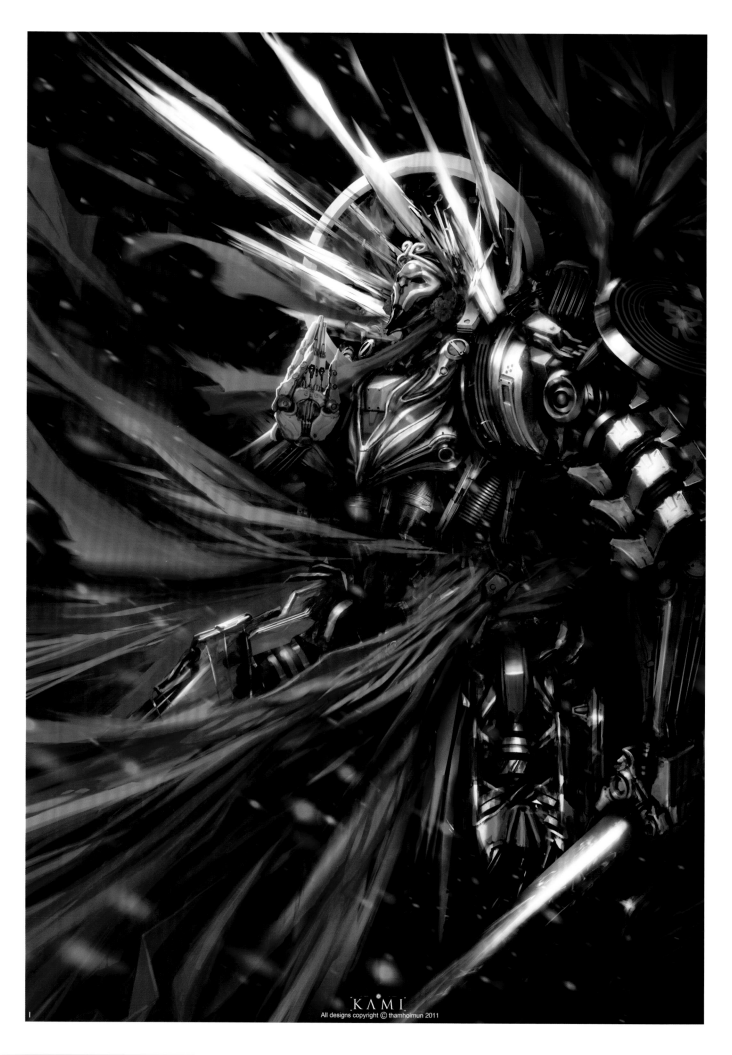

KAMI
All designs copyright © thamhoimun 2011

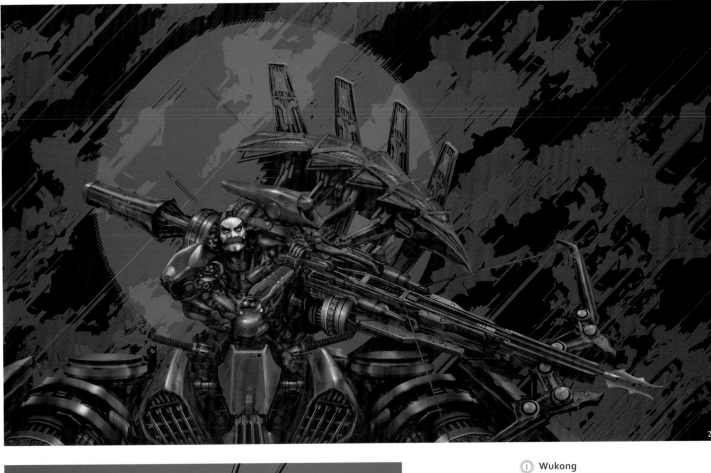

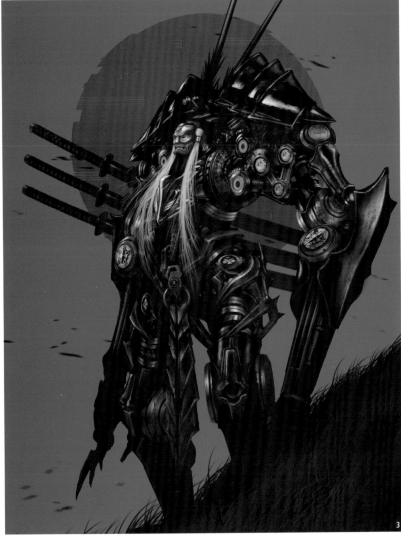

① **Wukong**
Thom Hoi Mun | Robot | 2011 | Personal work
Monkey King as a robot created an uproar in heaven; it's my attempt to create an epic feeling in the piece

② **Susanoo**
Thom Hoi Mun | Robot | 2012 | Personal work
My design takes on Susanoo for KAMI project

③ **Fujin**
Thom Hoi Mun | Robot | 2010 | Personal work
I played with existing Fujin designs from Japanese folklore without being too similar or literal but more of my recreation of the deity as a robot

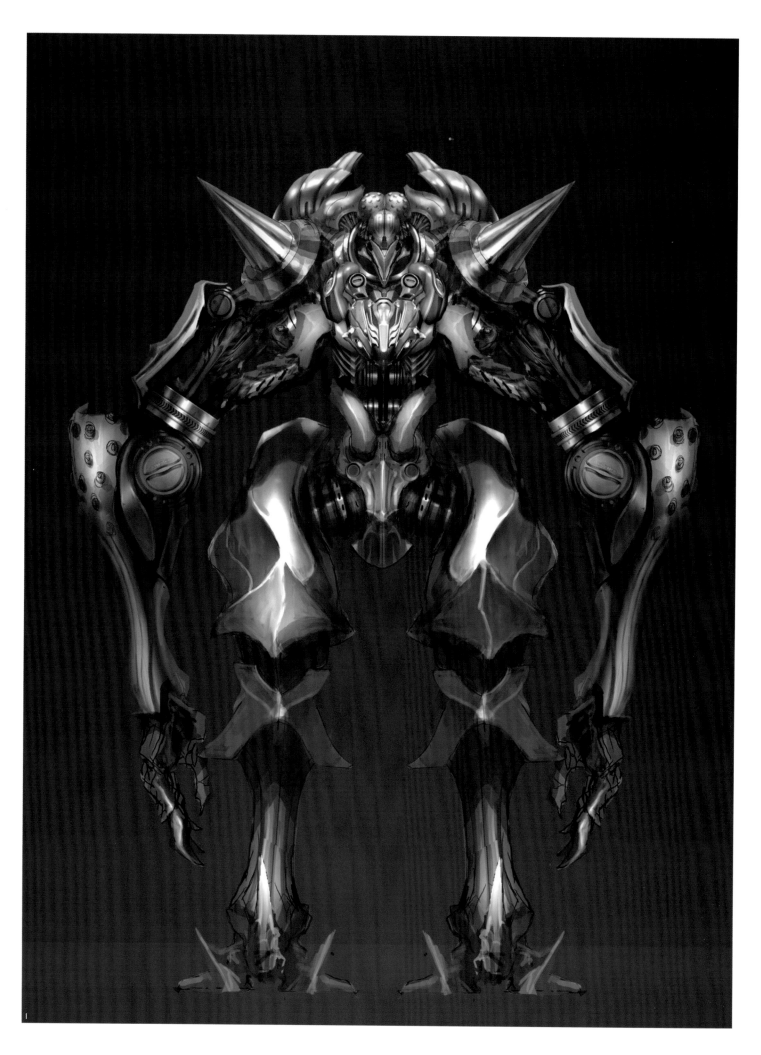

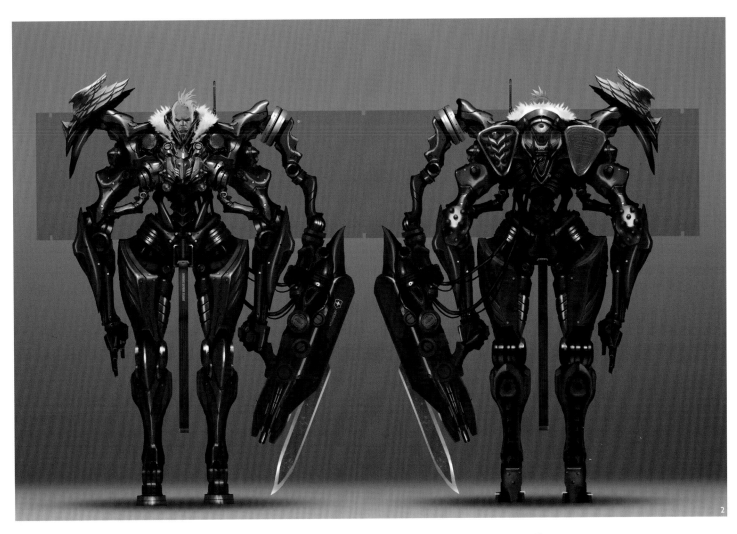

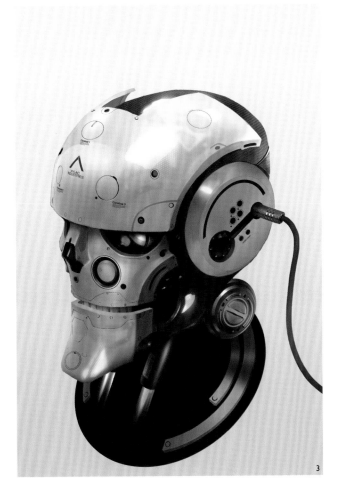

① **Mark Six**
Thom Hoi Mun | Robot | 2012 | Commercial work
At times I just love organic hard surface shapes. This robot is the best example of that

② **Lt. Gustav**
Thom Hoi Mun | Cyborg | 2011 | Personal work
An updated design of its sold form

③ **Droid Head**
Thom Hoi Mun | Robot | 2011 | Personal work
I'm always a big fan of very industrial-looking design, so this is my attempt to design a robot-like household appliance

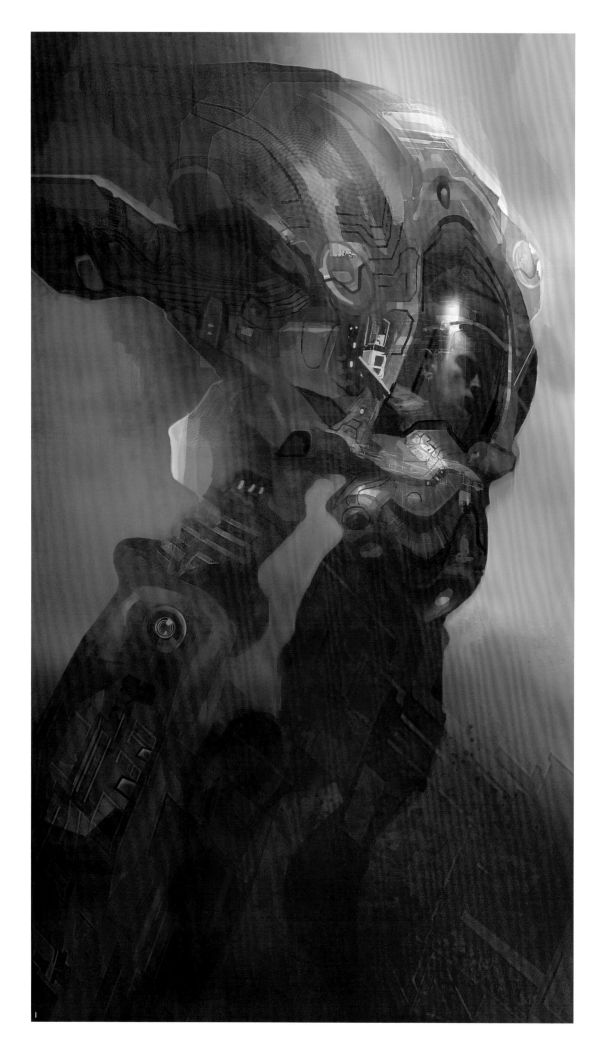

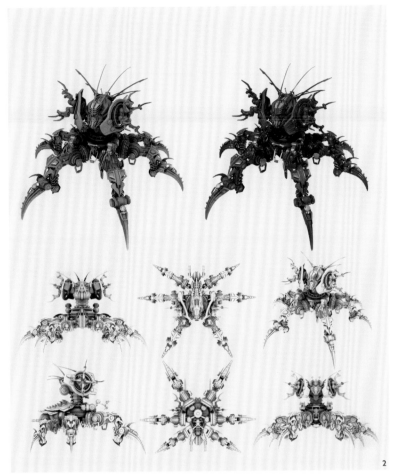

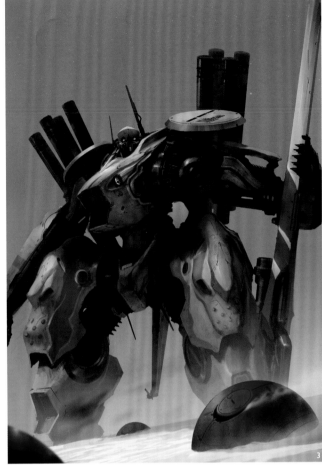

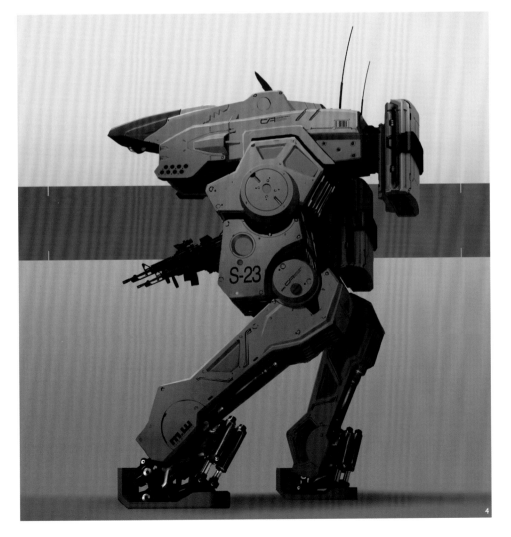

① **Assault Soldier**

Alejandro Martinez | Robot | 2012 | Personal work

The Assault Soldier's armour is made of metal and titanium. Its brain, connected to sensors of movement, is of top human intelligence. The sockets contain automatic mechanisms with weapons, missiles, rifles and lasers

② **Roachster Walker**

Thom Hoi Mun | Robot | 2009 | Personal work

It's one of the very few personal 3D concept models I did; this design didn't start from a drawing; it was all just free-style modeling after doing a bunch of research on cockroaches

③ **Zoltán**

Thom Hoi Mun | Robot | 2012 | Personal work

An illustration as comic cover for *Zoltán*, featuring a gigantic robot in search of the lost capsule

④ **Sentry**

Thom Hoi Mun | Robot | 2012 | Personal work

I imagine a future army with unmanned walking turrets or sentries

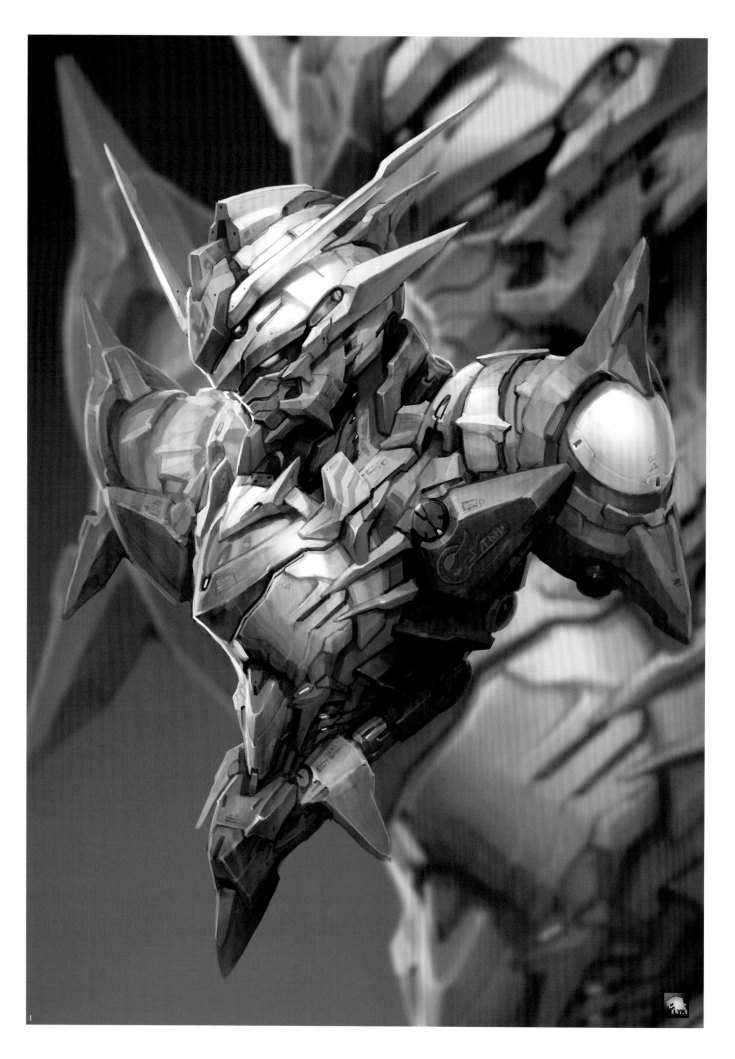

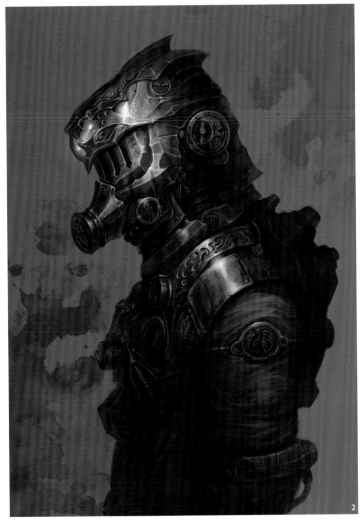

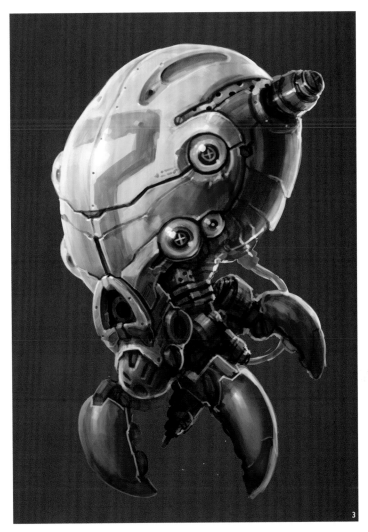

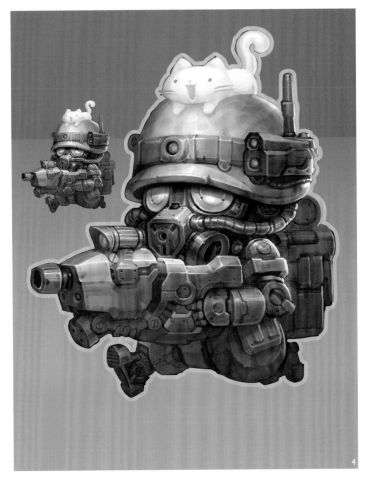

1. **Steel Egg (Gundam)**
 LYK|Robot|2011|Personal work
 This Gryphon steel egg has a built-in electromagnetic and highly ionized pulsating compression furnace

2. **PTK640**
 LYK|Robot|2011|Personal work
 An exercise; a set of gears with fantastic flavor attached to the bionic robot

3. **Eight Claw**
 LYK|Mechanical creature|2011|Personal work
 An egg-sized medical robot implanted in patients, preferably downed with warm water

4. **CS**
 LYK|Robot|2011|Personal work
 Fan mechanical rendering based on CS games

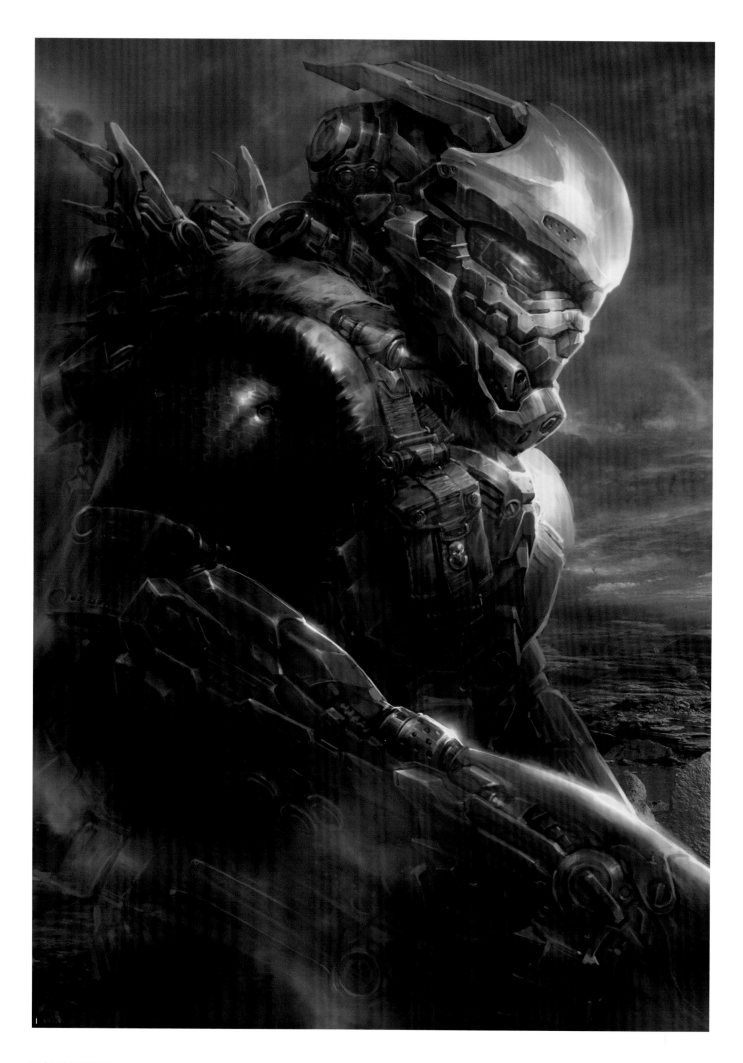

① **Squad Leader**
**LYK | Robot | 2011 | Personal
work**

Earth citizens, known as
nomads with a militant
nature, take their weapons
to seize this newly
discovered, undeveloped
planet

② **Tyrannosaurus**
**LYK | Mechanical creature |
2011 | Personal work**

This predator dinosaur is
my spiritual icon

③ **Mass-produced Soldier**
**LYK | Robot | 2011 | Personal
work**

A subordinate robot which
can defeat the leading
robot

④ **Lemon Machine**
**LYK | Robot | 2011 | Personal
work**

This is a combat machine
converted for civil use.
This machine once
hovered over mountains,
but now is painted in
attention-grabbing
lemon yellow

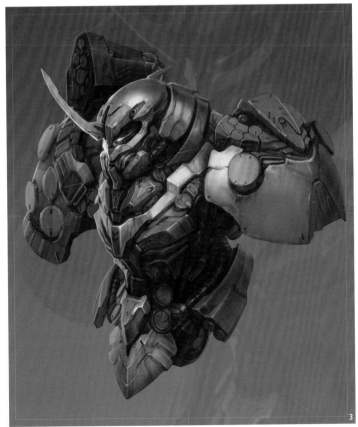

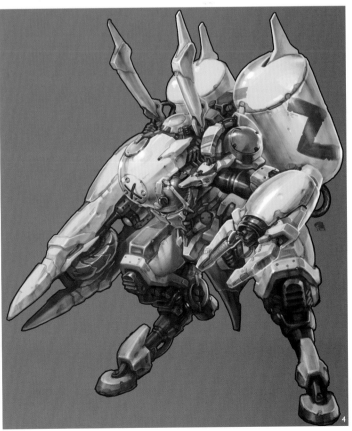

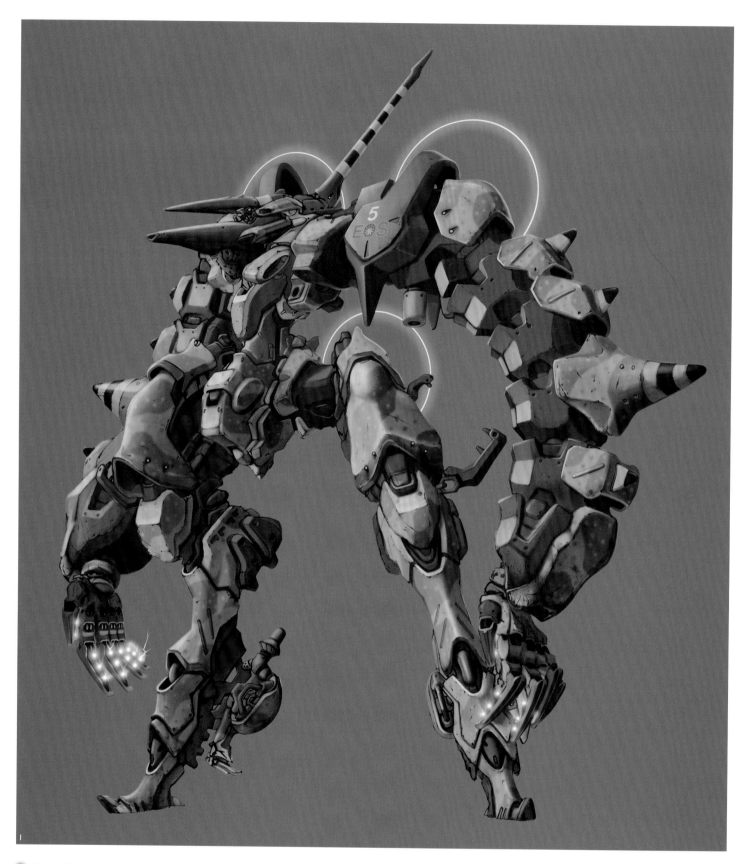

① **Gottheitzerst**

Karl Östlund | Mechanical creature | Original version in 2005, updated version by TKP in 2008 | Commercial work

The Gottheitzerst, developed by Waimanu, is one of the most dreaded weapons ever to prowl the battlefields of Polemos

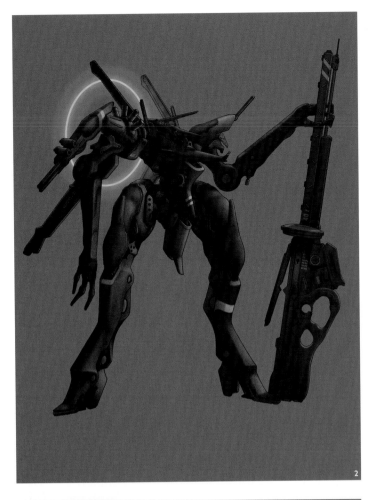

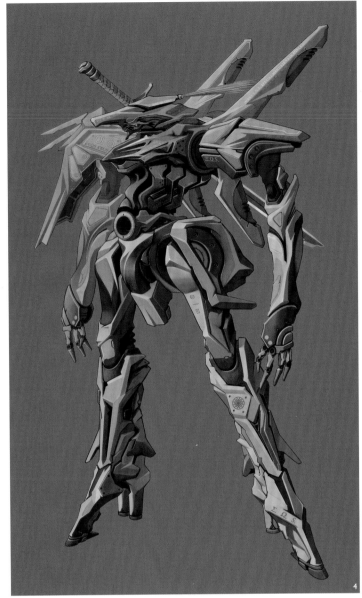

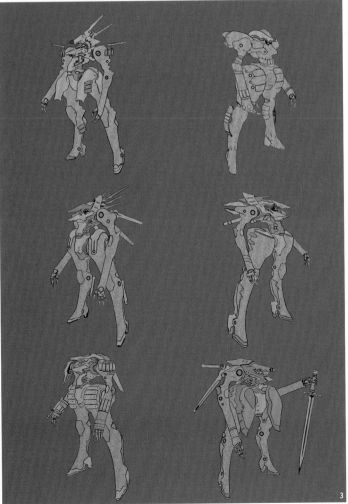

(2) **Harma-Bhatra**

Karl Östlund and Mike Majestic | Mechanical creature | Original version in 2005, final version by TKP in 2012 | Commercial work

The Harma Bhatra MJ-11a was developed by the Waimanu FOIL Works. The company was also responsible for the dreaded Gottheitzerstorer FOILjaeger's of the wildly experimental third generation of FOIL development

(3) **FOIL Thumbs**

Mike Majestic | Mechanical creature | 2012 | Commercial work

A collection of more "refined" fifth generation (final era of FOIL development in SOL); FOIL rough thumbs as an example of the design process

(4) **Lavess Mirari**

Karl Östlund and Mike Majestic | Mechanical creature | 2012 | Commercial work

Lavess Mirari is a Polemon combat FOIL manufactured by Lavess SoSo, a company specializing in customized designs

⓵ **Dethrod Profile**

Nicolas Crombez | Mechanical creature | 2011 | Personal work

A transport vehicle featuring a combination of skull and motorcycle seems to storm into this world from the hell, disseminating fear and intimidation

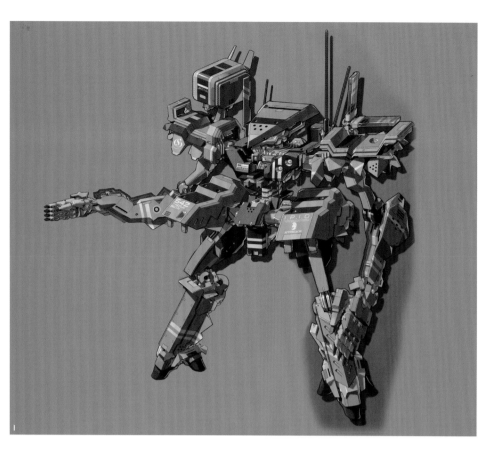

1. **Combat Taedus Gedai Ya'eel**
Nicholas Maradin | Mechanical creature | 2012 | Commercial work
Gedai Ya'eel is a taedus-type sendai custom-built by the Lavess SoSo corporation. Gedai exemplifies the company's design philosophy: The absolute realization of individual expression and personal character

2. **Semaphore-G**
Nicholas Maradin | Robot | 2012 | Personal work
This piece is my take on a more "traditional," retro-space design style using hard edges and planar surfaces. The initial concept was a giant robot wearing a spaceship

3. **Robot 01**
Sam Brown | Robot | 2010 | Personal work
A robot with simplified shapes and complex internal components

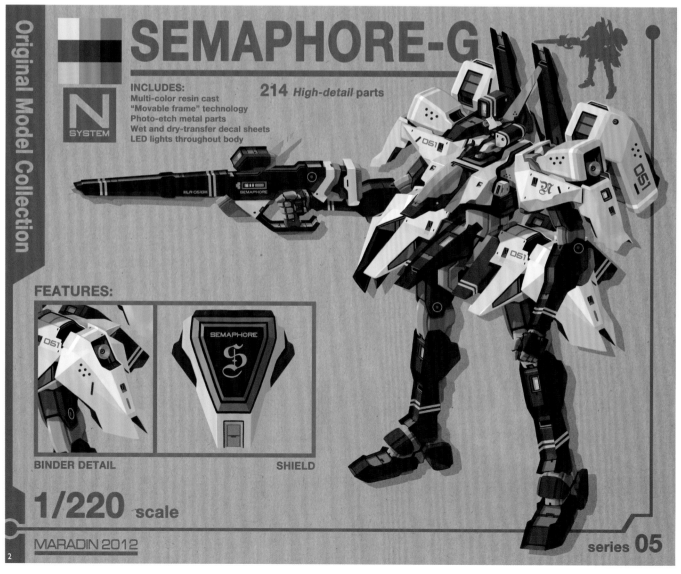

Original Model Collection

N SYSTEM

SEMAPHORE-G

INCLUDES:
Multi-color resin cast
"Movable frame" technology
Photo-etch metal parts
Wet and dry-transfer decal sheets
LED lights throughout body

214 *High-detail* parts

FEATURES:

BINDER DETAIL

SEMAPHORE

SHIELD

1/220 scale

MARADIN 2012

series **05**

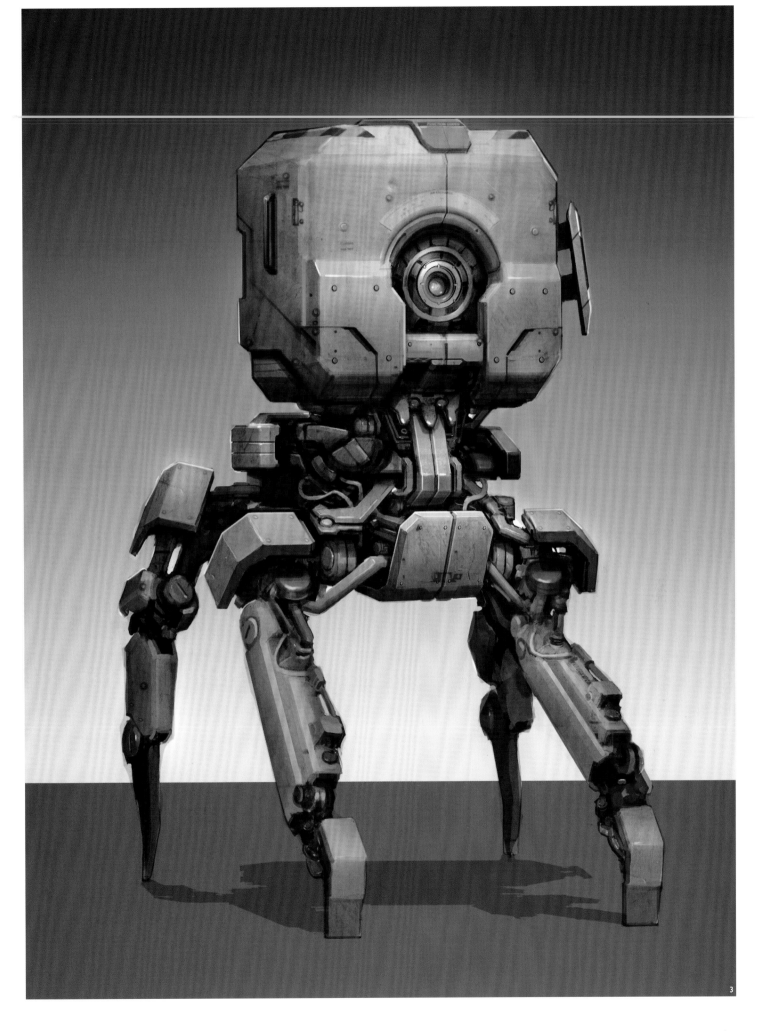

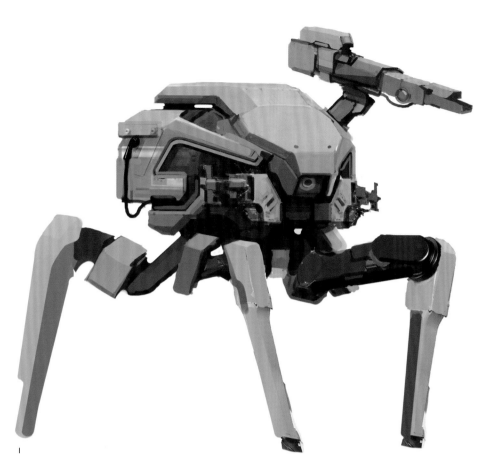

① **Robot 09**

Sam Brown | Robot | 2009 | Personal work

For this robot as well as Robot 10 I wanted to use the same body shapes with different leg configurations and weapons for variety

② **Robot 02**

Sam Brown | Robot | 2010 | Personal work

This sketch was meant to be a pilot-driven robot, although it could also be controlled with AI

③ **Robot 03**

Sam Brown | Robot | 2010 | Personal work

This is a concept with some retrofitted tank parts

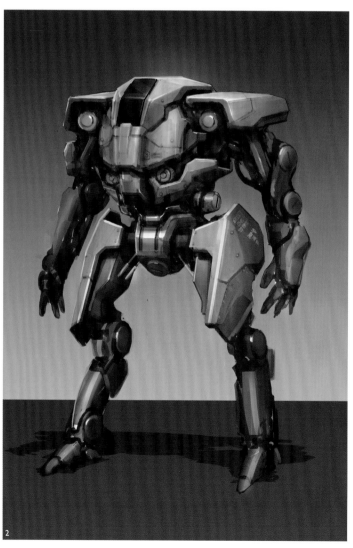

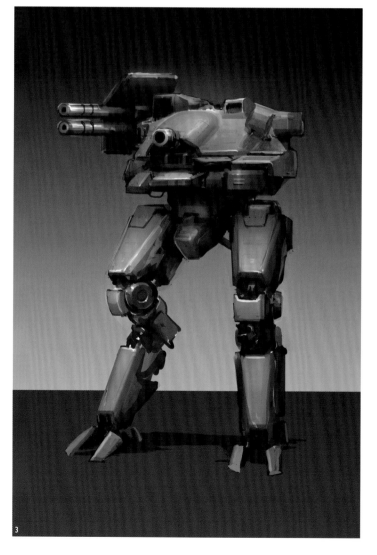

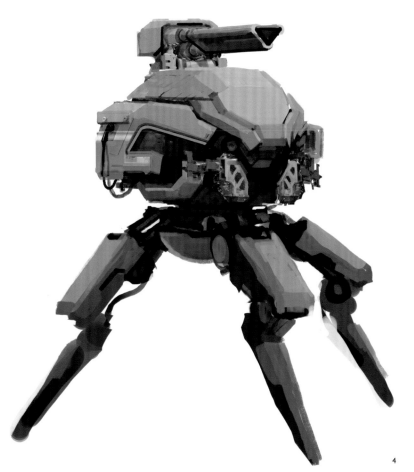

4

4 **Robot 10**

Sam Brown | Robot | 2010 | Personal work

This piece put different small shapes together and referenced the outline of tool kits

5 **Robot 04**

Sam Brown | Robot | 2010 | Personal work

For this sketch I wanted to design a droid robot that had armoured sections with an open framework underneath

6 **Robot 05**

Sam Brown | Robot | 2010 | Personal work

This is a heavily armed robot; I was trying out some unexpected design elements for a concept like this

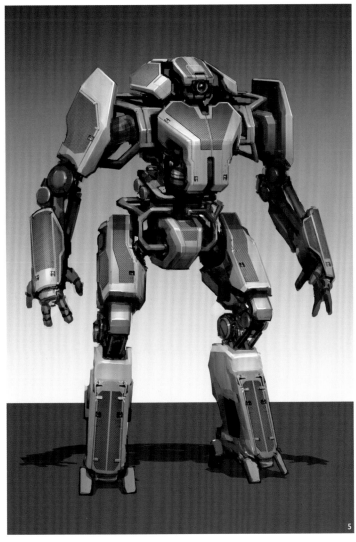

5

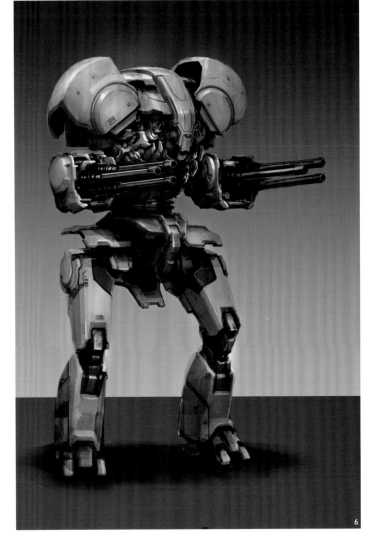

6

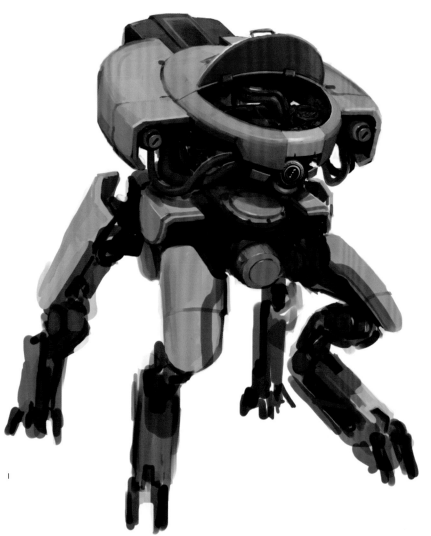

① **Robot 08**

Sam Brown | Robot | 2010 | Personal work

For this sketch I wanted to show a bit of the interior working of the robot and how that would be accessed

② **Robot 07**

Sam Brown | Robot | 2010 | Personal work

This was a scout robot that was part of a pitch I made for a network

③ **Robot 06**

Sam Brown | Robot | 2010 | Personal work

For this concept I was going for something that was simple yet kind of stood out from a typical droid robot

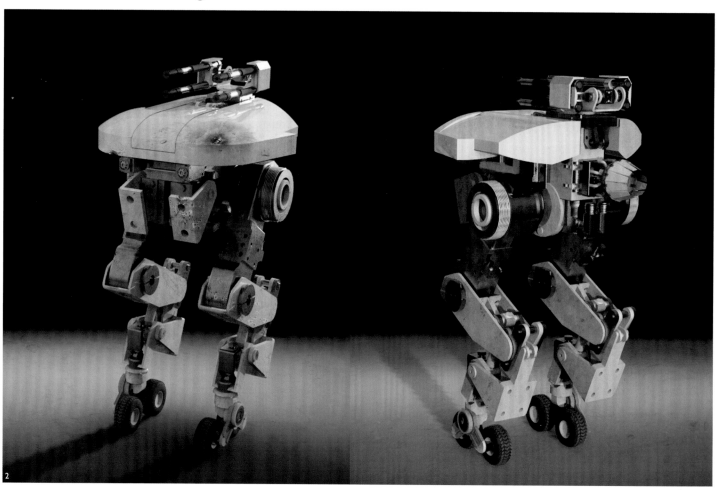

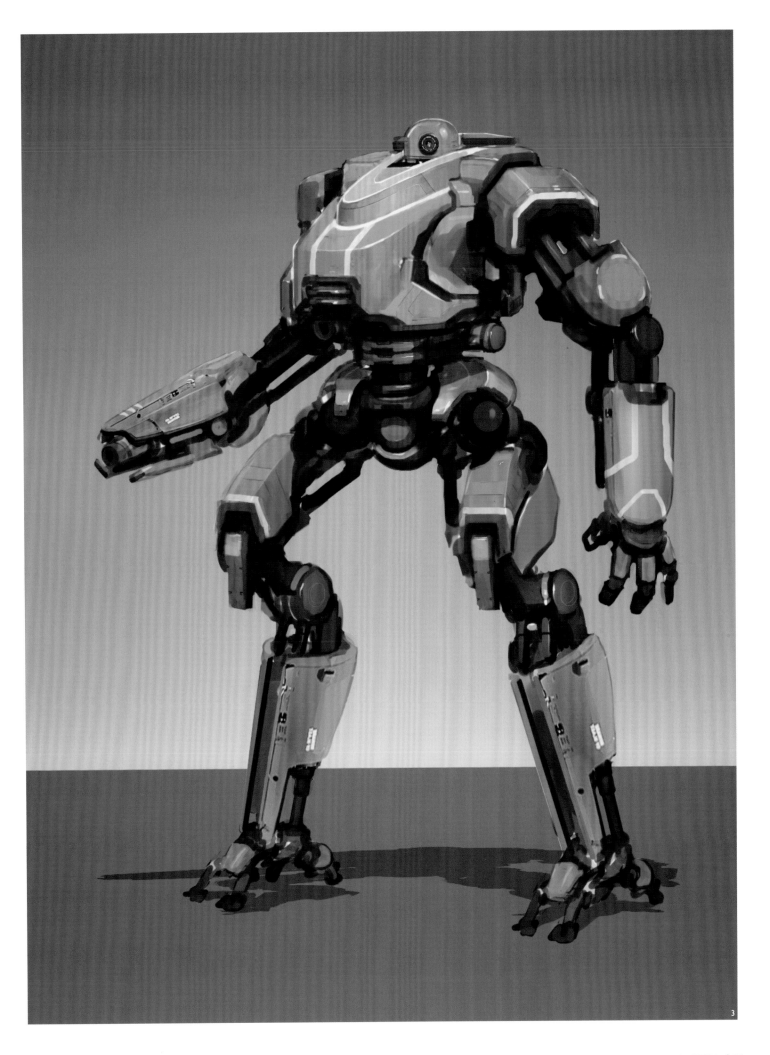

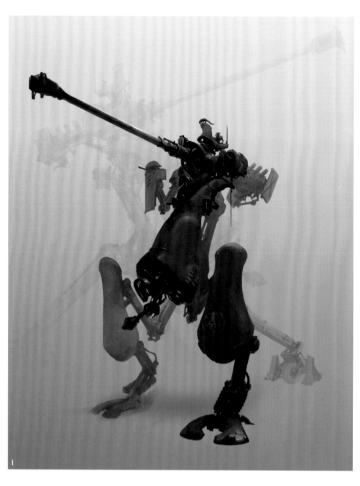

② **Nicotine | Robot | 2011 | Personal work**

A machine rendering exercise, painted in 2D

③ **Carrier Design**

Nicotine | Robot | 2011 | Personal work

Machine modeling, produced by use of 3D MAX

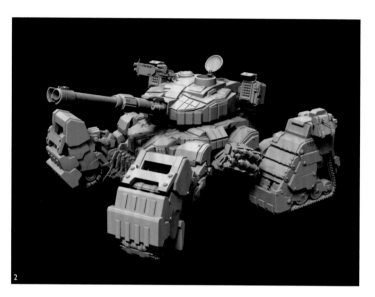

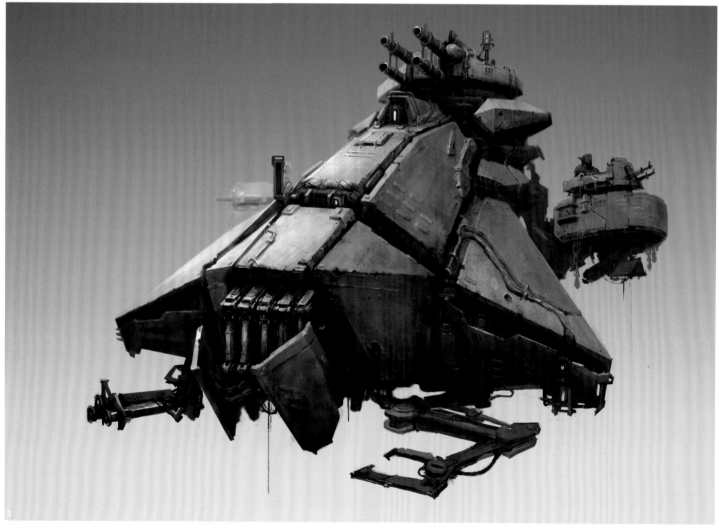

④ **Alfonso Zais**

Nicotine | Robot | 2012 | Personal work

This creature was recorded to be living in the extremely hot volcanic caves on Paronamile Plateau, feeding on organic compounds and metal ore in lava. His most powerful weapon, the hammer, is called Hellbreaker Hagan

⑤ **Donaugh Tis**

Nicotine | Mechanical creature | 2012 | Personal work

This creature lived in huge underground caves, feeding on giant ancient insects. Later, it was domesticated by one of the Devil Walkers, Morse Payne, into a war machine and put onto the battlefield

1. **Imperial Technology Lieutenant**

Nicotine | Robot | 2012 | Personal work

This portrait of Burrard was finished by the renowned portrait artist Gerard Kasmove Angusna Gilva Van Rong at the request of the Imperial Archive after Burrard was granted the title baron

2. **Assault Soldier from Megalodon Force**

Nicotine | Robot | 2012 | Personal work

This soldier tempered his rock-solid will in the Sakana Battle. He was chosen as the elite of the battle group

3. **General Hinds Guderian from Blood Owl Force**

Nicotine | Robot | 2012 | Personal work

Blood Owl was founded as a core elite battle group. Its members came from different Armoured Solider Schools. Combining these scattered parts into an elite battle group was General Hinds Guderian's strategic purpose

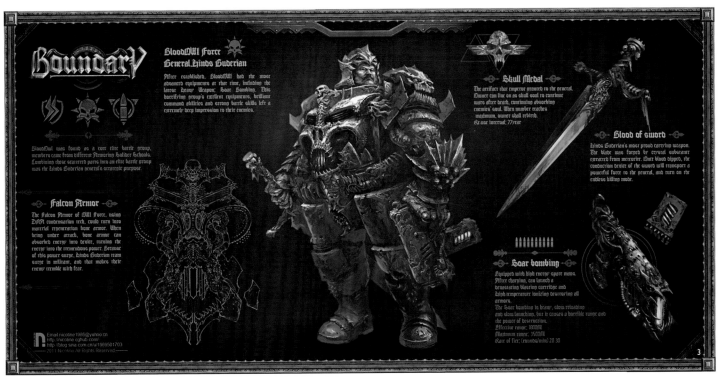

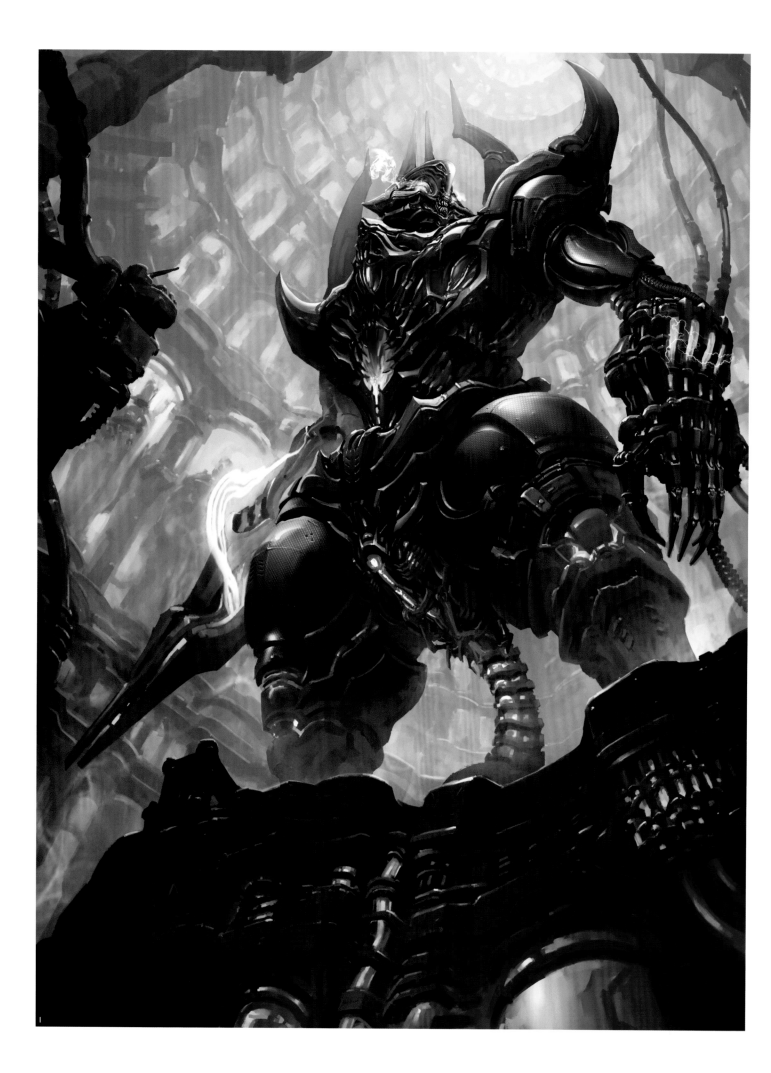

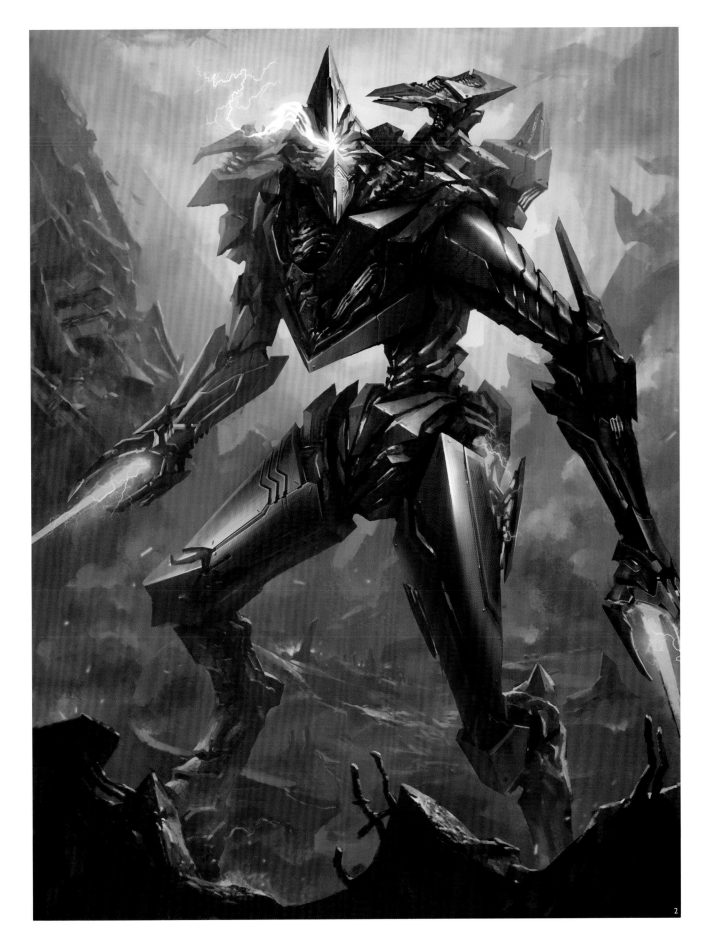

① **Robot Monster**

Nicotine | Robot | 2012 | Commercial work

This was drawn as Galaxy Saga ISO online game card for AppLIpot. Despite its identity as a mechanical robot, it is an incredible fighter with high intelligence. The horned antennas have become an integral part of its body

② **Alien Soldier**

Nicotine | Robot | 2012 | Commercial work

This was also drawn as Galaxy Saga ISO online game card for AppLIpot. The solider is clad with glittering silver scales and circulates illuminating blue blood. He has a distinctive body and a face reminiscent of that of a dragon-man

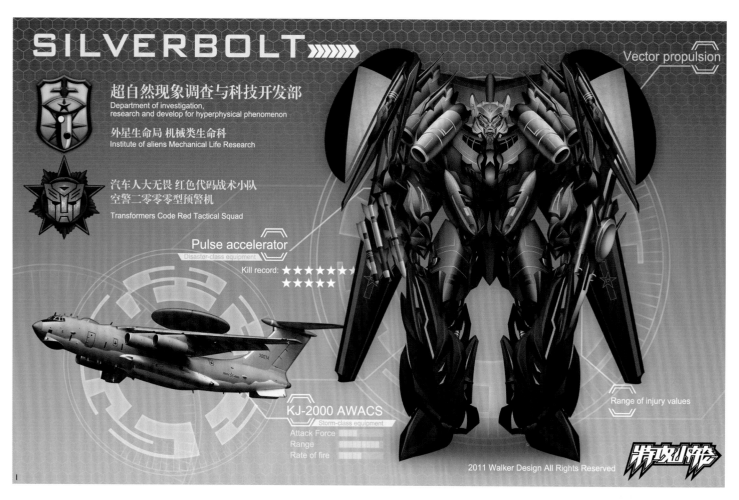

SILVERBOLT »»»»

超自然现象调查与科技开发部
Department of investigation,
research and develop for hyperphysical phenomenon

外星生命局 机械类生命科
Institute of aliens Mechanical Life Research

汽车人大无畏 红色代码战术小队
空警二零零零型预警机

Transformers Code Red Tactical Squad

Pulse accelerator
Disaster-class equipment

Kill record: ★★★★★★★
★★★★★

KJ-2000 AWACS
Storm-class equipment

Attack Force	
Range	
Rate of fire	

Vector propulsion

Range of injury values

特攻小轮

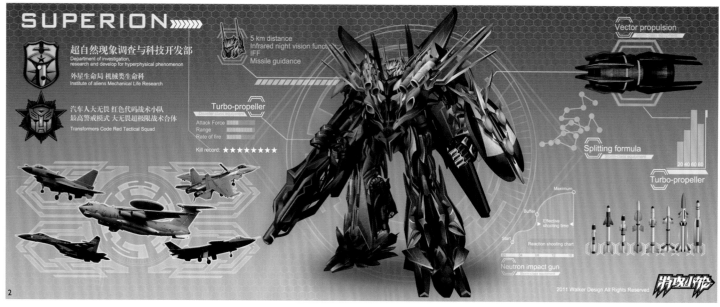

SUPERION »»»»

超自然现象调查与科技开发部
Department of investigation,
research and develop for hyperphysical phenomenon

外星生命局 机械类生命科
Institute of aliens Mechanical Life Research

汽车人大无畏 红色代码战术小队
最高警戒模式 大无畏超极限战术合体

Transformers Code Red Tactical Squad

5 km distance
Infrared night vision funct
IFF
Missile guidance

Turbo-propeller

Attack Force	
Range	
Rate of fire	

Kill record: ★★★★★★★★

Vector propulsion

Splitting formula

20 40 60 80

Turbo-propeller

Maximum

Buffer

Effective
shooting time

Start

Reaction shooting chart

Neutron impact gun

特攻小轮

① **Code Red's Fearless Strategies**

② **Agentwalker | Weapon | 2011 | Personal**

③ **work**

④ Department of Investigation, Research
and Development for Hyperphysical
Phenomenon, Mechanical Life Research
of Institute of Aliens, and Red Code
Tactical Squad represent a combination
of fearless strategies

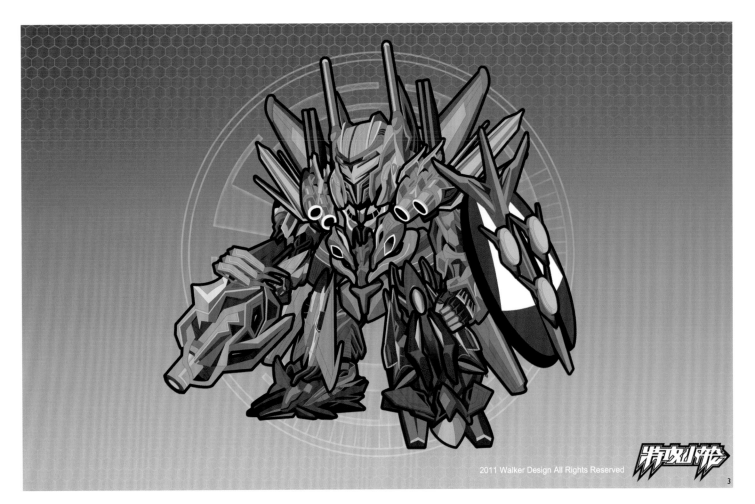

特攻小能

3

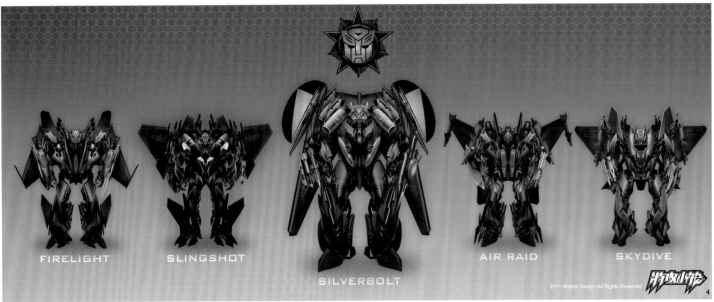

FIRELIGHT　　　SLINGSHOT

SILVERBOLT

AIR RAID　　　SKYDIVE

特攻小能

4

① **Cloaked Alien**

Aaron Whitehead | Mechanical creature | 2011 | Commercial work

This piece is one of the six different alien races created for the RTS space game "StarRuler" released in August 2010. I wanted this particular race to be quite mysterious and intimidating, enclosed within a large, impenetrable mechanical body suit. I imagined the race being advanced far beyond having a "home world" and that the suit allows them to live and operate in almost any condition they might encounter

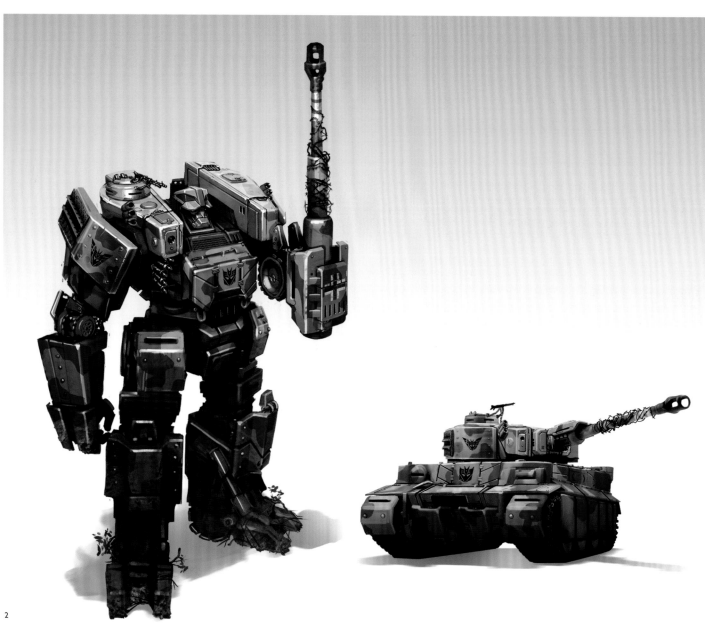

2

3

② **Blitzkrieg—Decepticon**

Aaron Whitehead I Mechanical creature I 2012 I Personal work

I have always been a huge fan of "Transformers" and I always thought it would be cool to set the war between the Autobots and Decepticons in WWII. Blitzkrieg is the leader of a Decepticon pathfinder contingent. Its alternate form is the T1 Tiger Tank

③ **Space Commando**

Aaron Whitehead I Mechanical creature I 2011 I Personal work

This piece utilizes a lot of hard surface rendering techniques. I am a huge fan of the art of "Creaturebox" which is really what inspired me with this piece. This creature is an Elite Space Commando, a one-man space army designed to handle any given situation. He is an interstellar Rambo

① **Ghost in the Machine**

Alex Figini | Robot | 2012 | **Personal work**

This image had been in my head for a long while before I rendered it out. I was trying to capture something of a cross between man and machine

② **Iron Girl**

Evan Lee | Robot | 2011 | **Personal work**

As a fan of "Iron Man," I tried to re-design this character in a female outfit

③ **Battle in the Market**

Evan Lee | Mechanical creature | 2011 | **Personal work**

A battle scene incorporating future mechanical characters in a traditional Taiwanese market

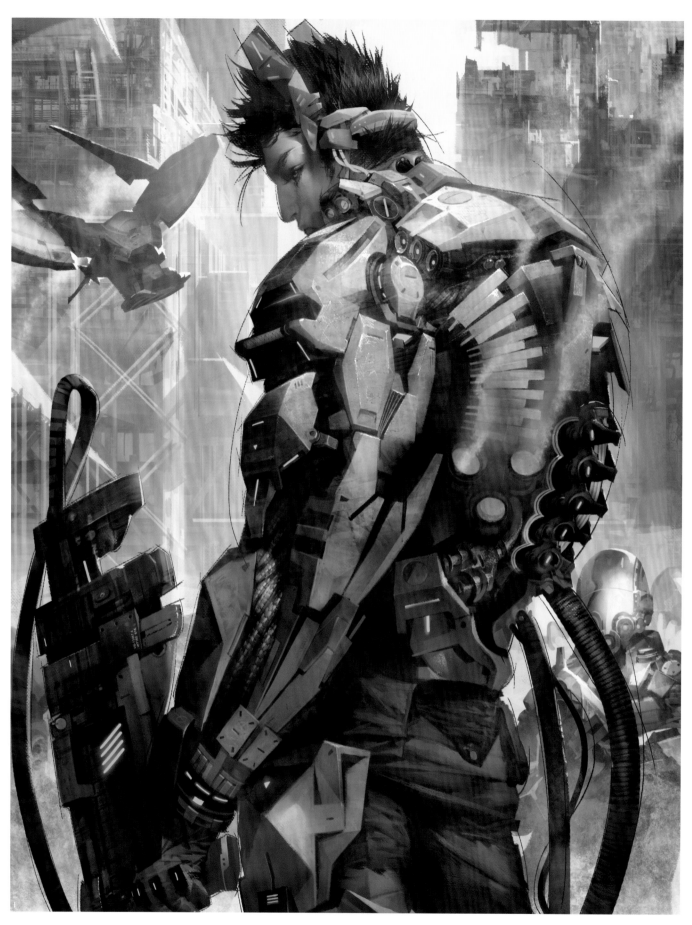

① **Irvine the Coward**
 Evan Lee | Robot | 2012 | Commercial work
 It employs the technical halo indigo color
 to highlight the mechanical design

② **Irvine the Coward (advanced version)**
 Evan Lee | Robot | 2012 | Commercial work
 This version uses powerful, heavy
 machinery and giant weapons to express
 the explosive power

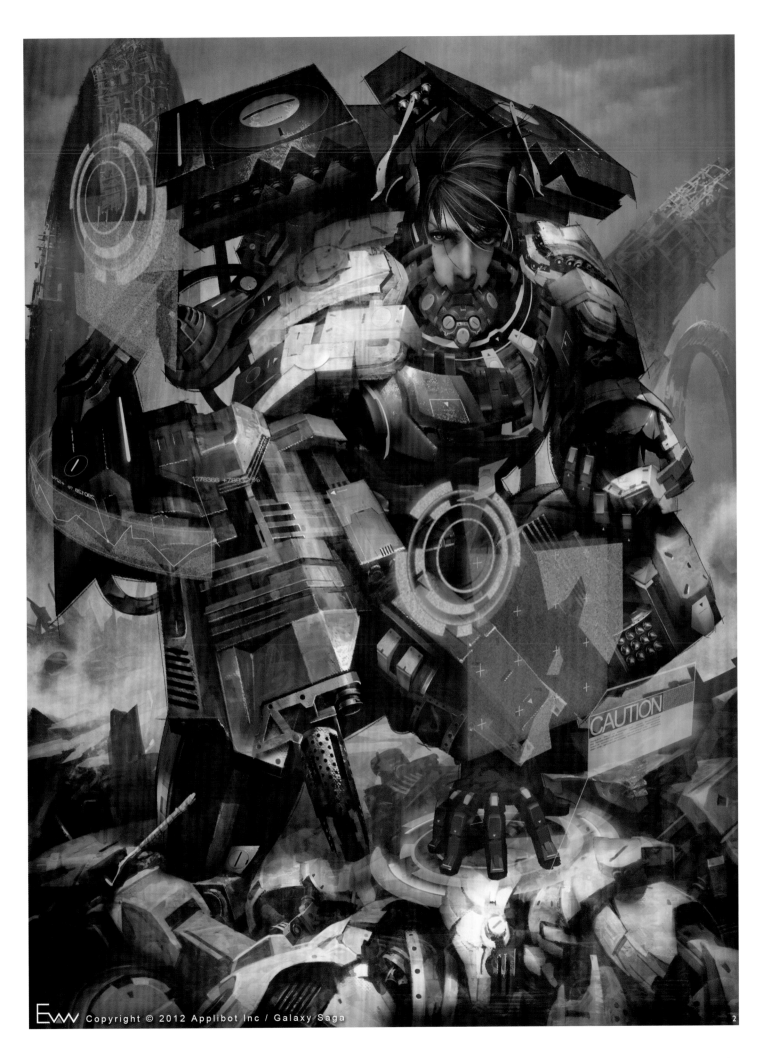

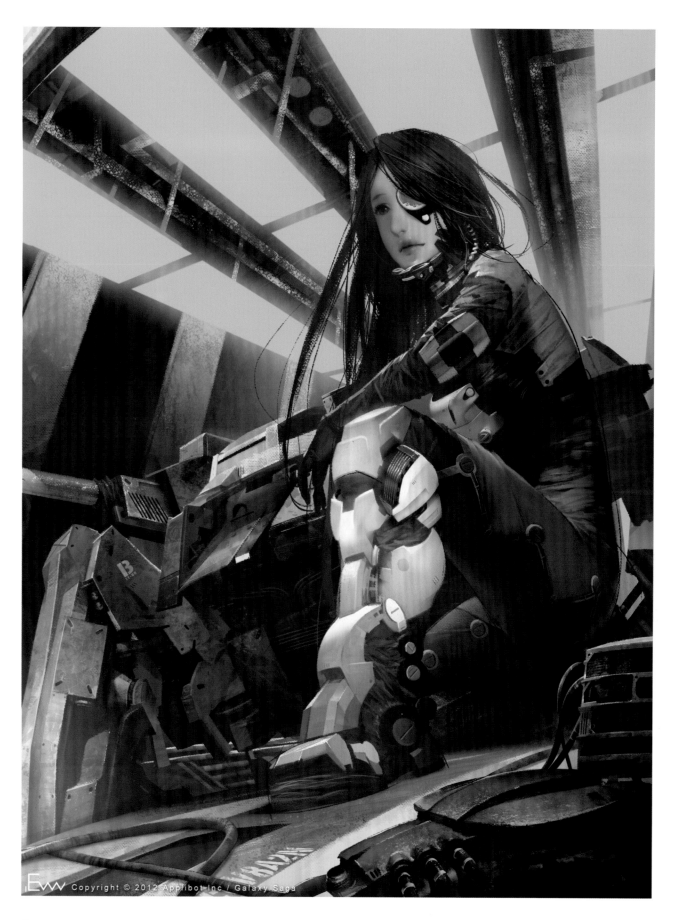

1. **Naomi, War Machine**

 Evan Lee|Robot|2012|Commercial work

 The original version of "Naomi, War Machine" depicts how the driver clad in tightly-fitting armor enters the base

2. **Naomi, War Machine (advanced version)**

 Evan Lee|Robot|2012|Commercial work

 This version depicts a scene capturing readiness for battle. The interior of this multi-footed war chariot is fully exposed with the driver's cabin open

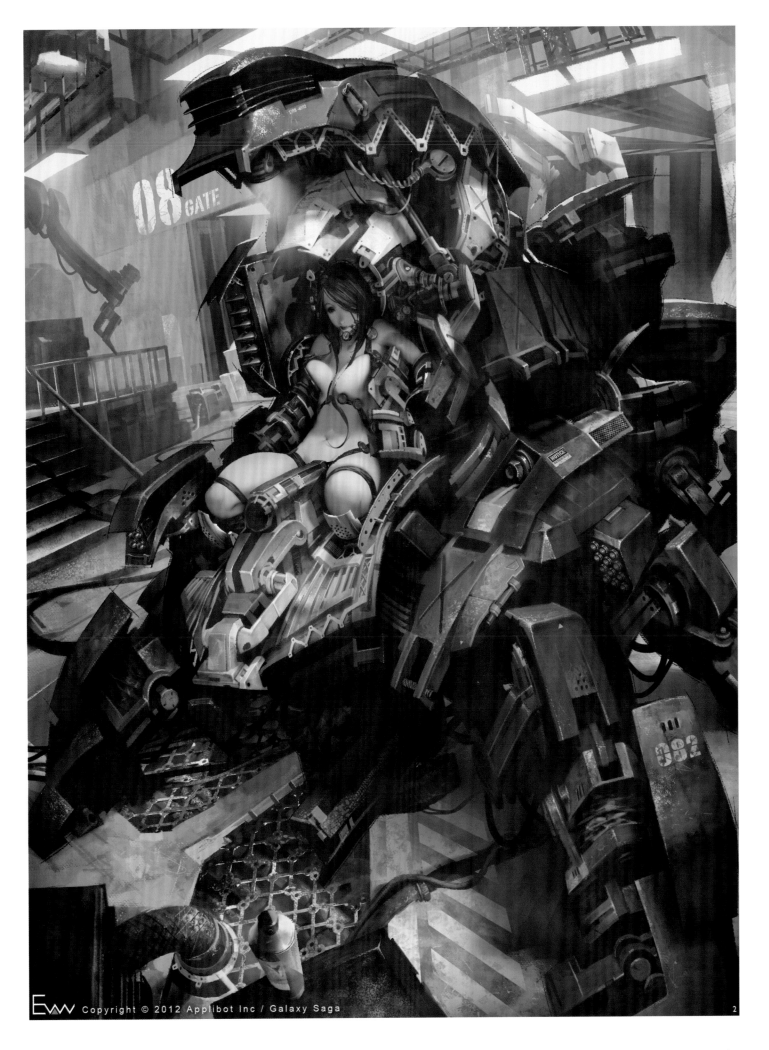

08 GATE

① **Echo's Armour**

Kory Lynn Hubbell | Biomechanical armour | 2012 | Personal work

Echo's armour is a complex biomechanical suit. It not only allows for increased strength and quicker reflexes and movement, but also allows Echo to see. Echo is blind, so he wears a suit specially adapted to detect his surroundings and offer him feedback via neural interface

② **The Material**

Kory Lynn Hubbell | Biomechanical armour | 2012 | Personal work

This is a biomechanical helmet. A small portion of the military captured several beings wearing armours seeming to be completely biological, yet performing technological functions such as life support and strength enhancement. Over many centuries, human beings have molded the new Material to suit their own needs for survival

③ **Cybernetic Organism**

Kory Lynn Hubbell | Robot | 2011 | Personal work

Jin's severed arm was replaced with an experimental cybernetic substitute at the age of 7. Over the years he has continued to test government robotics in the field as a ward of the military, often sporting new limbs and attachments intended for various purposes

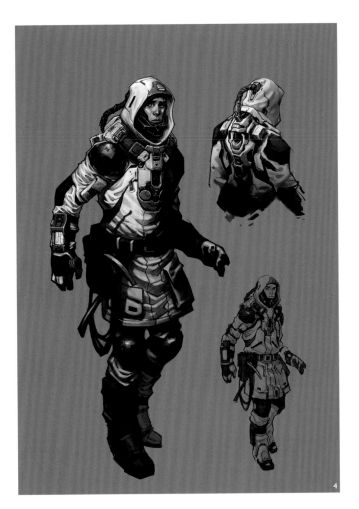

4 Europa EVA Suit

Kory Lynn Hubbell | Life support system | 2012 | Personal work

In preparation for an expedition to the icy moon Europa, the U.S. Military created a suit intended for Extra Vehicular Activity on the surface. The rebreather on the back cycles air and pulls in a tenuous oxygen atmosphere for its wearer to breath. The mask has an energy field that keeps the artificial atmosphere and heat in the hood, allowing for quicker suiting and long term EVA deployment. The suit also protects against temperatures as low as -250 °C by using a heating system and specially created nanofibers

5 Planet Jumper

Kory Lynn Hubbell | Vehicle | 2012 | Personal work

The Planet Jumper, originally intended for scientific exploration of nearby planets and asteroids, was outfitted for combat upon detection of an unknown signal being broadcast from the ice moon Europa. The legs can perform as skis, thrusters, and also house several types of heavy artillery. Within the bay doors are two nuclear warheads per vehicle and the rear portion can detach and act as a scout

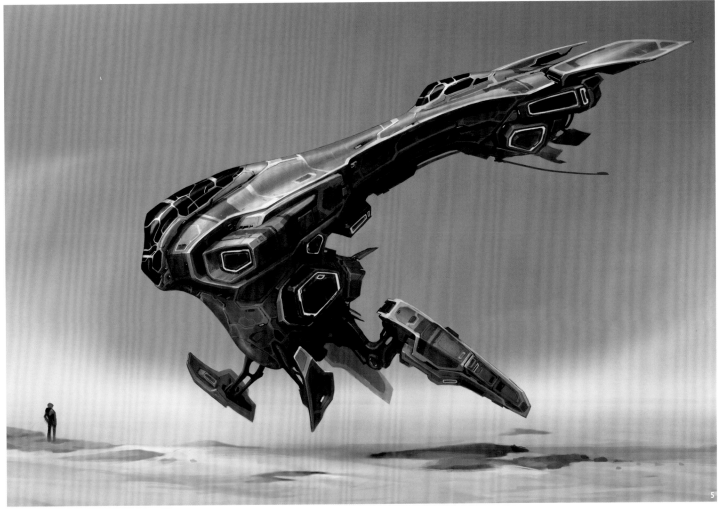

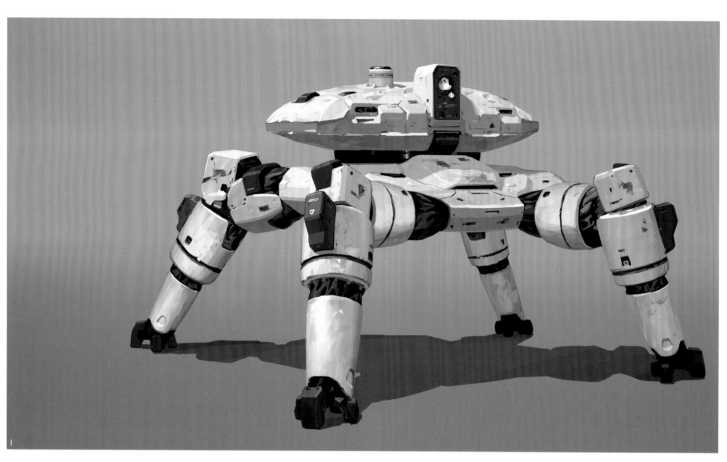

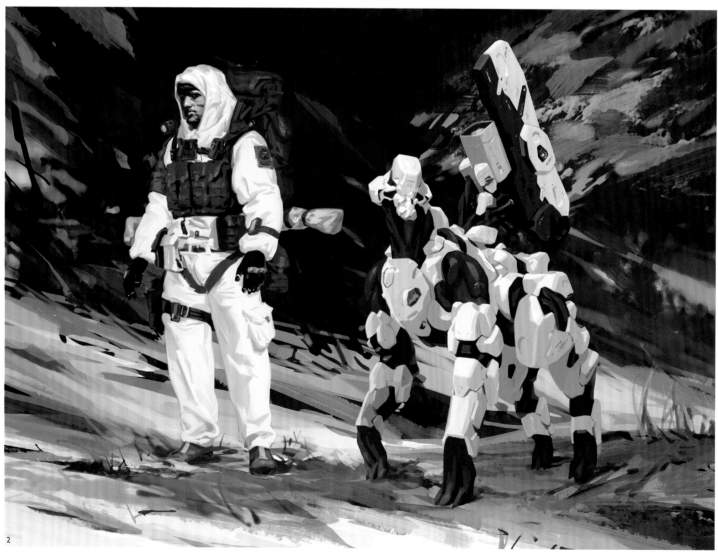

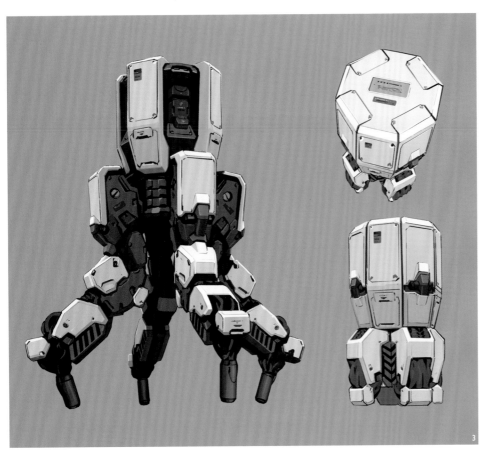

1. **Moonwalker**
 RD | Robot | 2012 | Personal work
 Designed for an individual comic as an engineering robot working on the moon

2. **Ice Piton**
 RD | Robot | 2012 | Personal work
 The white robot used to be a concept design for a canceled collaborative project

3. **Baby Drone Prototype**
 RD | Robot | 2012 | Personal work
 An experimental design

4. **TURpedo**
 RD | Robot | 2012 | Personal work
 An anti-submarine drone

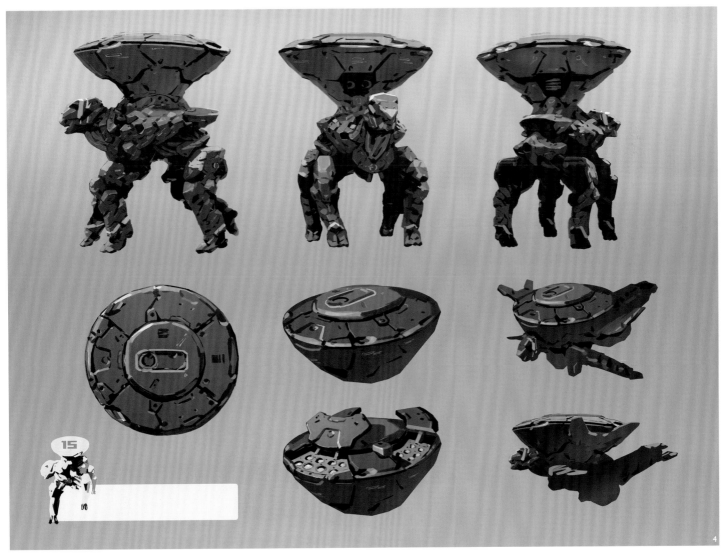

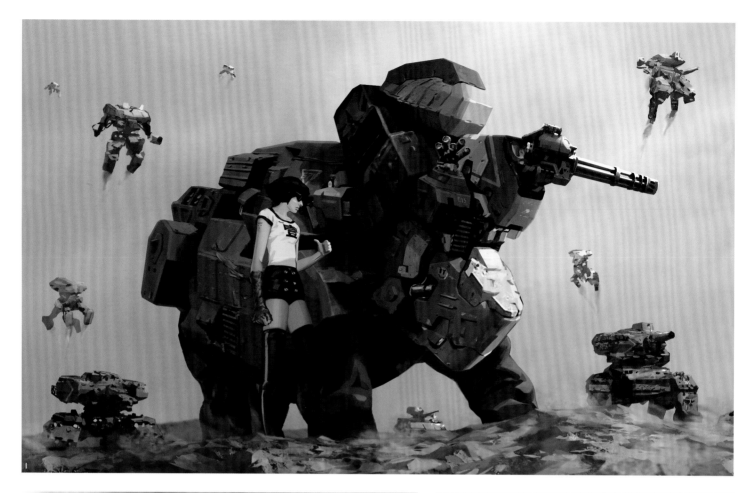

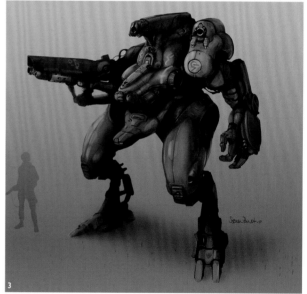

① **Machine Horn**
RD | Military | 2012 | Personal work
Hot girl and huge war machine

② **Biomech Fighter**
Søren Bendt | Robot | 2009 | Personal work

This work features an alien soldier on the battlefield. The organism and the armour are fused together through elaborate procedures and rituals

③ **Biobo**
Søren Bendt | Sci-fi Robot | Original version in 2009, revised version in 2012 | Personal work

This five-tonne robot is quite rare. It sports a shoulder-mounted grenade and a small bomb launcher. Left arm is mostly used for labor, but has two flame-throwers for close encounters. The smaller right arm can support a range of large-scale weapons

④ **Mecha Flea Market on the Beach**
Lorenz Hideyoshi Ruwwe | Robot | 2011 | Personal work

Concept for a mecha flea market where robot spare parts are sold; the robot has a sleek and agile appearance

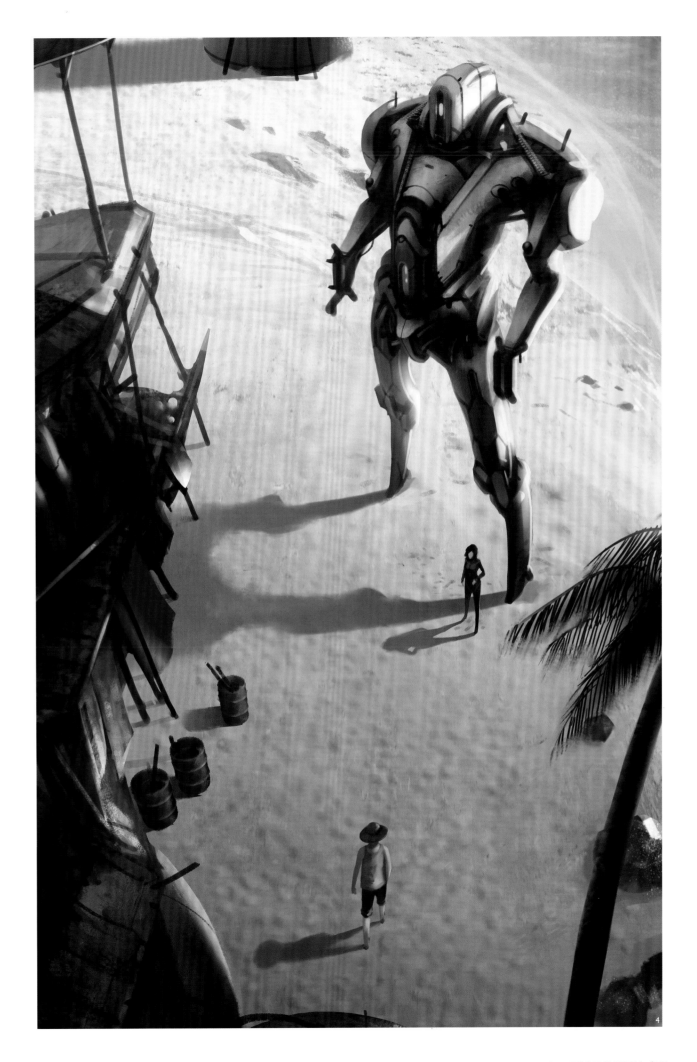

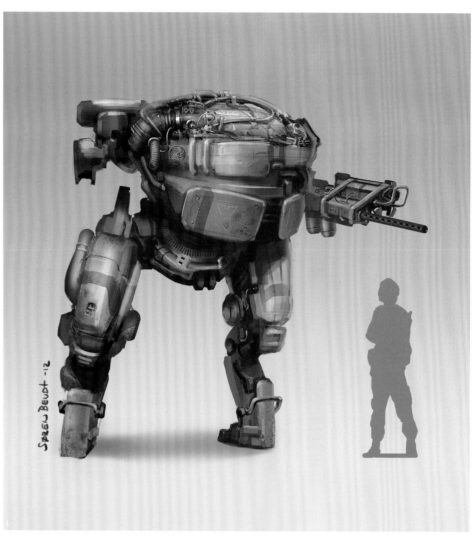

1. **Motor Brain Mech**
 Søren Bendt | Robot | 2012 | Personal work
 The 65-R Motor Brain is an agile light mech, not packing much of a punch, but has it where it counts when it comes to speed

2. **City Mech**
 Søren Bendt | Robot | 2011 | Personal work
 The TA-30 support mech is a first class front line urban fighter. Standard outfit includes a rocket launcher and a heavy assault rail rifle

3. **Jumper**
 Søren Bendt | Robot | 2011 | Personal work
 The Jumper is a primary reconnaissance mechanic from the earlier days of walker warfare. The two jet pods enable high jumps and temporary hovering for scouting. Armaments can be removed to decrease fuel consumption and weight, and increase jump range

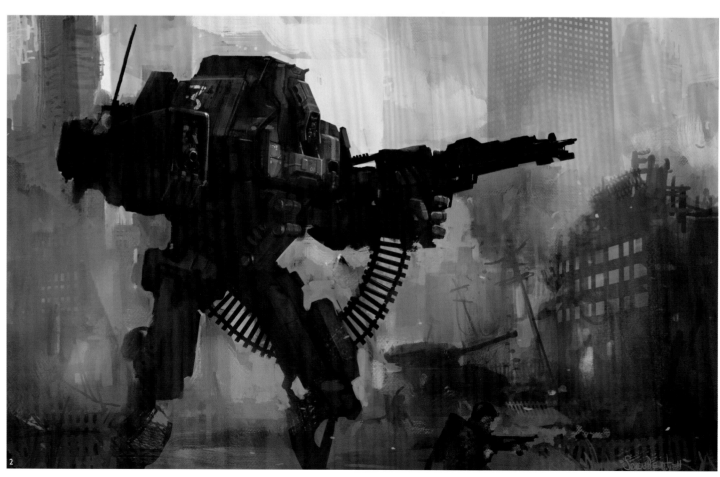

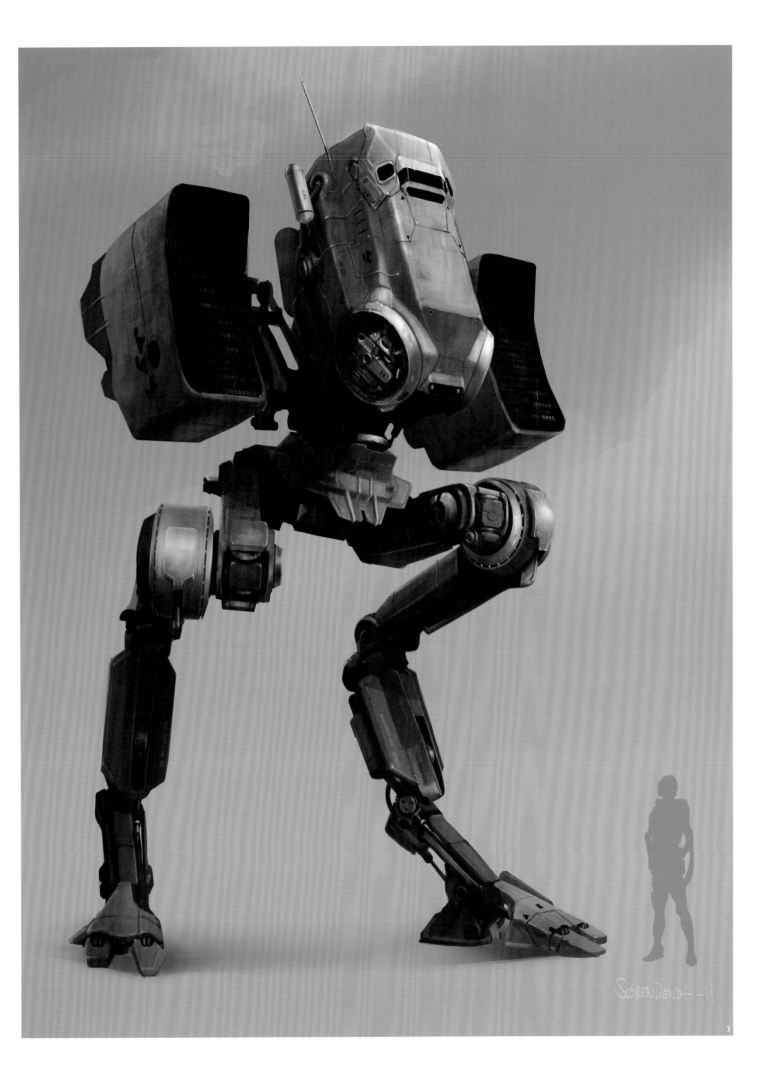

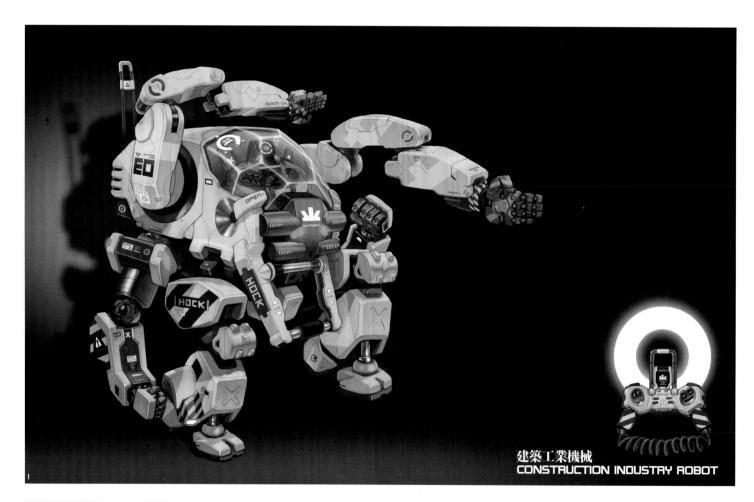

建築工業機械
CONSTRUCTION INDUSTRY ROBOT

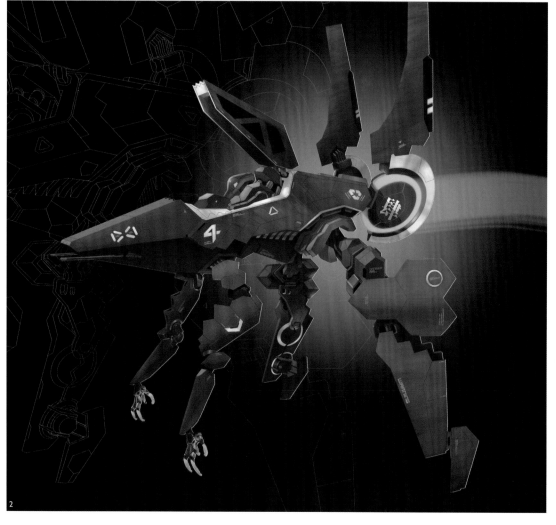

1. **Construction Industry Robot**
 X2R | Robot | 2011 | Personal work
 An industrial robot

2. **Stealth Jet Fighter**
 X2R | Robot | 2011 | Personal work
 A robot in the style of a stealth jet fighter

3. **Explorer Robot**
 X2R | Robot | 2011 | Personal work
 A futuristic robot

4. **Submarine Robot**
 X2R | Robot | 2011 | Personal work
 A submarine robot

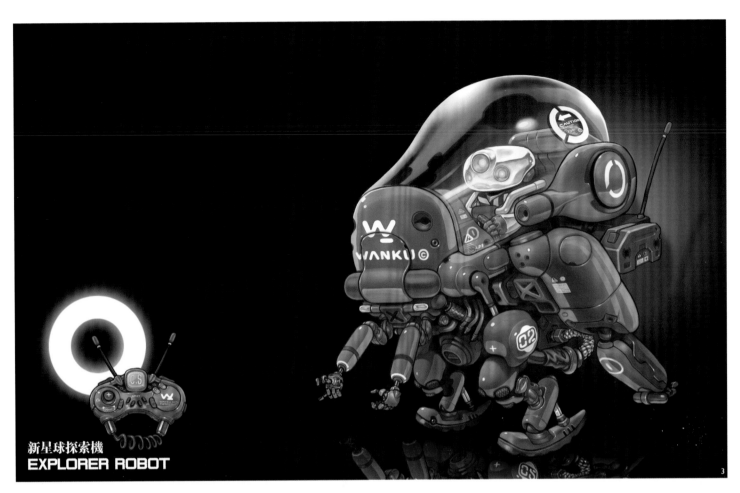

新星球探索機
EXPLORER ROBOT

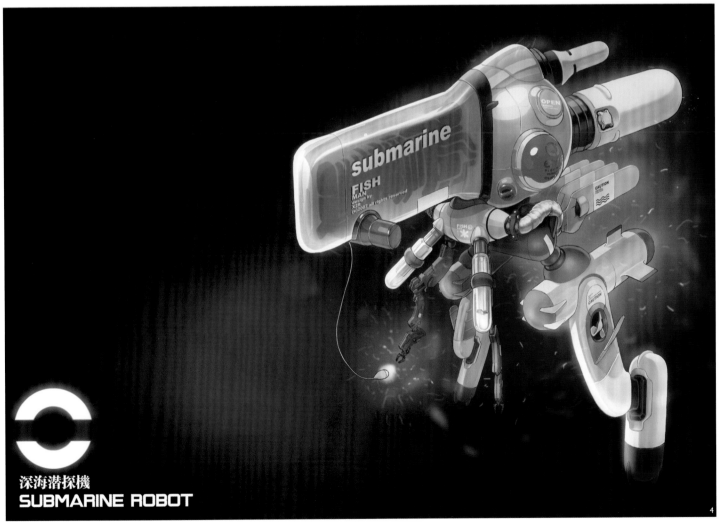

深海潜探機
SUBMARINE ROBOT

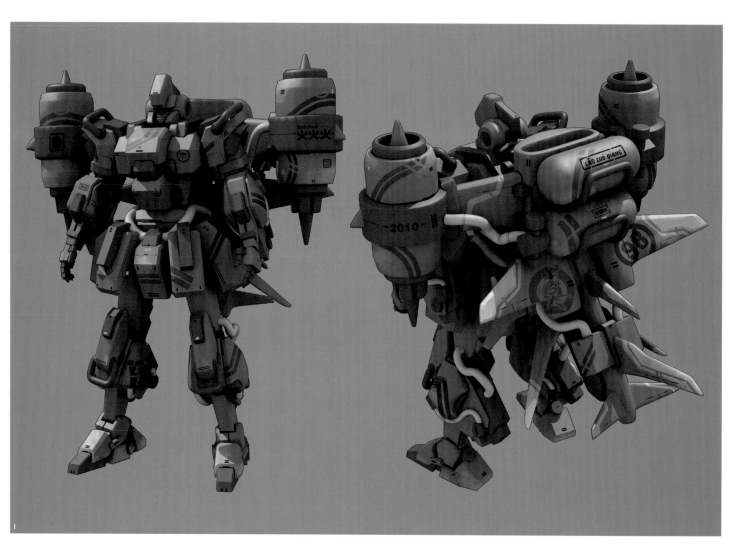

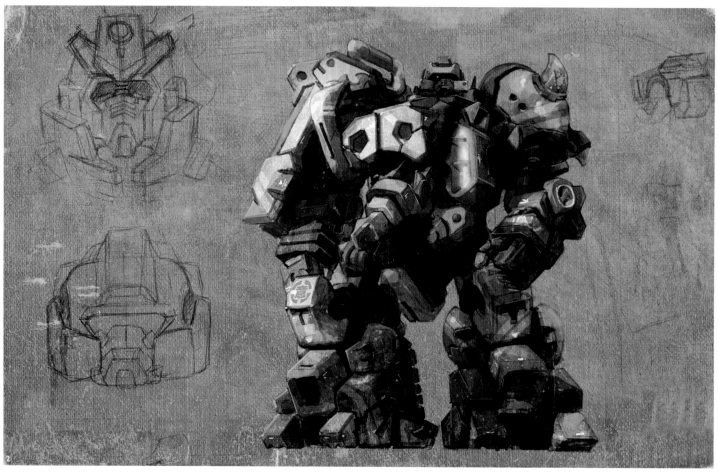

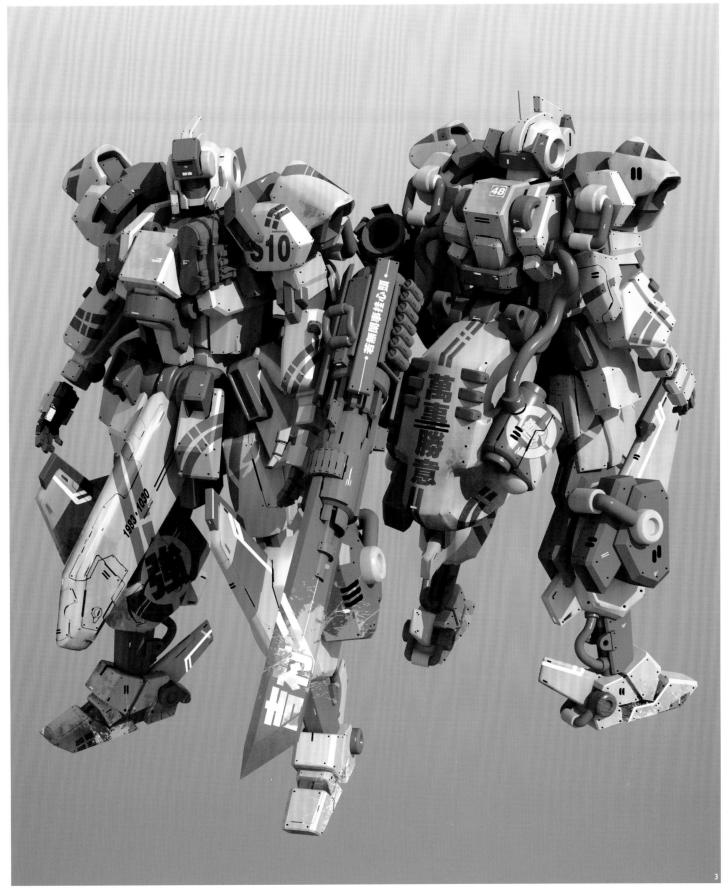

① **No.1 Test Robot**

Lao De | Robot | 2010 | Personal work

A test robot featuring the Gundam style,
No. 1

② **Pigsy**

Lao De | Robot | 2008 | Commercial work

A Pigsy robot themed on "Journey to the
West," an unused draft

③ **No.2 Test Robot**

Lao De | Robot | 2010 | Personal work

A test robot featuring the Gundam style,
No. 2

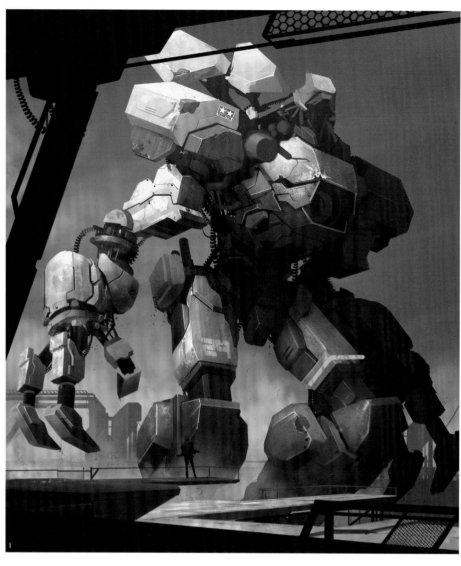

1. **And Outcome the Wolf**
 Reza Ilyasa | Robot | 2011 | Personal work
 My exploration into large object design

2. **Chronicles of the Void Boss**
 Reza Ilyasa | Robot | 2011 | Commercial work
 I'm proud, because it's the first time I completed a piece of work in one day

3. **Dune Boogie**
 Reza Ilyasa | Robot | 2011 | Personal work
 My first exploration into big bots! Yeah!

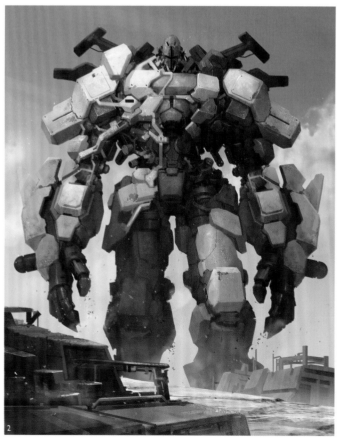

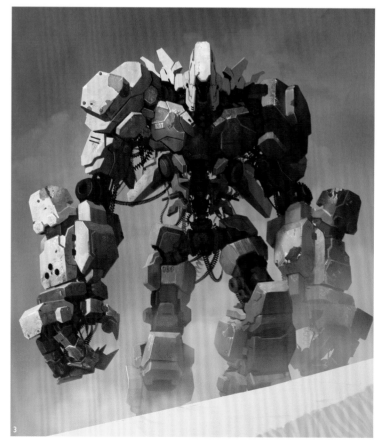

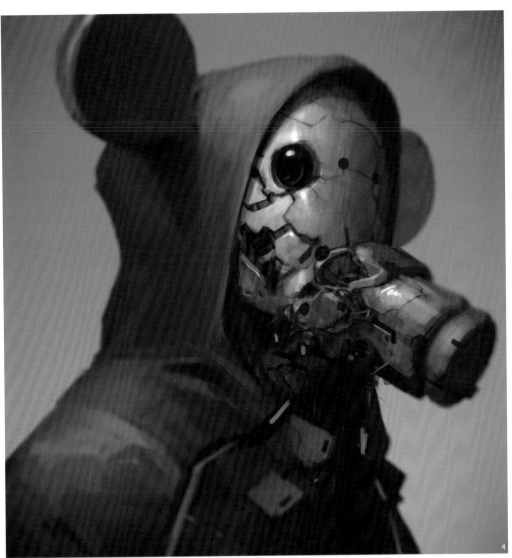

(4) **Mickey Mouse**
Reza Ilyasa | Robot | 2011 | Personal work
A study of mask, metal plating and lenses, and feeling, which I think pretty successfully makes people wonder what happens behind the mask

(5) **Athena**
Reza Ilyasa | Robot | 2011 | Personal work
Exploration of lenses effect

① Khadam

Reza Ilyasa | Robot | 2011 | Personal work

Exploration to large objects

② Ichido Temple Walker

Reza Ilyasa | Robot | 2011 | Commercial work

This was a project I worked on for Ichido Samurai Bot (C); it took quite a while

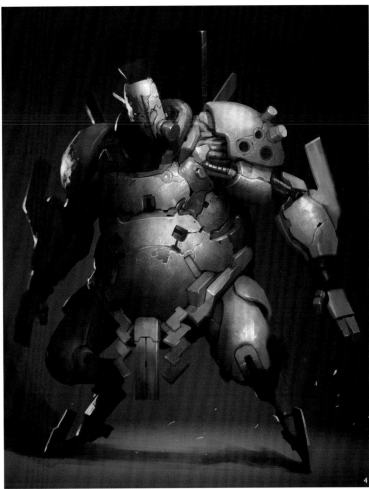

③ **Monk Mecha**

Reza Ilyasa | Robot | 2012 | Commercial work

A project I worked on for Ichido Samurai Bot (C); I was given lots of freedom to explore, which allowed me to play with every element in the design

④ **Sumo Mecha**

Reza Ilyasa | Mask | 2012 | Commercial work

A project I worked on for Ichido Samurai Bot (C)

⑤ **Scarface**

Reza Ilyasa | Robot | 2011 | Personal work

A demo I did on my livestream; I'm quite satisfied with this. I really enjoy how it flows

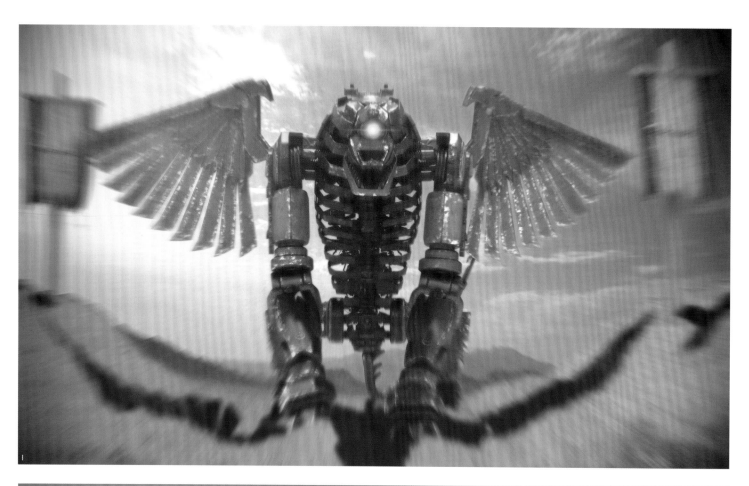

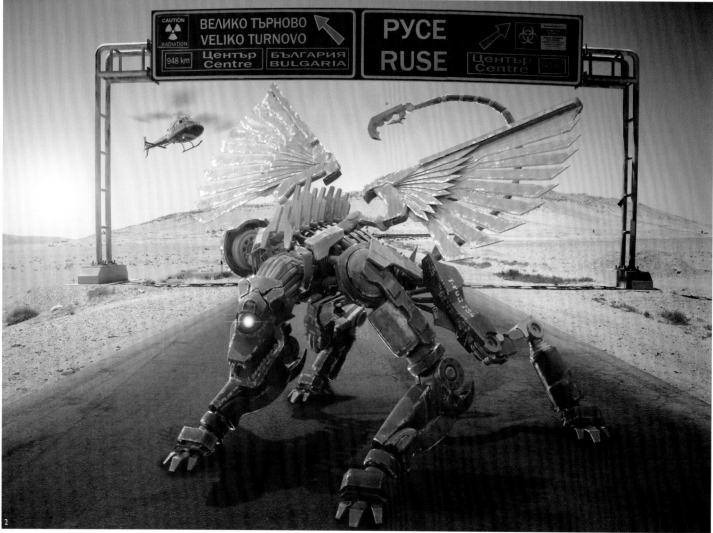

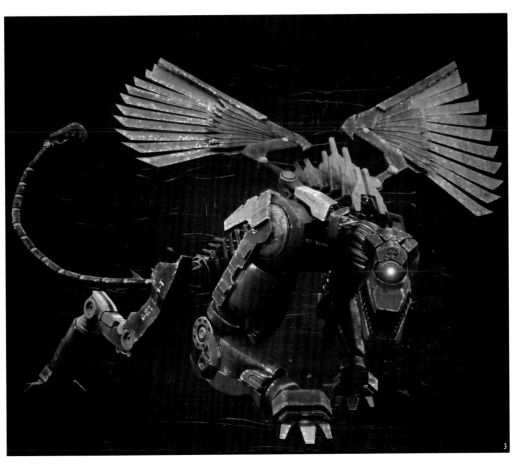

1. GriffinRun
2. Valentin Yovchev | Robot | 2010-2011 |
3. Commercial work
4. Robot designs done for a series of artworks on www.griffinrun.net

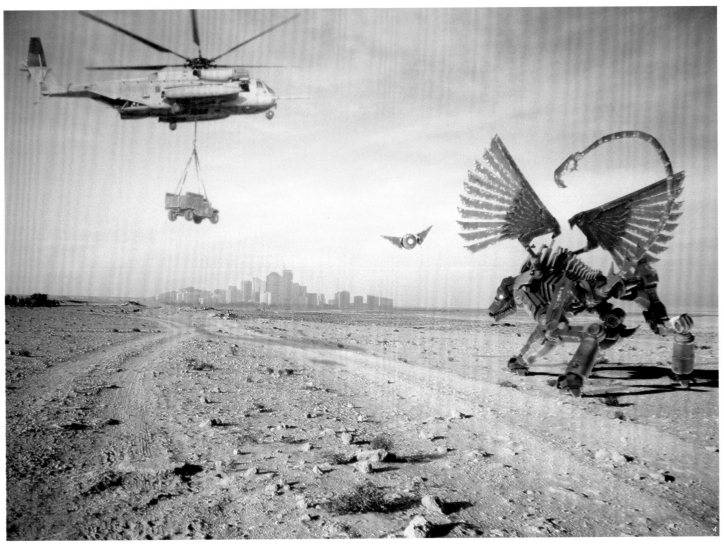

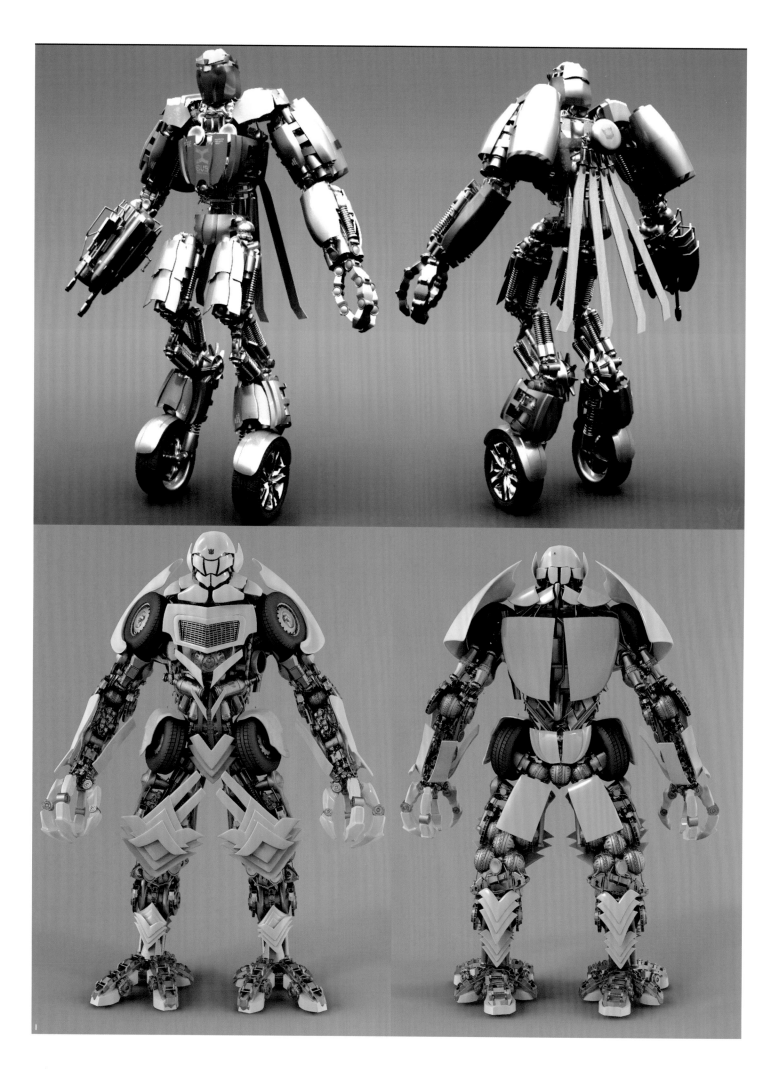

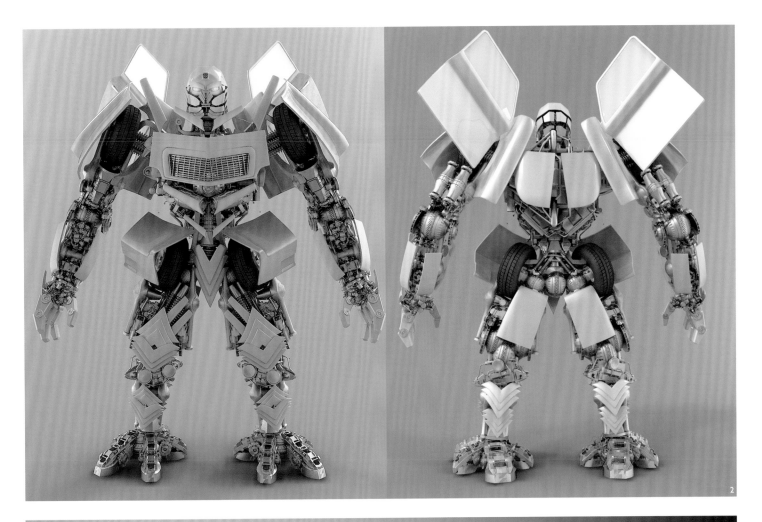

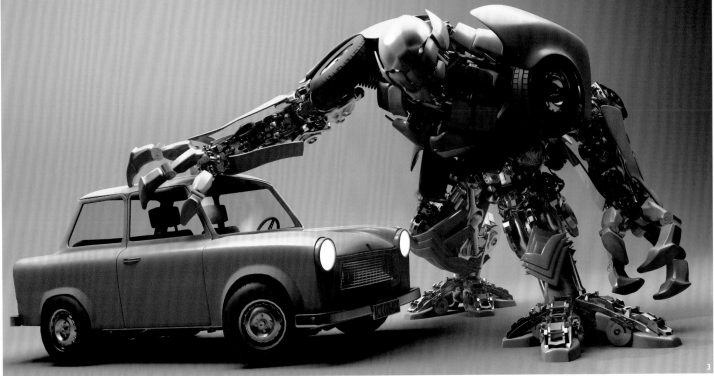

① **Decepticon Trabant**

Valentin Yovchev | Robot | 2009 | Personal work

These two pieces are a retro design and an early design for a decepticon robot respectively

② **Autobot Trabant**

Valentin Yovchev | Robot | 2009 | Personal work

A trabant design version of an autobot robot

③ **Robot in Disguise**

Valentin Yovchev | Robot | 2009 | Personal work

A trabant design version of a decepticon robot

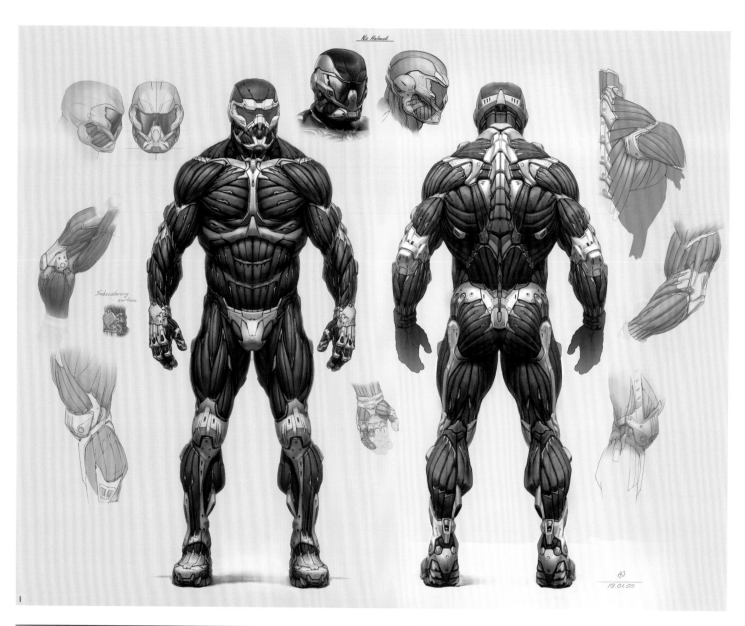

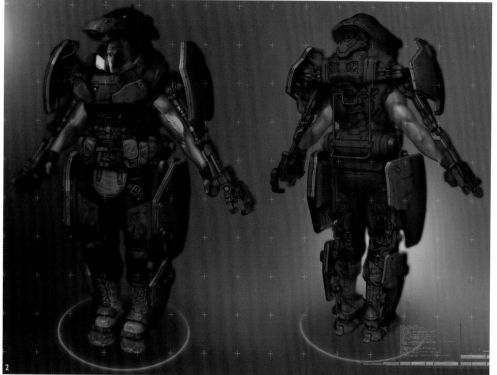

① **Nanosuit 02**

Timur Mutsaev | Robto | 2009 | Commercial work

Nanosuit was made for the Crysis 2 (FPS game) project. The main concept was to create a "force trooper" suit that renders soldier wearing it virtually invulnerable. My idea was to compose the suit from lifelike Nano-muscles that will provide all the basic motor functions of the human body. Moreover, it amplifies soldier with four advanced abilities: battle armour, super strength, super speed and invisibility

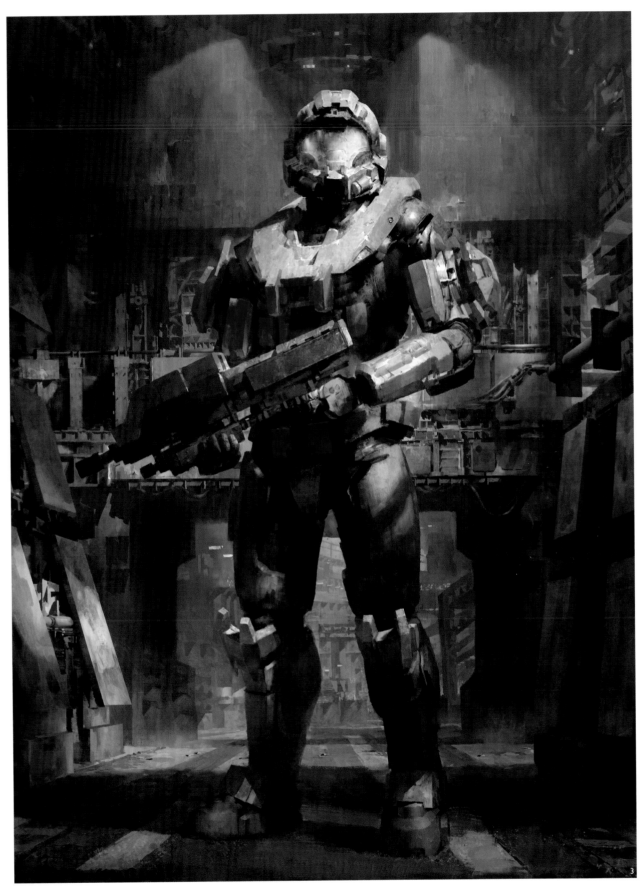

(2) **Exo-Skeleton for Armoured Infantry M2.A.P: Prototype Model 2034-2**
Stephen | Robot | 2011 | Personal work

This is a military exo-skeleton. Its low-end civil version was previously used in transport and manufacturing. This 2034-2 model was used for real-combat testing for the first time by the former Lieutenant Commander Bern Dam

(3) **Halo**
Ruan Jia | Robot | 2012 | Personal work

A spartan soldier based on my imagination

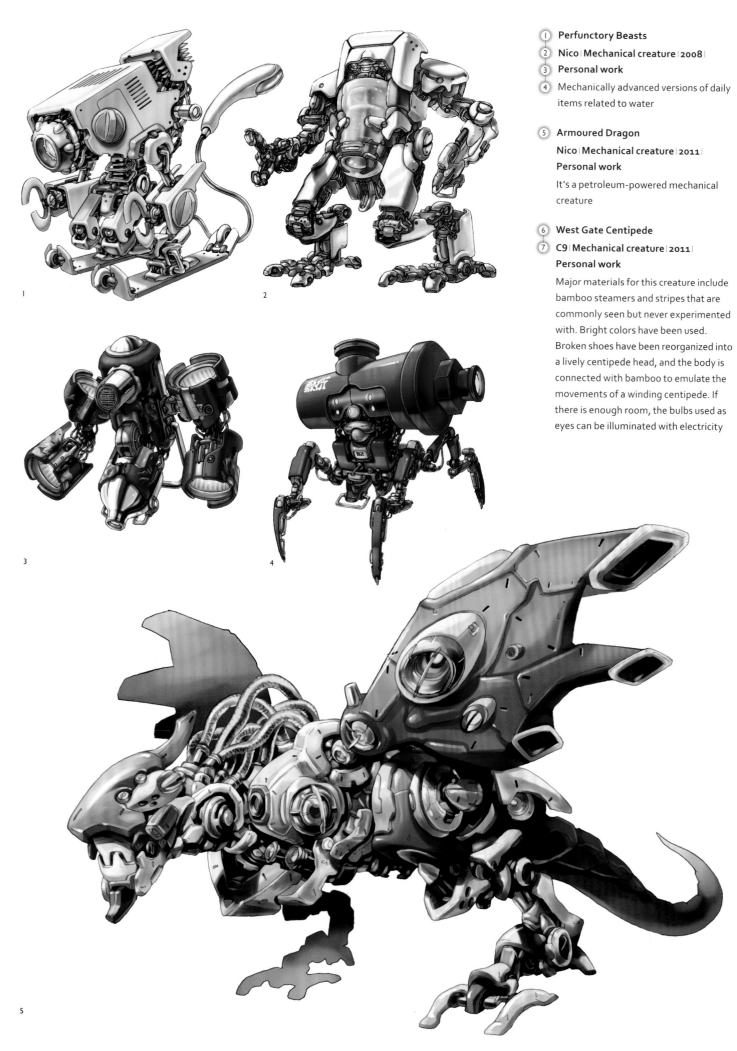

1. **Perfunctory Beasts**
2. **Nico | Mechanical creature | 2008 |**
3. **Personal work**
4. Mechanically advanced versions of daily items related to water

5. **Armoured Dragon**
 Nico | Mechanical creature | 2011 |
 Personal work
 It's a petroleum-powered mechanical creature

6. **West Gate Centipede**
7. **C9 | Mechanical creature | 2011 |**
 Personal work
 Major materials for this creature include bamboo steamers and stripes that are commonly seen but never experimented with. Bright colors have been used. Broken shoes have been reorganized into a lively centipede head, and the body is connected with bamboo to emulate the movements of a winding centipede. If there is enough room, the bulbs used as eyes can be illuminated with electricity

1

2

3

4

5

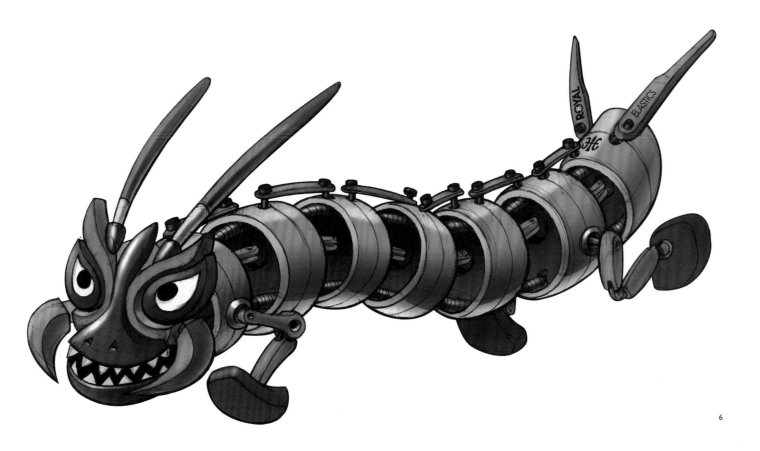

6

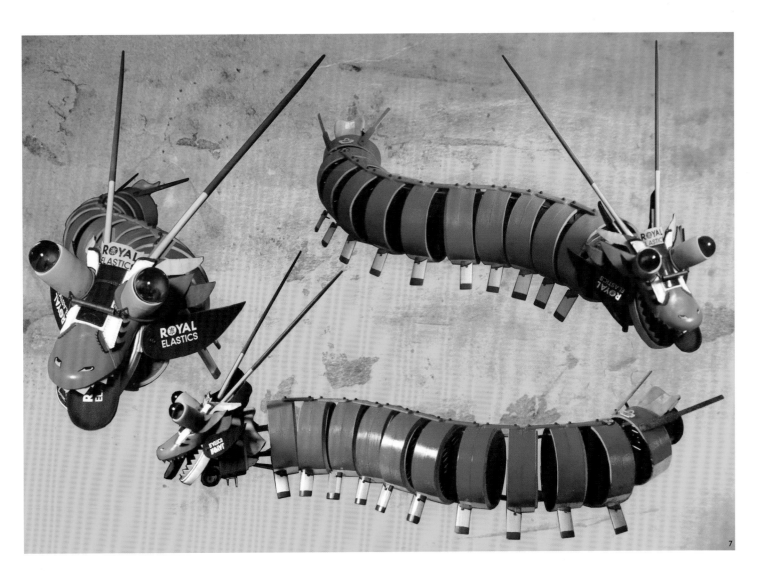

7

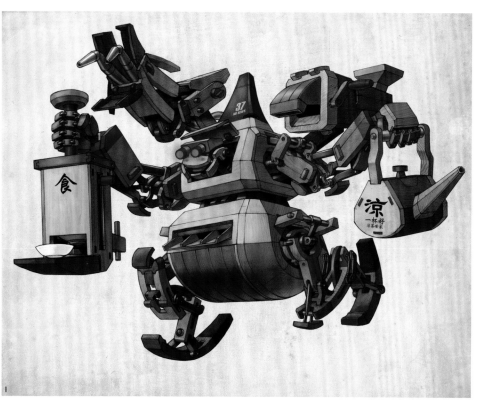

1. **Tea Machine**
C9 | Robot | 2011 | Personal work
This tea machine is an ancient wooden robot, which supplies tasty cold and hot tea in the street. When customers choose bitter tea, the opening in the robot's chest will offer them complimentary candies

2. **Drum Beating Machine**
C9 | Robot | 2011 | Personal work
On the occasion of festive parade, the machine performs festive music with built-in musical instruments

3. **Dragon Racer**
C9 | Robot | 2011 | Personal work
Amphibious robot contestant; in water, the robot folds up its lower part under the boat and moves forward with its four paddles; on land, the lower part controls the robot to march forward

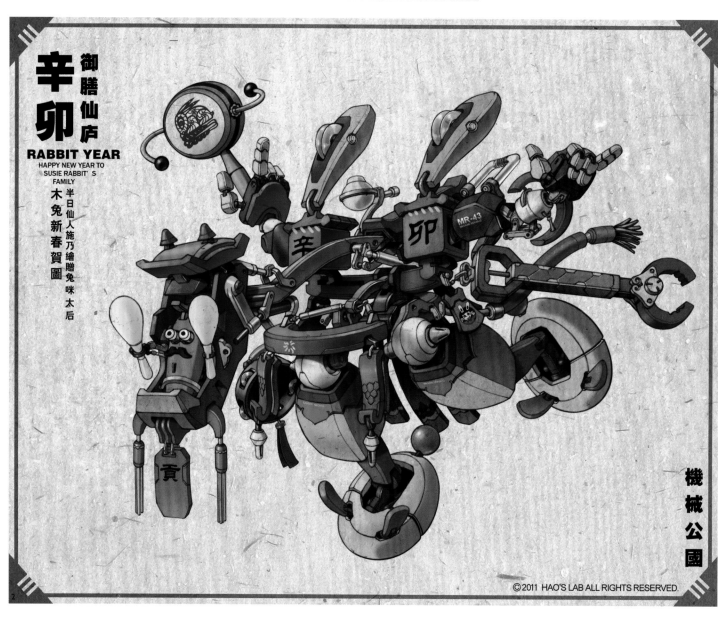

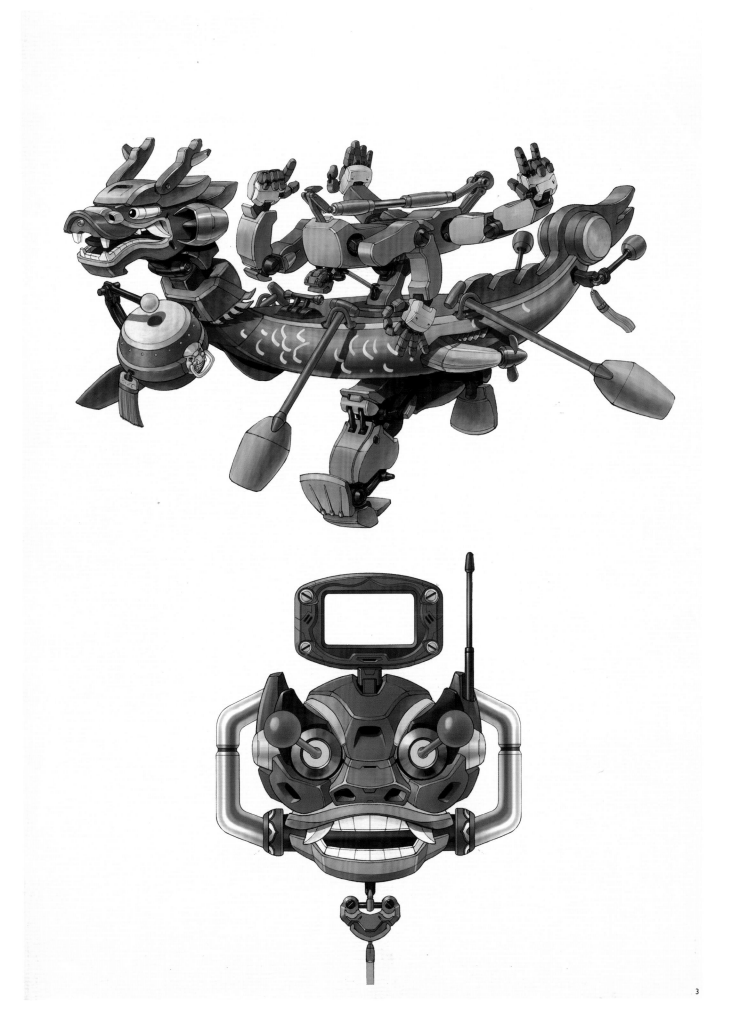

3

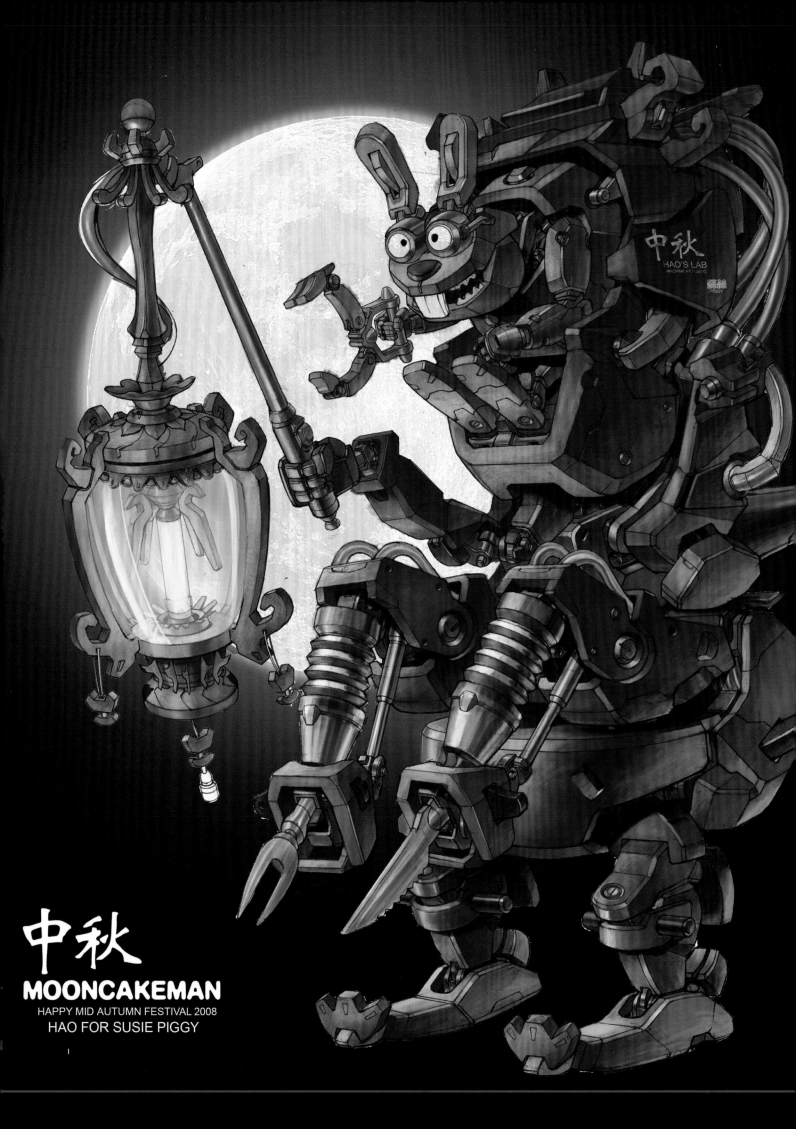

中秋
MOONCAKEMAN
HAPPY MID AUTUMN FESTIVAL 2008
HAO FOR SUSIE PIGGY

① **Mooncake Man**

C9 | Robot | 2011 | Personal work

Children light lanterns in the street on Mid-autumn Day. Some naughty boys will hide in corners to put out others' lanterns with slingshots, while Mooncake Man is there to prevent the lanterns from being broken

② **Take-out Robot**

C9 | Robot | 2011 | Personal work

This highly efficient robot machine delivers take-out orders for various fast food stores. Its right hand was originally a battery but now has been converted into a cooking device with freezing and heating functions as well as a place to carry chopsticks and dressing

③ **Mobile ATM**

C9 | Robot | 2010 | Personal work

On some occasions, a mobile ATM will be rented to make it easier for visitors to withdraw cash. The users can take its front escalator to go up and take the one at the back to the ground. The ATM itself is an armed robot to guard against robbery

2

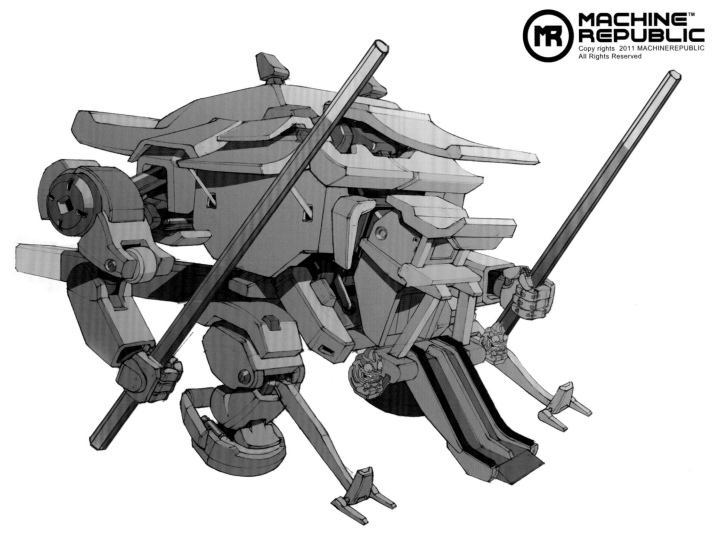

3

Firework Machine

C9 | Robot | 2010 | Personal work

On the occasion of festive parade, the firework machine lets off brightly colored fireworks

SUMMARY

Compared with designers interested in drawing automatic machinery, creators of manned machinery tend to be more rational than romantic in scientific terms. Evident traits suggesting whether a plane is technologically feasible, or whether it is fast, or camouflaged need to be explicitly put down on paper. You may have little interest in military issues, but a good designer should have a fair understanding of the military. Working on a variety of subjects helps create a solid and fundamental training in industrial design. Whether you are designing a concept vehicle or a tank, it should all be built around models you are familiar with and tools you are comfortable using.

The underlying principles for manned machine rendering include precision, practicality, and accordance with background requirements (or clients' needs). Any re-design based on scientific rationale is too much work for most designers. According to Scott Robertson, enhancing the imaginative power of professionals is key in education, while masters who have taught themselves are often efficient observers and summarizers. Through the work displayed readers are introduced to some unfamiliar vehicles. They are so weirdly credible that they often seem just around the corner. Manned machinecal designers are often like prophets visualizing the future.

MANNED MACHINERY

Nickname: Sononbeno
Age: 29
Occupation: Concept designer/Storyboard artist
Email: soerenbendt@gmail.com
Homepage: artofsorenbendt.com

SØREN BENDT

▶ INTRODUCTION

Søren Bendt likes to draw, play video games and make movies. He has four years of experience working professionally with previzualization and layout in the animation and VFX industry at several world leading studios like Framestore CFC, The Moving Picture Company and currently Double Negative VFX. He won several awards for his CGI short film "Hum", now licensed under the Future Short label. He has the ability to jump onto storyboarding, visual development, concept art and animation when needed.

▶ INTERVIEW

Would you please share with us how you started the journey of painting?

I've been drawing since I could hold a pencil. My older brothers would draw with me as a kid, which was like magic to me. I remember thinking that if I could ever draw that well, why would I ever do anything else? That led me to study 2D and 3D animation at The Animation Workshop in Denmark. I believe that was the best place to develop a really strong drawing foundation. This is also where I got properly introduced to doing storyboards and short films, things I also really enjoy.

When did you start to experiment with machine rendering? For what reason?

I drew tons of X-wings fighters from "Star Wars" when I was a kid. They were just the coolest thing I'd seen. The simple mechanic of the S-foils opening up for attack really fascinated me. I loved how beat-up the machinery was and how some mechanical bits were exposed. My dad also showed me how to draw airplanes when I was quite young, and we would glue WWII airplane model kits together. I've always had a tendency to break things down into separate objects, draw each module and then find ways to fit them together. I guess that can work well for drawing machines.

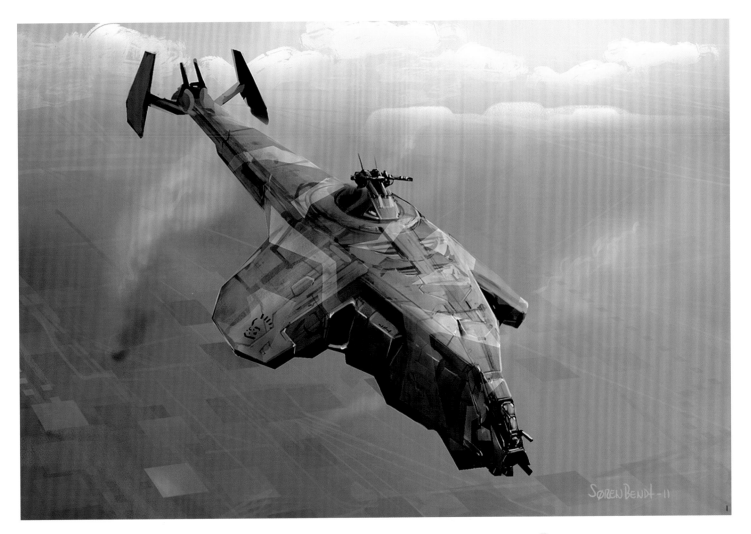

① Choppah

Vehicle | 2011 | Personal work

The AL-80 mainly serves as a transport for light mech or tank deployment. Its speed reaches 200 knots and is capable of vertical take-off

You have extensive working experience. How do you obtain opportunities to show your talent?

I believe that in a lot of cases, creating the work also creates opportunities in some way. If you create a large enough, consistent body of work (especially considering how easy it is to get it online), eventually opportunities will arise. Things like keeping an active blog with a steady flow of updates seem to have helped me a lot and I would pick up a lot of freelance work, even when working full time, to push myself drawing as much as possible. Many of those freelance jobs helped me create work I could present when other potential clients asked to see my work, and one thing would lead to another. I've been so fortunate to have my work featured at CGhub.com and the conceptships/conceptrobots blogs. I was also invited to the Nuthin' But Mech blog, which has some of the best artists I know. It really motivates me to try and get better.

What are the defining features of your work? How did you come up with this style and make the best use of it?

I'd like to think that my work has the illusion of functionality, even if its rather fantastical. I hope the spectator "believes in it" within its own realm. I hope to make images that quickly communicate a world with a story, and let the viewer fill in some of the blanks themselves. I find that inspiration in other people's work. I'm heavily influenced by artists like Ralph Mcquarrie, Chris Foss, Ron Cobb, Syd Mead, Rob Cunningham, Paul Richards, Greg Broadmore, and Aaron Beck, to mention just a few.

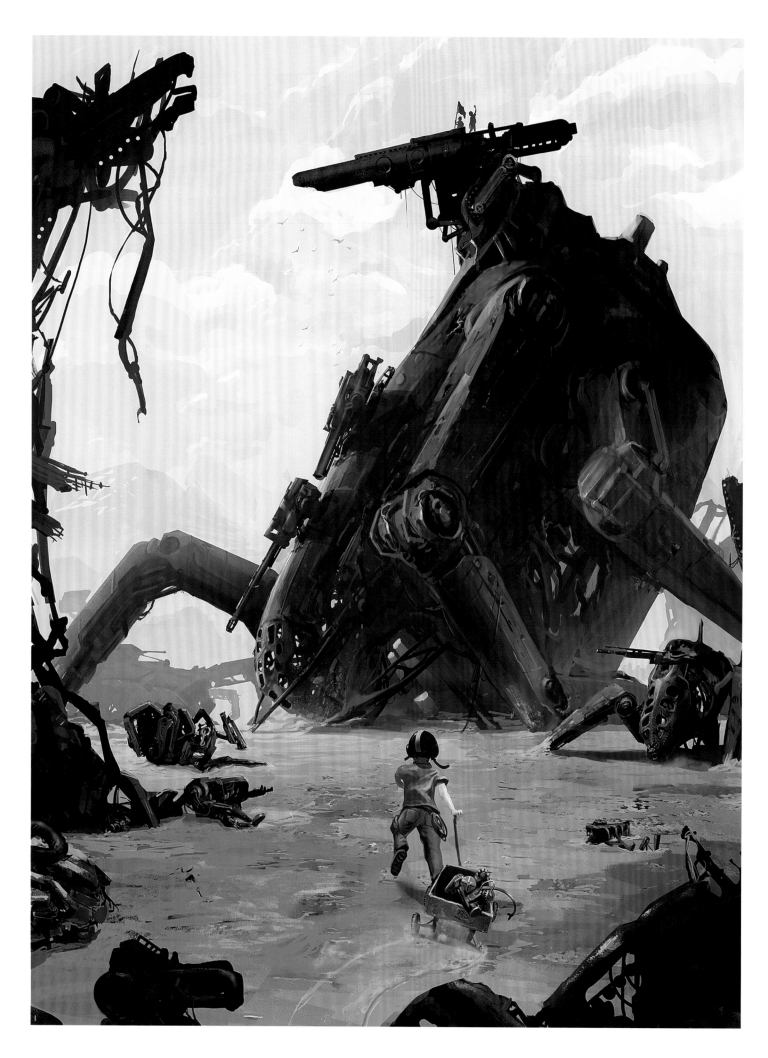

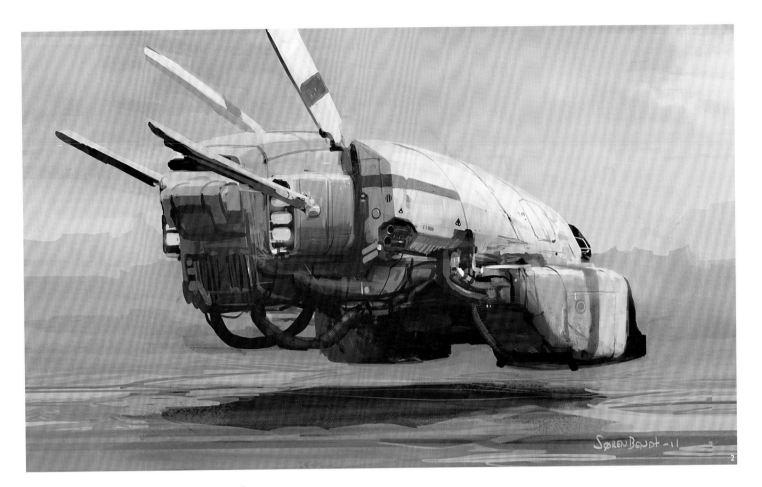

① **Secret Club**

Mechanical device | 2011 |
Personal work

Robot's graveyard on the old battlefields.
It is said an entire city was once here, now
covered only by sand and the metallic
skeletons of war. Kids are not supposed to
play here

② **Speeder**

Vehicle | 2011 | Personal work

Corporate transport provided for mailmen
across the colonies

How did you win the CGI short movie award? What does this award mean to you?

I was fortunate that my shortfilm "Hum" got accepted into a lot of festivals and was nominated and won at Sicram 2007. The Animation Workshop was a great help in promoting the film and getting it out. It meant a lot to me. The prize money helped me a lot financially, and I think it really helped putting me out there. It managed to attract the attention from established people in the animation and VFX industry which has opened many doors for me.

Compared with some artists who occasionally take machine rendering assignments, you have produced a large quantity of machine renderings. What accounts for your productivity?

I get immense joy from turning a black canvas into something (hopefully decent). It doesn't necessarily have to be mechanical but I must admit that it's in my comfort zone. I was always "that robot guy" you know. I should probably draw some more different things. When it comes to productivity and motivation, I feel an obligation in a way. I'm so fortunate to live in a way that allows me to create and study art. If I don't take advantage of it and develop what I feel like, I'm letting the people who have helped me and myself down, wasting past effort. It just scratches my itch in a way nothing else can.

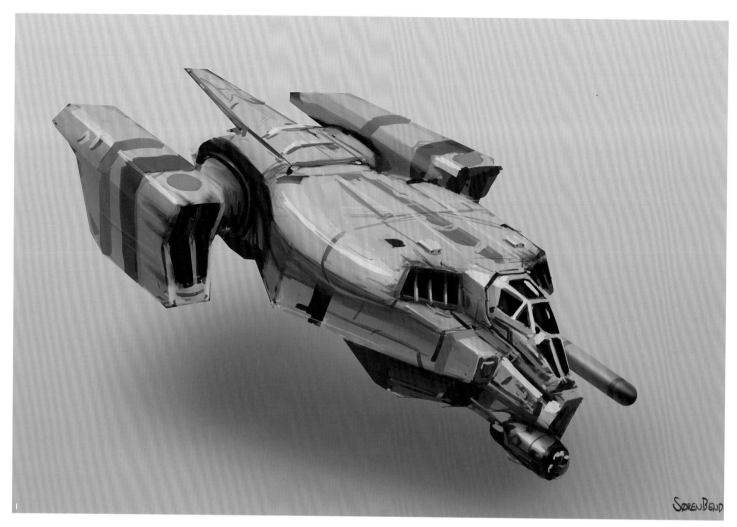

① **Ship Concept**

Vehicle | 2012 | Personal work

This is a space-fighter

② **Desert Sail**

Vehicle | 2010 | Personal work

The "sky-sails" was a favorite on many of the early low gravity colonies. The vast desert of Vesta5 is frequently used for amateur sail-racing, using the strange round rock-formations in the mountains as racing tracks

Many people have worked on their dream vehicles. In your view, what considerations do you need to take into account while creating vehicles? What preparations do you need to make?

When I design a vehicle, I think its very important to think about where the thing comes from, and what kind of world it belongs to. I usually start out with small simple shapes (like staring into the clouds), and once something starts emerging, I tend to make up small stories about them. Gathering reference material is huge as well. I try to find real-life equivalents (like tanks, helicopters, etc.) and mimic certain elements from them, to make the artwork seem more rooted in reality.

The vehicle you have created fits well with the background. How important do you think the environment is to machine rendering?

The environment is another chance to tell the viewers more about the vehicle you are portraying, and the world it comes from. Things like: Is it a low gravity planet? What purpose does it serve there? It all ties in with the thoughts I'm getting while I develop the concept. I do like to have a simple background when presenting certain concepts, and see how well the design does all on its own as well.

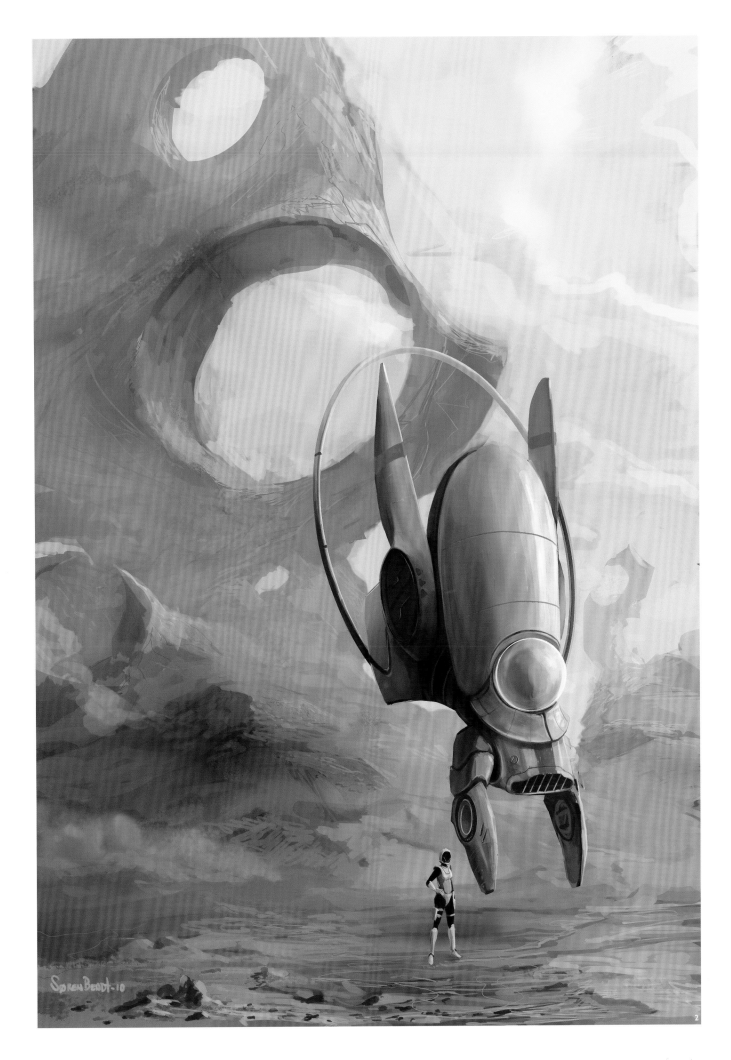

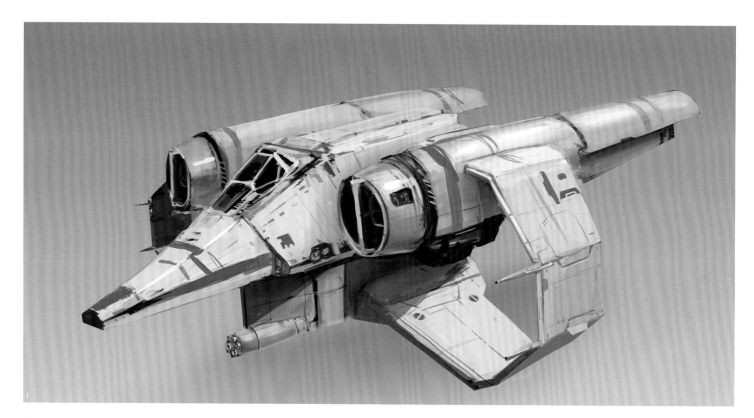

1 Plane Concept: The Duck

Vehicle | 2011 | Personal work

A space-fighter, originally designed for
racing, but adapted for war

Which movie or game has impressed you most with its machine rendering effect? How has it inspired your creations?

Few things beat the model FX created at ILM for "Empire Strikes Back" for me. The AT-AT walkers in the snow, the Millenium Falcon in the asteroid fields, the Cloud City...The "Alien" series impresses me as well, the Nostromo, the showdown between Ripley in the power loader versus the Alien Queen onboard the Sulacco, the Pulse Rifles... Duncan Jones' "Moon" is stunning too. It really hit the mark of hard sci-fi for me. The video game "Homeworld" blew my mind in 1999. It was so lush and vibrant, and the shapes so simple yet believable. Looking at the concept work from "Homeworld" is like an injection, which causes me to draw nothing but spaceships for a couple of weeks. I love the Syd Mead-inspired style of "Mass Effect" as well. It's such a varied world, yet design-wise everything ties together and feels really fresh. There is no way around the work the artists at Weta did for "District 9" either. Seeing that on the big screen was gorgeous. They also did brilliant work on "Avatar." I saw it twice just to marvel at the machinery, even though I didn't really care much for the characters.

Do you have any plans for your machine rendering career in the future? Can you share some ideas with us?

I'm currently doing a lot of concept work for Double Negative in London, quite a bit of it involving mechanical aspects, without giving anything away. I was a guest lecturer at the Danish Design School, and might get the chance to do more workshops involving mechanical design, and design fundamentals in the future. Meanwhile I try to keep myself busy at home with even more robots.

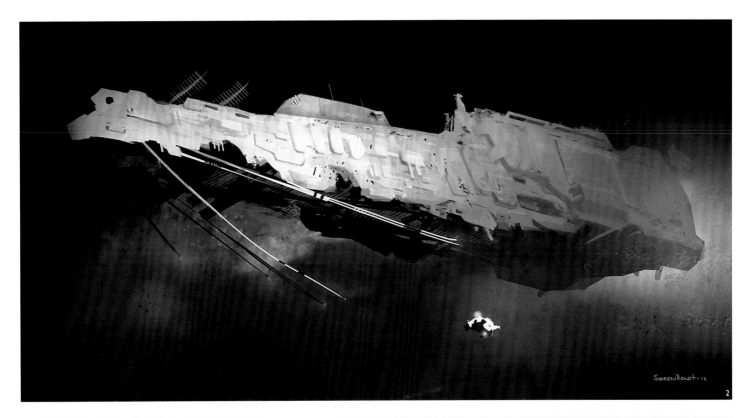

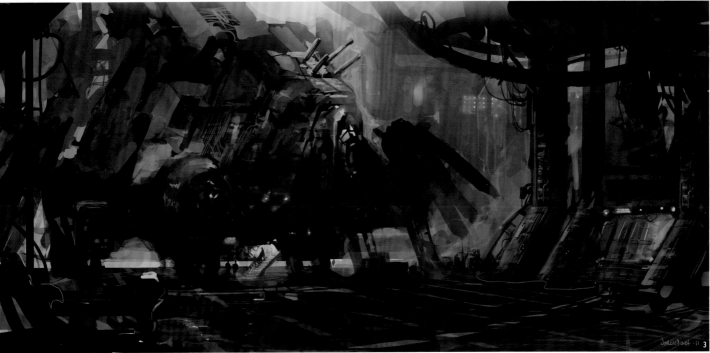

(2) **Spaceship Whiskers**

Vehicle | 2012 | Personal work

A large long-range freighter, 3,000 meters (9,800 ft) long

(3) **Hangar**

Vehicle | 2011 | Personal work

The crew of the old massive freighter C.O.S-Tarvos pack a few necessities before their next haul across deep space

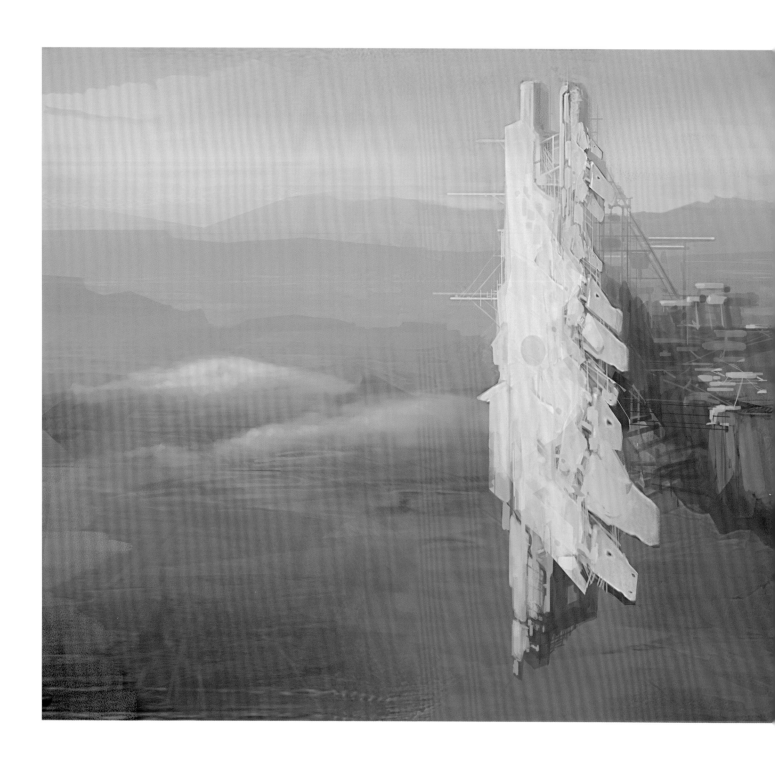

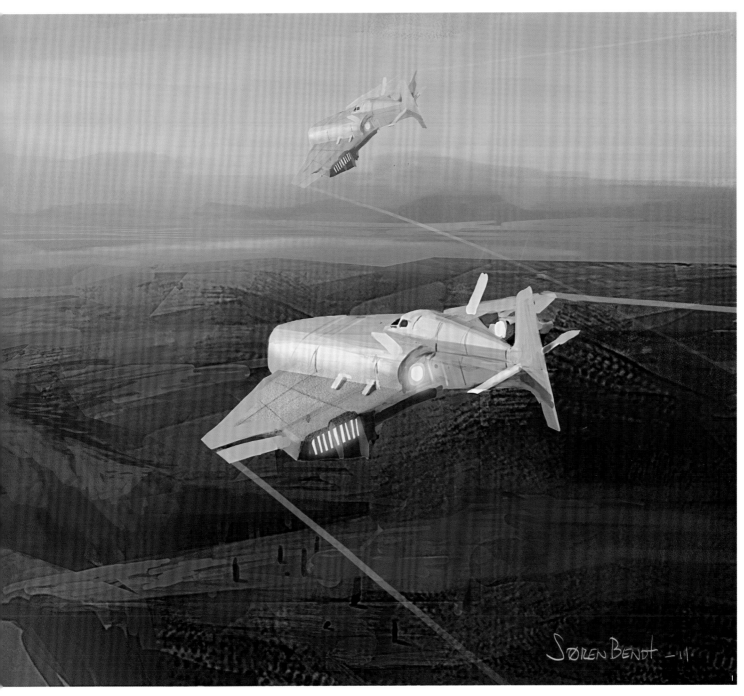

ⓘ **Launch**

Vehicle | 2011 | Personal work

Large Viper spaceship constructed on
the side of a cliff is prepared for launch

Nickname: Guoguo
Age: 33
Occupation: Concept designer
Email: georgeguo@foxmail.com
Homepage: georgeguo.cghub.com

GUO FENG

▶ INTRODUCTION

Known as Guoguo, Guo Feng is a veteran CG concept designer, illustrator and also moderator for the Chinese Concept Designer Forum. He graduated from the Fashion School of Wuxi University of Light Industry as a fashion design major. Currently, he works at the Shanghai branch of Perfect World and focuses on pre-production concept design and game illustration. He has participated in many game projects such as "The Legendary Swordsman 2," "The Return of the Condor Heroes," "Legend of Dagger Lee," "Meteor Butterfly and a Blade," "Iron Phoenix," "UO," and "Battle of Immortals."

① Ballista
② **Military equipment | 2012 | Commercial work**

Design for heavy ballista in a project; it was set in the Dark Continent Age in Europe

▶ INTERVIEW

What brought you to the machine rendering industry? How did you start with such a category of assignments?

I was primarily driven by interest. As a concept designer, my greatest joy is to translate ideas and inspirations into reality. More importantly, I can discuss and share my designs with friends. Specifically speaking, I started to experiment with this category in fourth grade when I started to put down "Transformers" characters onto paper. I began to understand perspective, mechanical structure and machinery function. Back then, I even tried to develop some new transformer models. In retrospect, I think those were my first attempts at mechanical rendering. Though I was still a primary school student, I gained an initial understanding of the design of robot joints and mechanical bionics through those imitation exercises, which turned out to be really rewarding.

What principles do you think a machine renderer should follow and what preparation should he or she makes when designing a mechanical device?

Actually, whether it is for traditional artistic creation or for specific machine rendering, fundamental artistic modeling capacities (such as those related to structure, light and shadow, color and space, etc.) and necessary aesthetics are indispensable. In addition, professionals in machine rendering should also have a comprehensive understanding of industrial culture and history, mechanical principles and structure, mechanical materials and technologies, ergonomics, bionics, industrial modeling design and other disciplines. Before the design begins, the

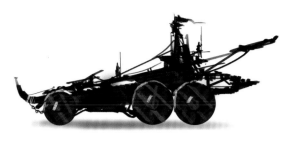

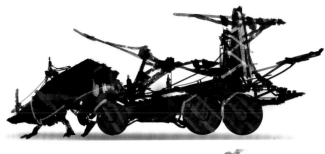

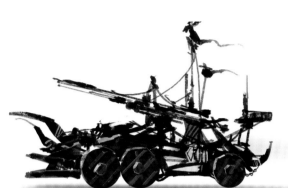

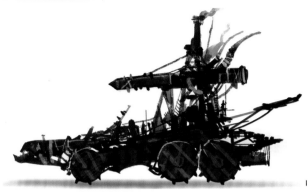

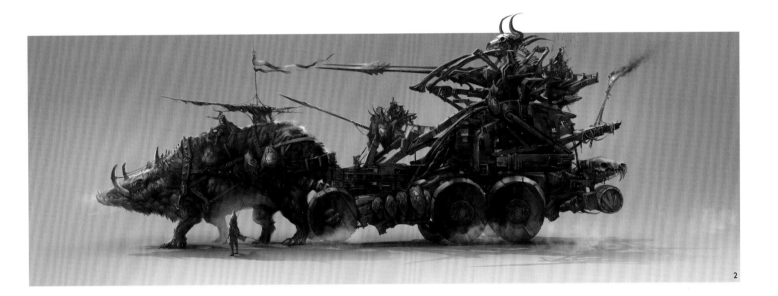

designer should take consideration of those non-flexible elements in the briefing process. For instance, when designing a supercar, we should first decide whether to focus on its practical or aesthetic function. If it is aesthetic-oriented, we should take account of its technical background (possibilities for powers and materials as well as their accordance with brief requirements), its use (the feasibility of the structure and the accuracy of function definition), its characteristics (the outlook and style from a visual perspective), the relationship with its user (how its look matches with the user's bearing), and other aspects. With respect to design drawings, we should take further consideration of expressive techniques, which will have a direct impact on the final design and determine whether the required timeframe is in accordance with the brief. This is of particular importance when dealing with a large workload.

Currently your machine renderings are internationally recognized. What's the defining feature of your works?

Compared to those who specialize in conceptual machine rendering, my work is inadequate in some aspects. After all, machine rendering is based upon industrialized civilization and mechanical structure principles. I have made some accomplishments and won some recognition in this respect, however, according to my own experience, accurate positioning and a lasting passion for industrial design and military affairs are of overriding importance. Therefore, I stress "concept design of the military industry" and draw inspiration from military industry elements in reality. This approach enables an integral and signature representation in my work related with mechanical themes.

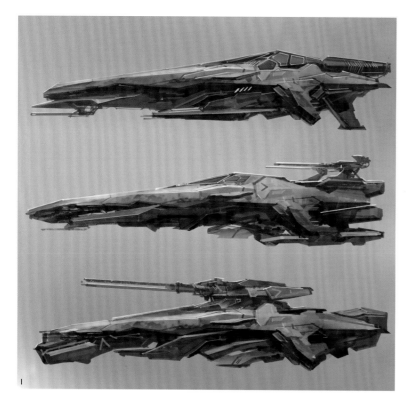

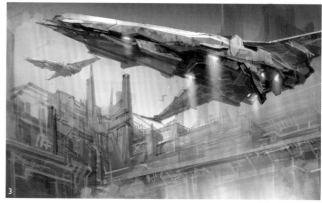

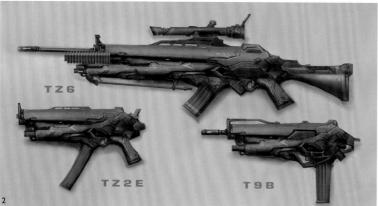

① **GUN**

② **Military equipment | 2008 | Personal work**

A set of near future gun re-designs based on those in reality

③ **Warship**
Military equipment | 2009 | Personal work

It is positioned as a series of one-man space battleship for wars in outer space.

④ **Martial Tool**
⑤ **Military equipment | 2012 | Personal work**

This biochemical battling platform is developed by some country in response to nuclear wars, featuring a combination of biological neural systems and mechanical structures

Most of your works are concerned with combat machines. What accounts for your preference?

I developed a great passion for military affairs and weapons from childhood. After starting to work, I gained access to a wider range of resources related with military equipment. To some extent, the increased accessibility of relevant resources has enabled a more profound understanding of military-oriented machine rendering and inspired a great interest in me. What's more, visually striking military equipment in numerous movies and games has spured my creative desires. Another reason is that compared with common civil devices, these military mechanical devices targeted for battlefields are crystallizations of state-of-the-art technologies. The optimized look and specialized function of military mechanical devices allow for a wider use of such figures in terms of visual impact and creative exploration.

We have noticed that many designers use bright colors, but your use of color is more uniform. Is this down to project requirements or personal habit?

This is more about personal habit and understanding of the project style. Designers should take account of coating, function positioning and the surroundings in the coloring process. My designs are mostly focused on mechanical equipment for military use. Therefore, considering the military equipment coatings, the weathering and battle damage, reality and uniformity are valued. I also hope that such a color palette will tell more about what the machine has undergone.

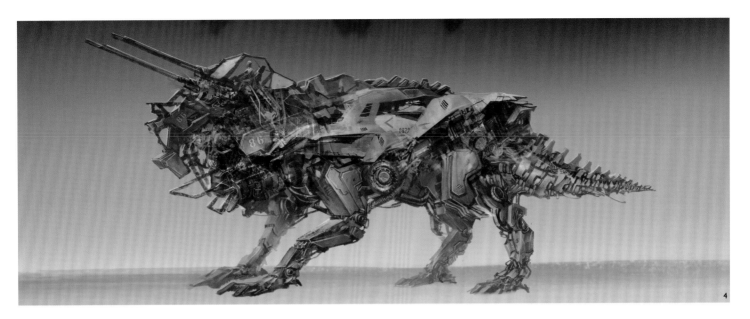

4

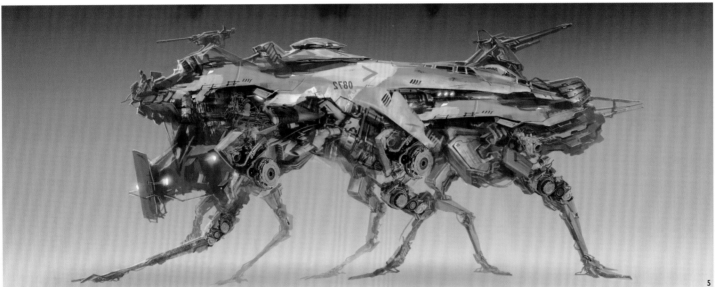

5

When you are designing a plane or a tank, what is your primary consideration? Where do you find your inspiration?

Firstly, I will consider the larger context of the design target, giving consideration to its model features, driving gears, battling performance, distinctive advantages and disadvantages that are plausible in its age. The final scheme should be based on validity and visual impact so that the design scheme will be sufficiently convincing and involving. Inspirations are drawn from different sources, such as bionic principles, reportage on latest technologies, books I have read, pictures downloaded from Internet, or ideas that pop into my mind during casual talks with friends.

For instance, when designing a tank, I was inspired by bionics and drew walking tanks with six and eight legs; experimenting with different driving forces, I designed gravity-resistant tanks driven by nuclear power or electromagnetic tanks; giving consideration to the battle environment, I came up with maglev tanks for marsh or mud flats; inspired by weapons developed by rebels in foreign military reports, I transformed a heavy civilian vehicle into a quasi-tank.

How much time does it take you to finish a piece of work? Do you think speed is one of the necessities to satisfy clients' requirements?

When working on such works, we have to take account of specific requirements. Generally speaking, commercial projects will set down clear deadlines. For instance, my "Fighter Motorcycle Concept" was finished within eight days. In contrast, designers will feel less restrained with personal work. In most cases, when the initial design concept is determined, I will not rush to finish it but try to incorporate various ideas into the process. This approach will allow immediate evaluation of the newest ideas. Of course, I always believe speed is an important factor in judging whether a designer is professional. After all, commercial projects and production schedules are closely related. The designers must stick to the schedules.

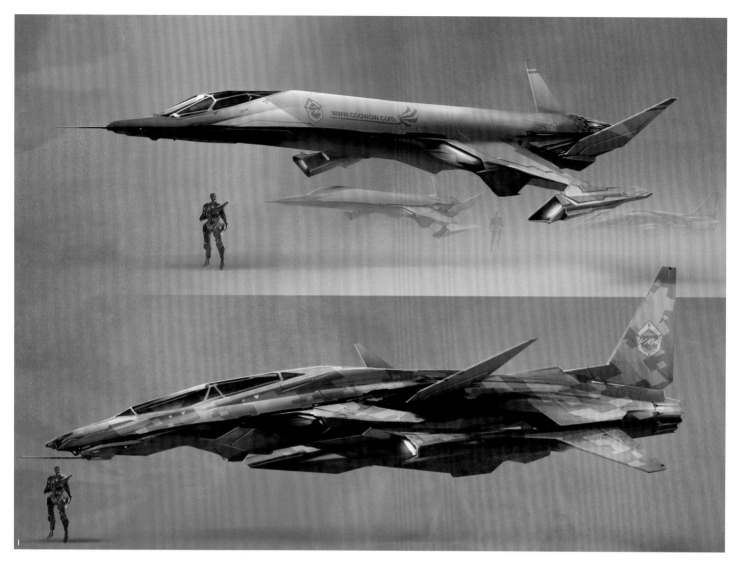

1. **Aviation Design**

 Military equipment | 2010 | Personal work

 This work features the design of a light and a heavy marine ship-borne plane for a future navy with the former specially intended for air defense and the latter for long-distance interception and ground attack

2. **Fighter Motorcycle Concept**

3. **Military equipment | 2007 | Commercial work**

 This is a maglev fighter motorcycle which incorporates racing and shooting capabilities, designed for an STG project

4. **Armoured Military Vehicle**

 Military equipment | 2008 | Personal work

 Design for some heavy equipment in an armoured division, including capital tanks, armoured troop carriers, automatic cannons, etc

Do you have some suggestions to share with other designers working on the same category of works?

Besides a lot of reading and a huge accumulation of relevant referential materials through industrious practice, we should also pay attention to knowledge from various fields and disciplines. Meanwhile, we should develop a habit to observe and analyze each element associated with the mechanical industry. For example, we can observe plane engines, aerodynamic configurations as well as the structure and function of the ground devices while we are in a departure lounge. In a factory or outdoor place, we should take notice of all the transport vehicles and industrial equipment. While broadening our vision, such observation enables us to make experiments with our accumulated references, so we can enhance our sensitivity and judgment uniquely associated with machine rendering.

What's your plan for the future? Have you ever thought about making your works into models?

Currently my concept designs are primarily applied to games. However, in the European and American CG industries, mechanical concept design is more widely used in movie and TV production, as the highlights of these concepts can be more directly presented. Therefore, I hope to engage in this medium in the future. Meanwhile, I also plan to summarize my conceptual mechanical design work and publish a design-themed book. As for developing my own work into models, I've been looking forward to that.

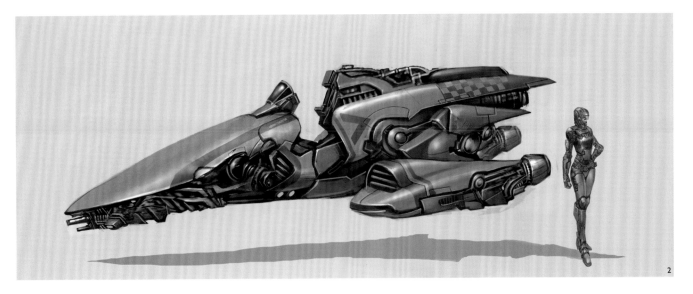

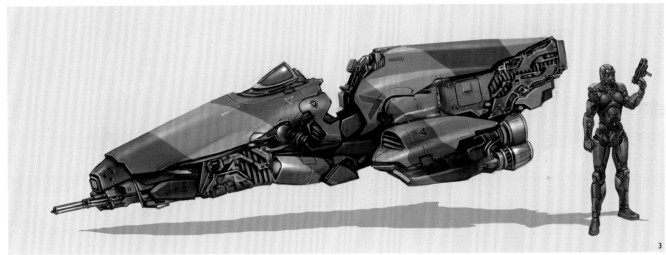

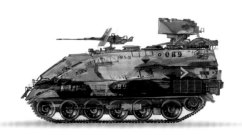

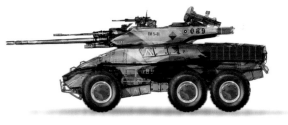

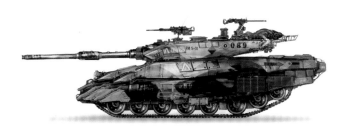

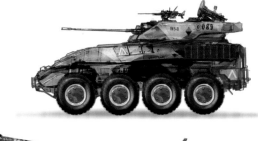

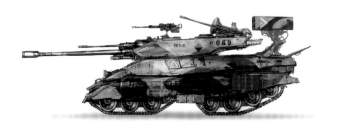

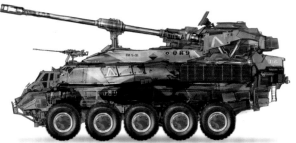

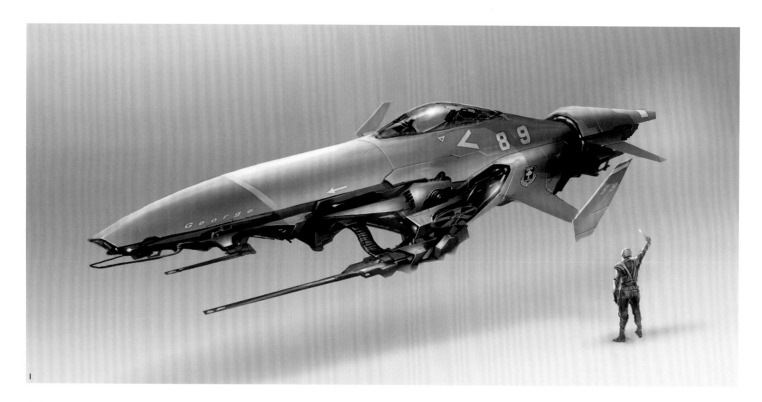

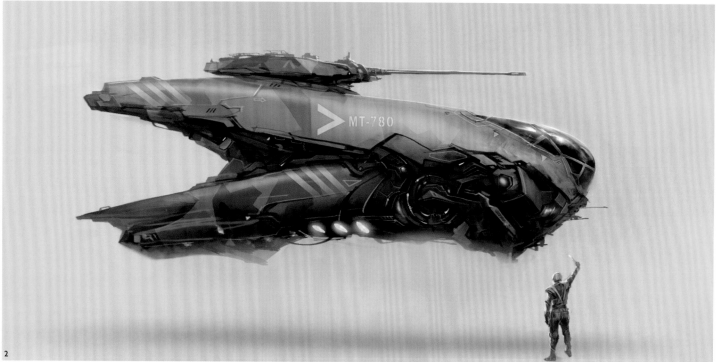

① **Battle Flyer**
② **Military equipment | 2009 | Personal work**

This work represents two designs of future fighter aircraft

③ **Z-airship Concept**
④ **Military equipment | 2012 | Personal**
⑤ **work**

This airship exclusively used by bounty hunters is driven by luminous energy and steam. Besides, it can also be used as a motorboat or a light plane

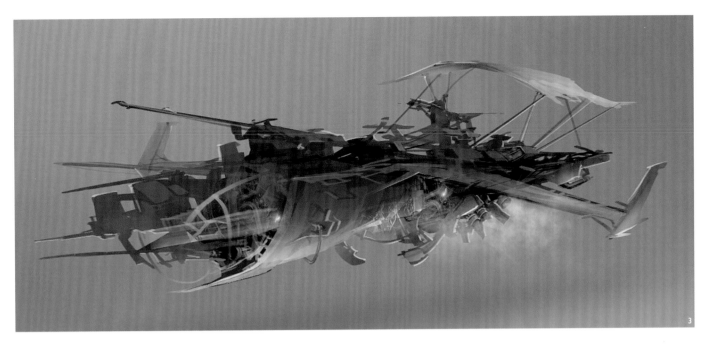

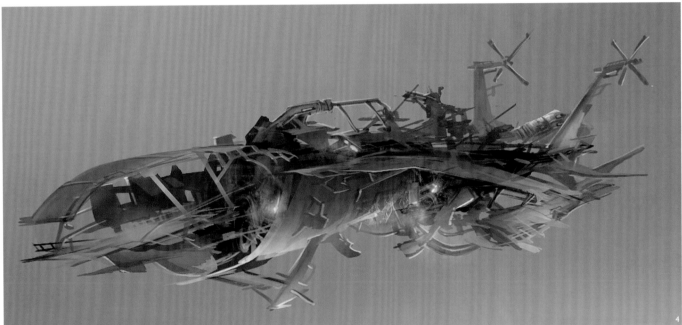

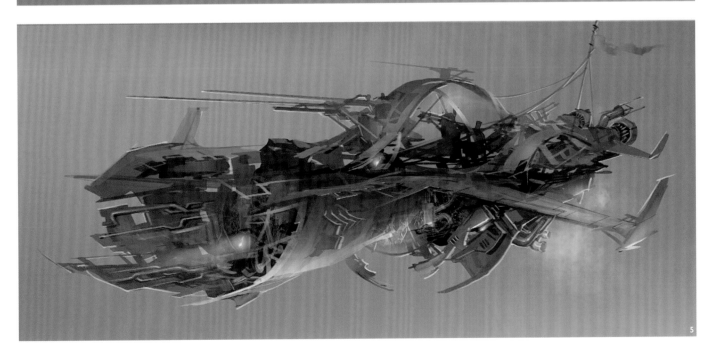

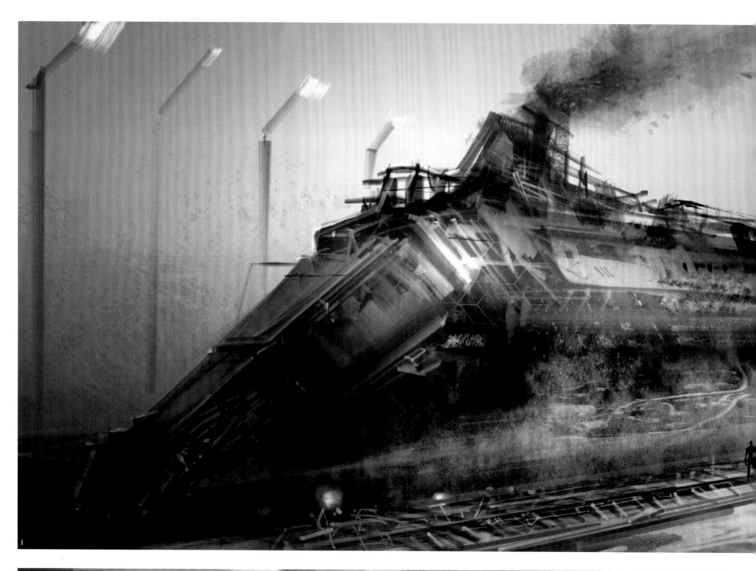

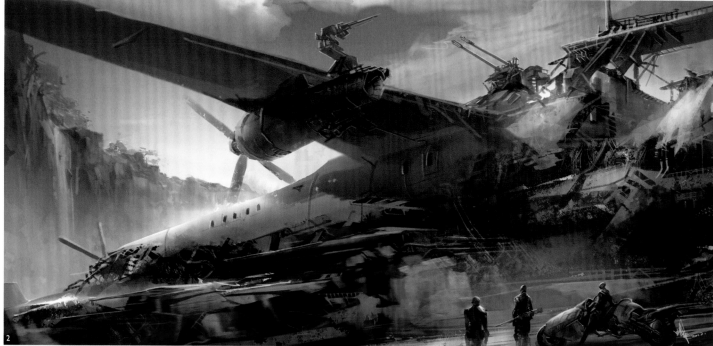

① **Nuclear-powered Military Train**

Vehicle | 2012 | Personal work

A heavily armoured train with two power
generation systems, electricity and
nuclear power respectively

② **Plane Fortress**

Vehicle | 2011 | Personal work

A fortress built on the remains of a
crashed plane

③ **Setting Sail**

④ **Military equipment** | 2012 | Personal work

Fighter pilots doing final inspection
before mission starts

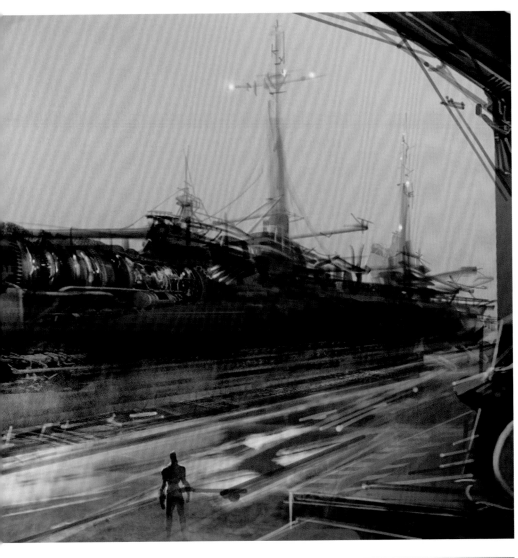

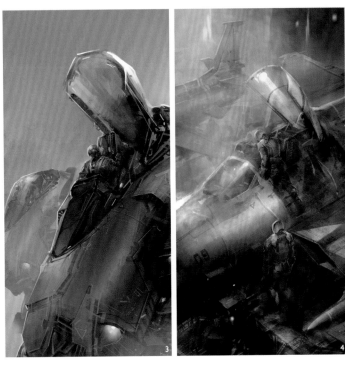

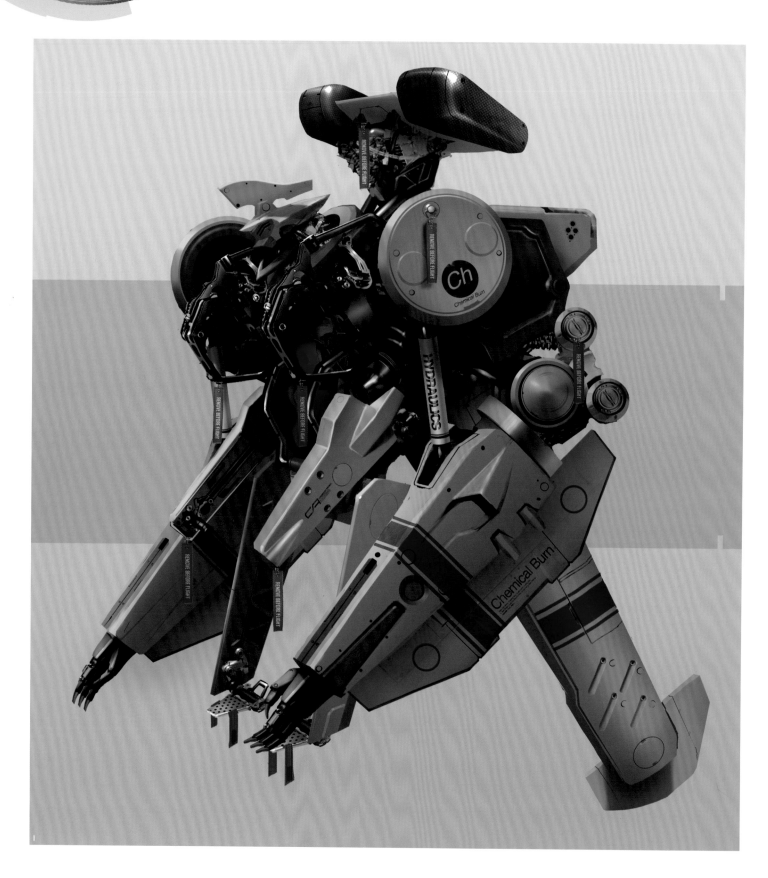

① **Skydive Mecha**
Thom Hoi Mun | Vehicle | 2011 | Commercial work
Mecha suited with wings and aerosols for a skydive race

② **Walker Tank**
Thom Hoi Mun | Vehicle | 2012 | Personal work
Inspired by the look of Metal Gear Rex, I experimented with different technical styles

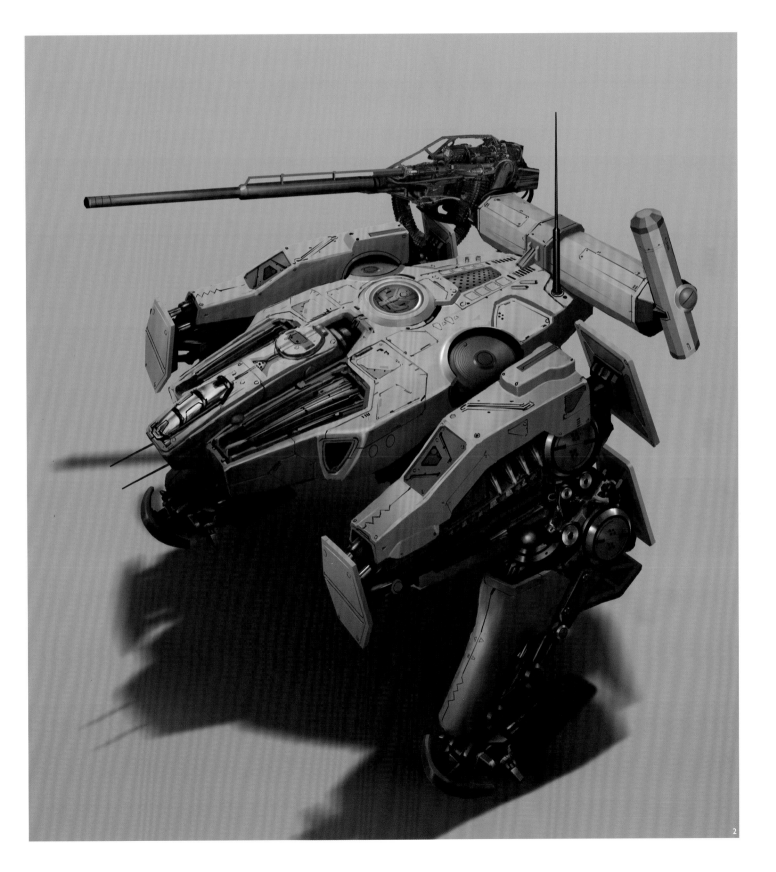

2

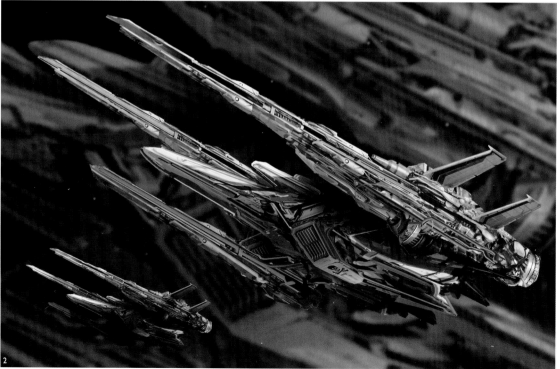

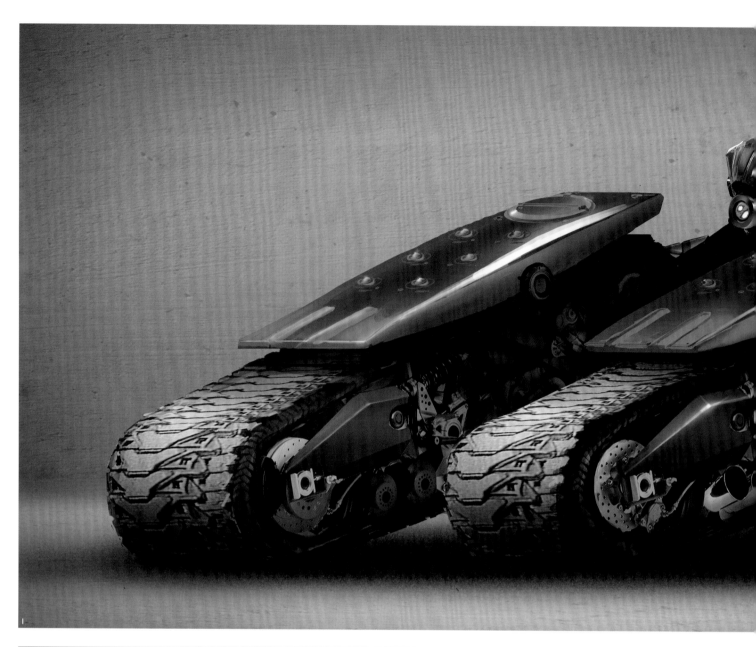

② Skull Leader
Thom Hoi Mun | Vehicle |
2012 | **Personal work**
Redesigning the Skull
Leader from Macross
with a more sic-fi NASA
space look

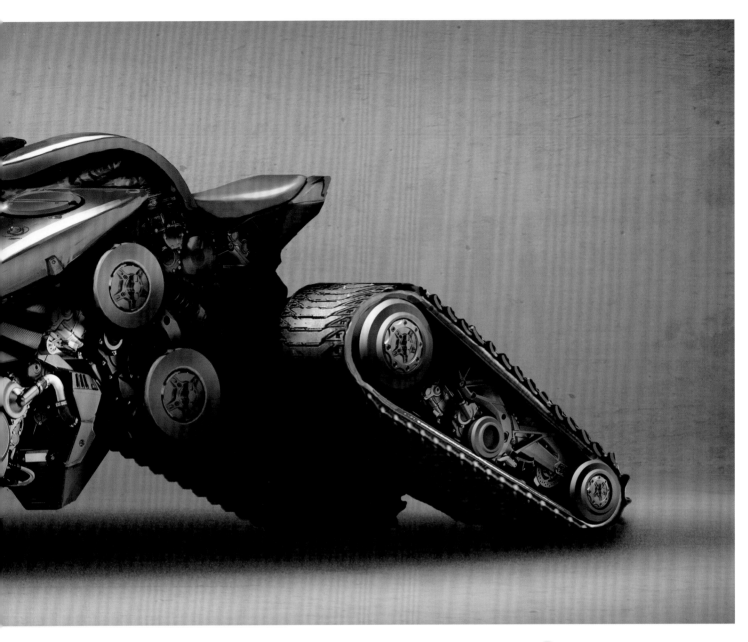

Threaded Bike

Thom Hoi Mun｜Vehicle｜2010｜Commercial work

This is an effort trying to mix a tank with a bike

① Chariot of the Divine Engine Division
② **Agentwalker | Weapon | 2011 |**
Personal work

Luban Chariot, as a Divine Blade Warrior, and Arrow Launcher, an invention by Zhuge Liang, shoulder the duty of guarding the capital and taking part in military expeditions

③ Clockwork
Alejandro Martinez | Vehicle | 2010 |
Personal work

This machine possesses a propelling spring, weights of chains, bands of steel, trains of gears, gear wheels, anchors, minute/hour hands, and screws

④ Hymenoptera
Alejandro Martinez | Vehicle | 2010 |
Personal work

The general design is inspired by a hymenopter insect, with wings connected during the flight to a series of hamulis aureus. The elements on its head are two "ovipositors" that launch bombs and mines, finishing enemies with a movable laser

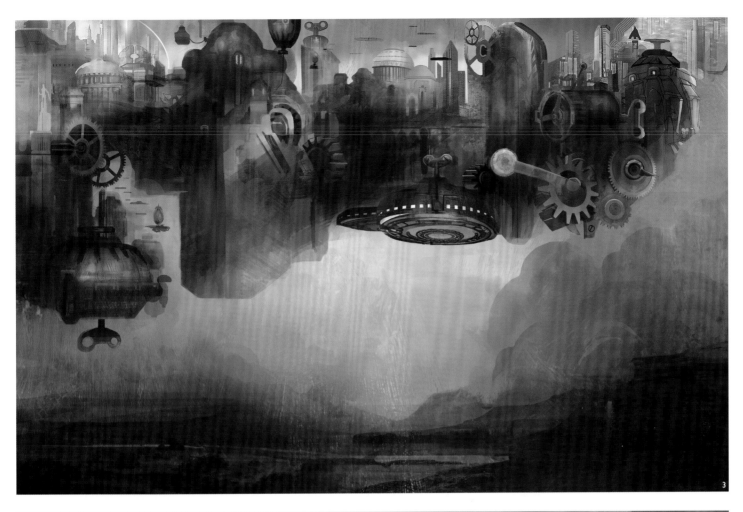

① Hangar

Alejandro Martinez | Vehicle | 2009 | Commercial work

The working robots install sensors, field generators, shield disruptors, field lasers and chambers of plasma along the fuselage. The fighter-bombers are equipped with shielding plasma both in the fuselage and in the low engines of vertical and directional impulse. Intelligent weapons spread on wings that can shoot air-to-air missiles, as a defensive precaution

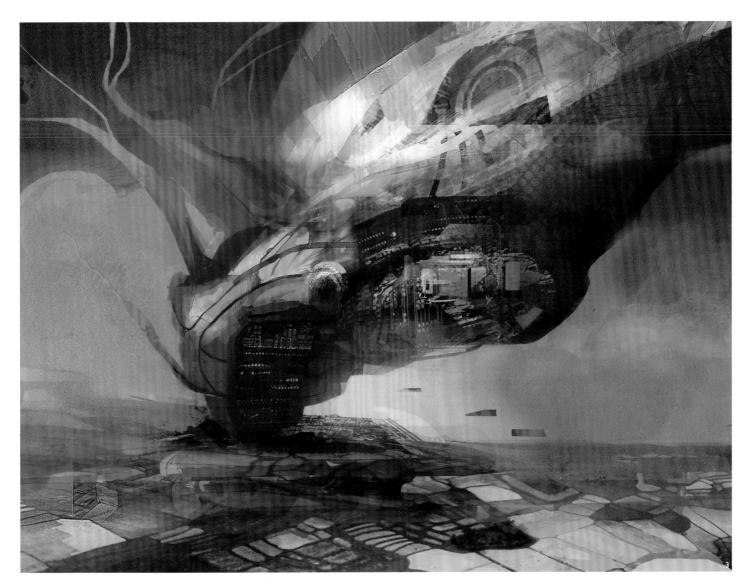

② **Ship O**

Alejandro Martinez | Vehicle | 2009 |
Personal work

Hybrid Zeppelin (plasma) of long scope
evolves in terms of a non-linear geometry,
having the aptitude to rotate or metamor-
phose following the pattern of a molecular
beehive shape

③ **Shade**

Alejandro Martinez | Vehicle | 2009 |
Personal work

This ship possesses a ghostly appearance
and colossal proportions. It is made of
organic materials. Once its camouflage
shield is activated, the ship will turn into
a spectrum in the ether

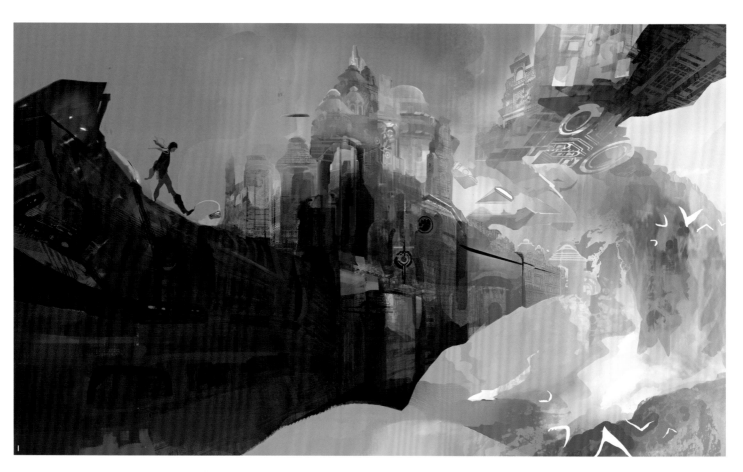

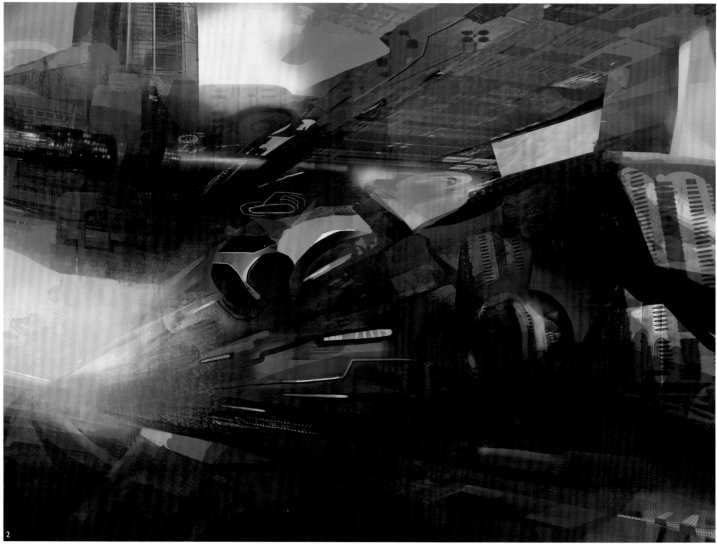

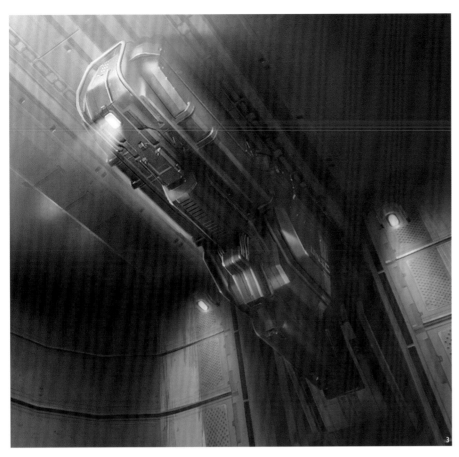

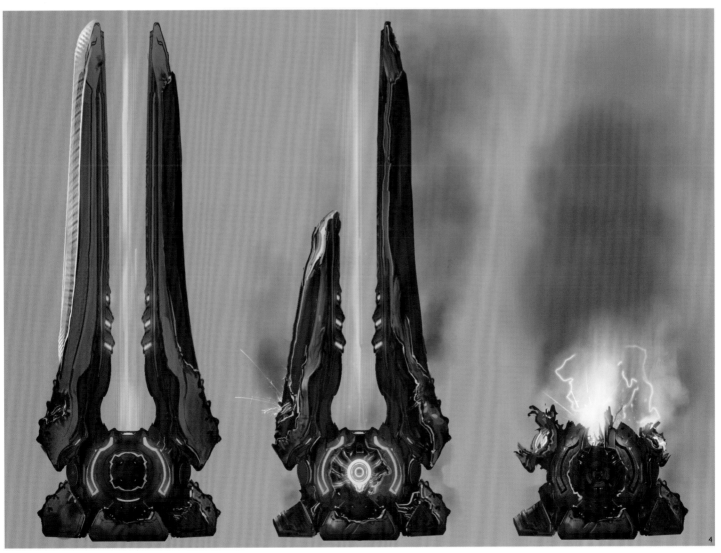

UNSC Base

Dave Bolton | Mechanical device | 2012 |
Commercial work

A back entrance road to a UNSC base

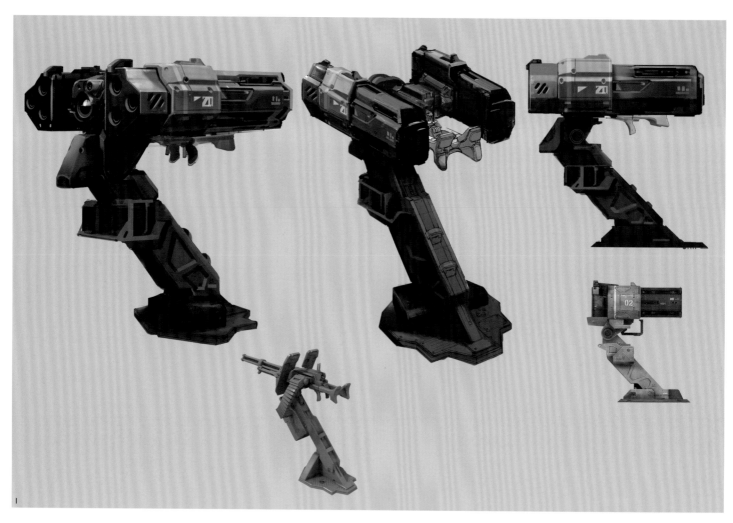

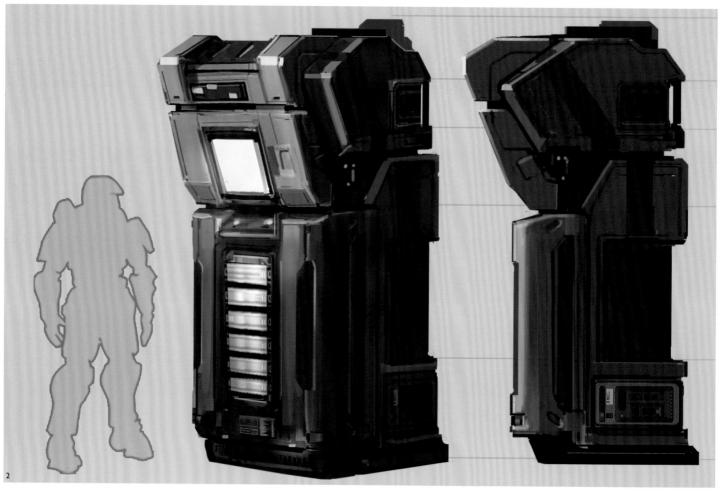

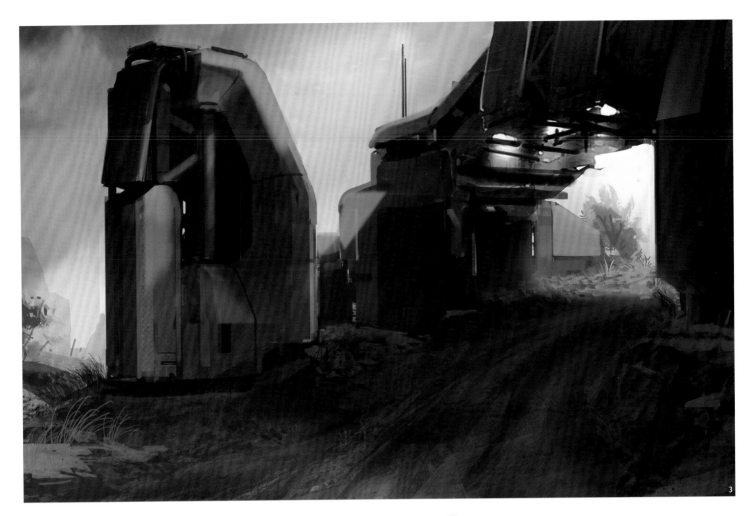

① **UNSC Warthog Rocket Launcher**
Dave Bolton | Mechanical device | 2011 |
Commercial work
This rocket launcher weapon is used on a
UNSC Warthog vehicle

② **UNSC Mainframe**
Dave Bolton | Mechanical device | 2011 |
Commercial work
Mainframe database machine for UNSC

③ **Complex Structures**
Dave Bolton | Mechanical device | 2012 |
Commercial work
UNSC communication base

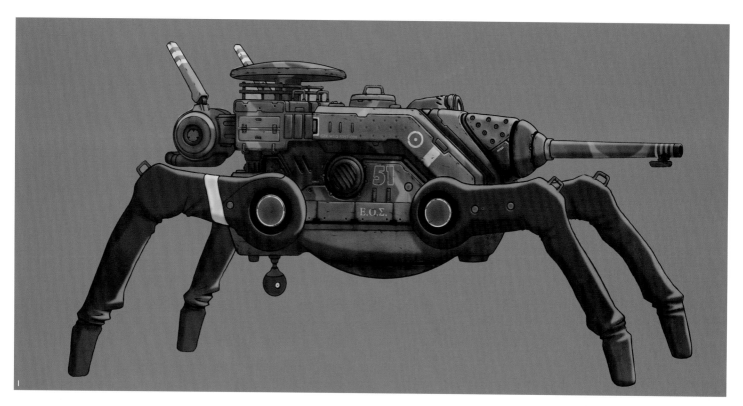

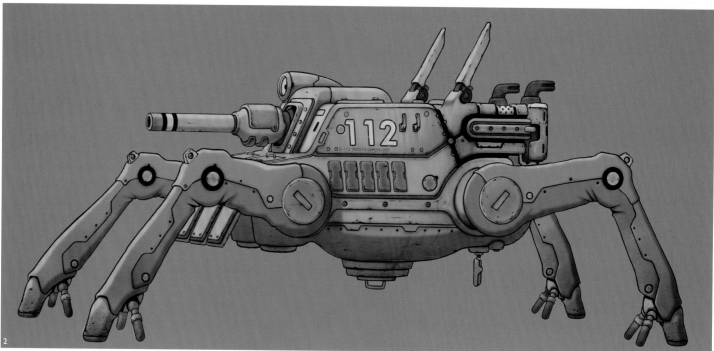

① **Guad Tanks**

② **Mike Majestic | Vehicle | 2010 | Commercial work**

Human-operated quadruped armour is to be found, exclusively, in the theater of war on the planet Polemos. Tanks, either treaded vehicles or quadruped walkers, were designed for anti-FOIL combat platforms in both FOIL warfare and defense of Polemon city states

③ **Hunter**

Nicolas Crombez | Vehicle | 2010 | Personal work

This is a ground panzer designed to slaughter the enemies

④ **Take Off**

Nicolas Crombez | Vehicle | 2010 | Personal work

An aircraft loading and unloading paratroops

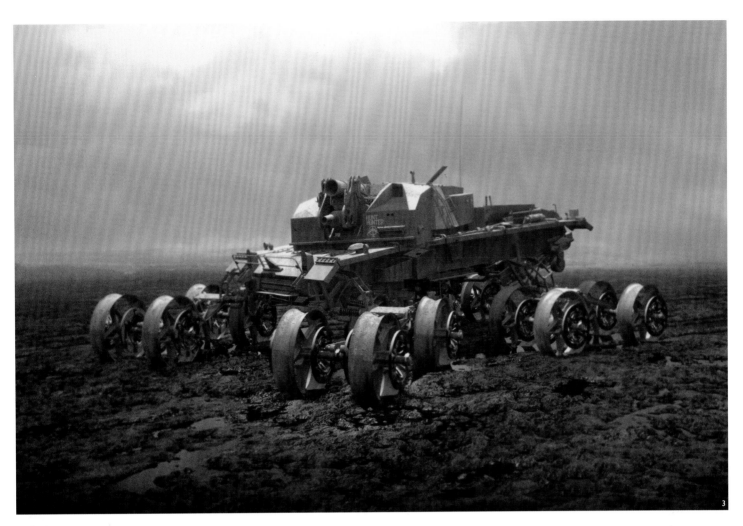

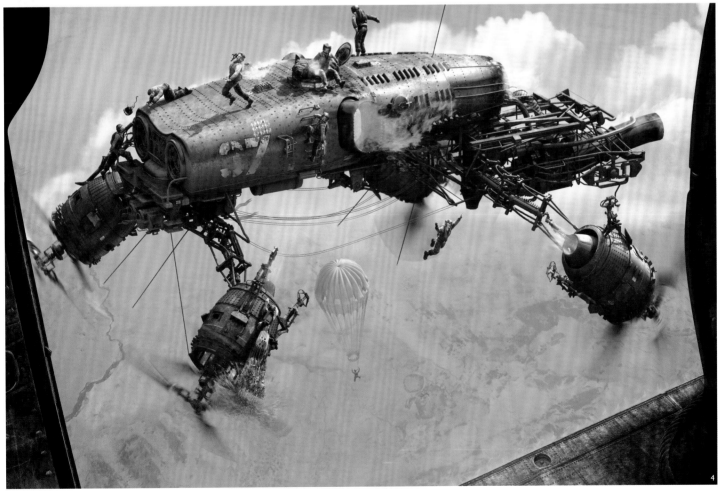

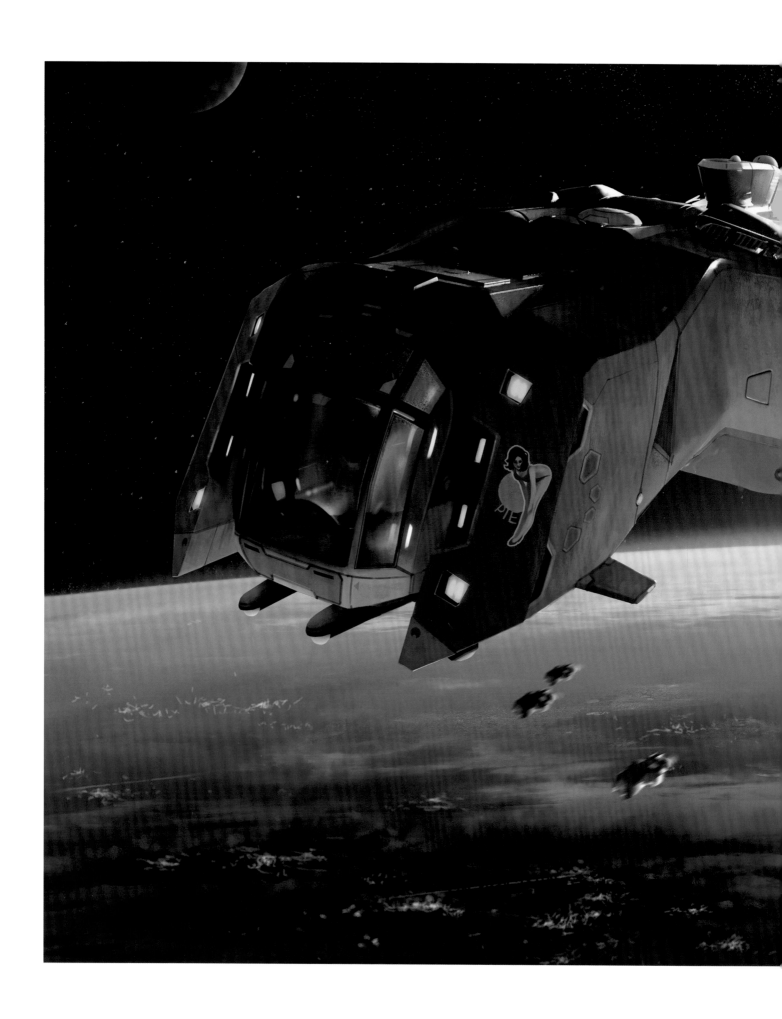

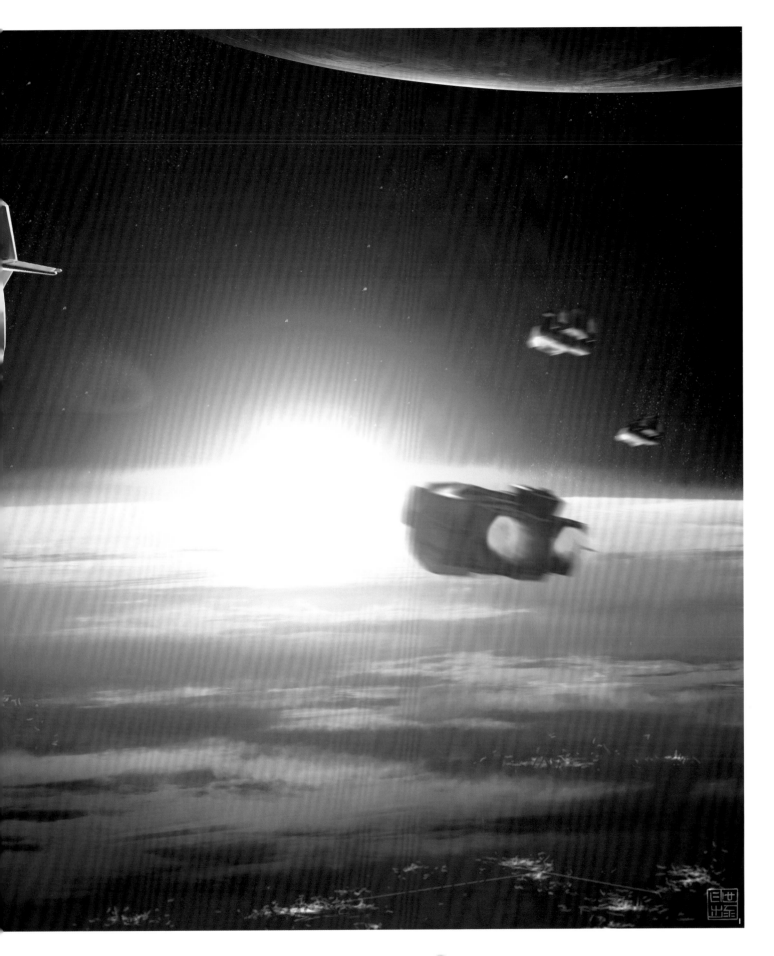

(i) Star Fall

Lorenz Hideyoshi Ruwwe | Vehicle | 2011 | Commercial work

A drop ship design for the short CG film "Star Fall" by Louis Boka and Ferdinand Reginensi

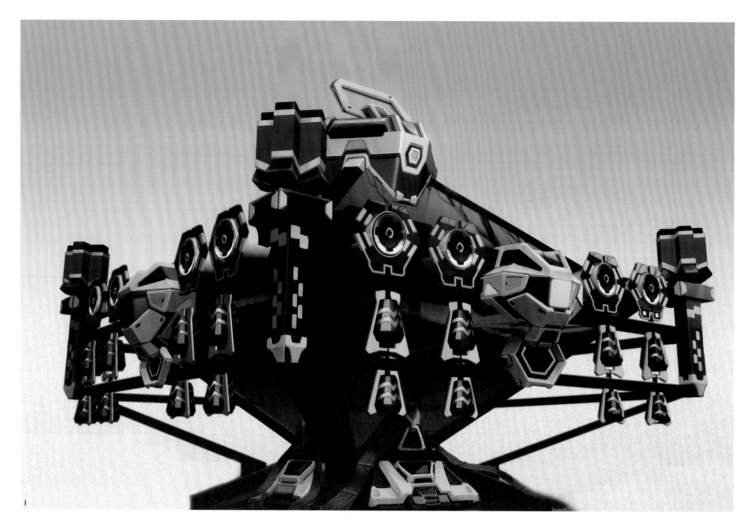

① Musical Nest

Mad Jojo | Mechanical tool | 2012 | Personal work

The device can be used to emulate a wide range of percussion instruments through switching modes. Exaggerated chimes, combined with special padding which changes into liquid or solid medium through increased or decreased pressure produces an amazing sound effect

② Count

Mad Jojo | Mechanical tool | 2012 | Personal work

Spherical AI in school lab can assist students learning. Students with outstanding performance in math are all members of the Engineering Club. Some students, having already taught themselves the courses, will go to the lab to use the facilities and software programmed by the Language Club to design their favorite engines and machinery

③ Machine Hound: Mr. Bark

Mad Jojo | Mechanical tool | 2012 | Personal work

The robot dog was originally intended to take part in field search and rescue. After being replaced by an updated model, it is now responsible for collecting bows launched in the archery class

④ Autumn Crabapple

Mad Jojo | Vehicle | 2012 | Personal work

Autumn Crabapple is the champion in the First Bender Racing Contest

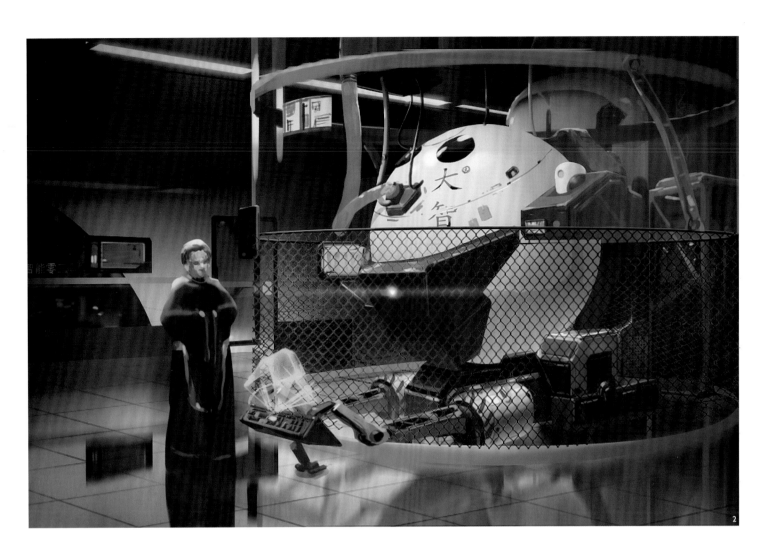

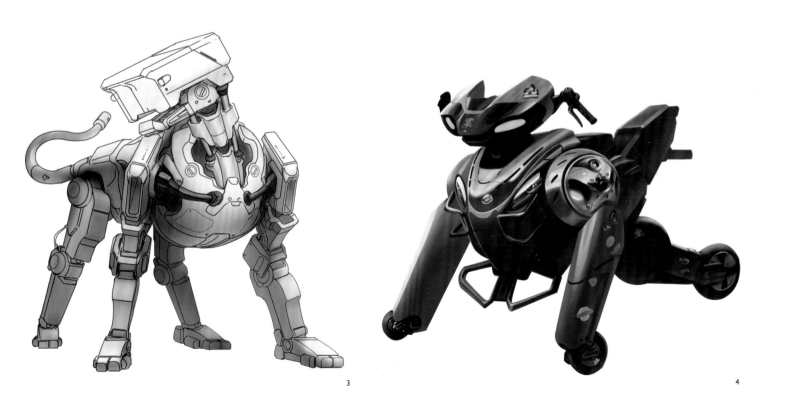

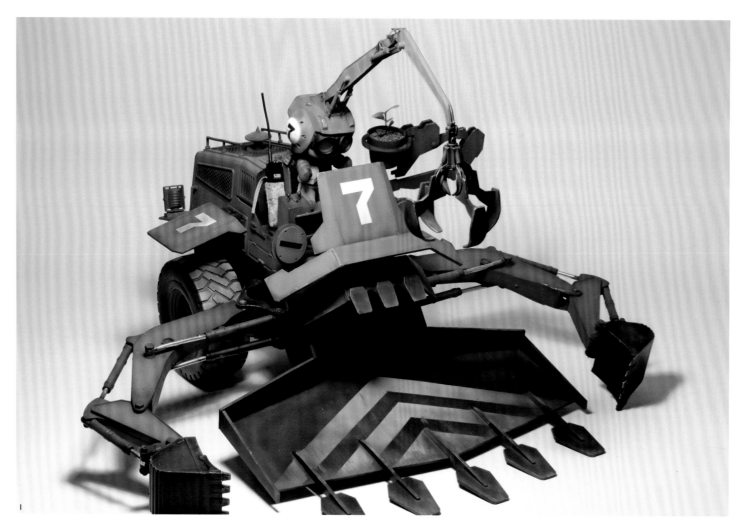

1

① **Trash Devourer: Monkfish Monster**

Mamax | Mechanical tool | 2011 | Personal work

A mechanical beast used to recycle heavy metals and toxic materials and transform them into safe, clean resources

② **Thunder Scorpion**

③ **Mamax | Mechanical tool | 2006 | Personal work**

A former Soviet Union counter-attack weapon, only subject to the control of the ultra-capable

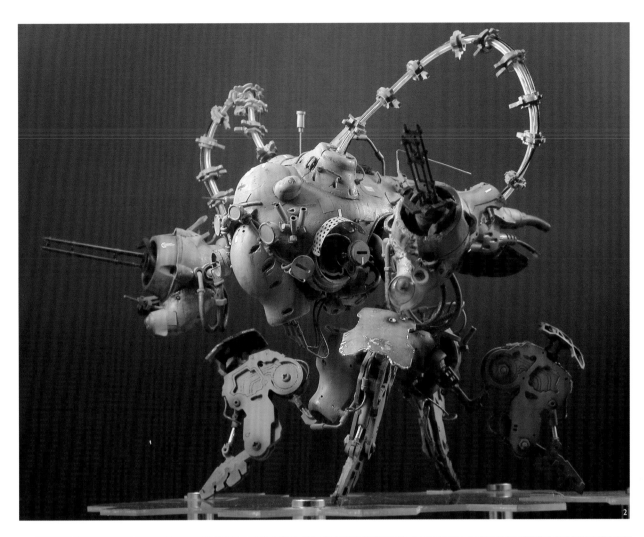

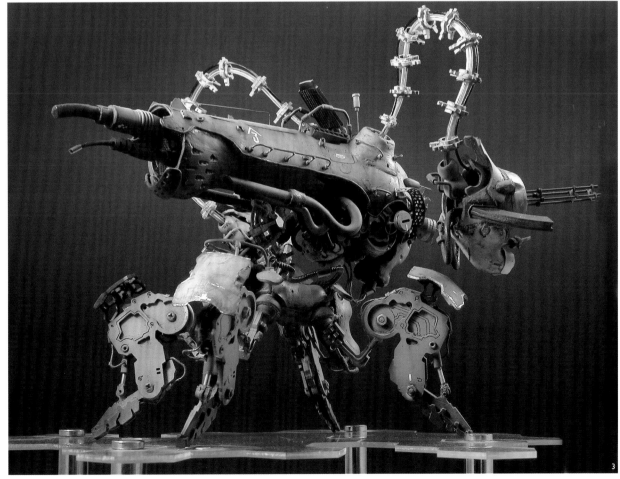

ⓘ **Moonlanding Knights: Sea Dragon Regiment**

Mamax | Mechanical tool | 2011 | Personal work

The first batch of conquerors sent by a
European country to the moon in a space race in
the Middle Ages

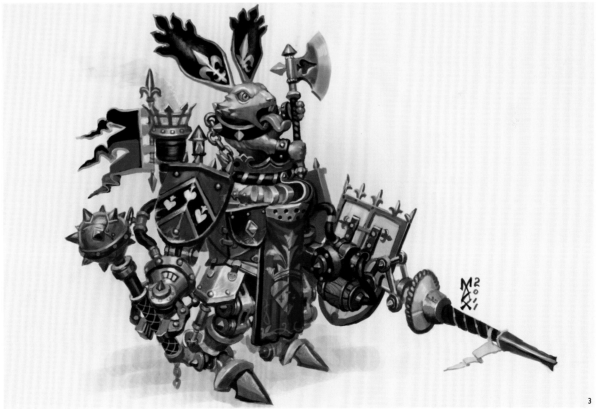

2 **International Chess: Knight**
Mamax | Mechanical tool | 2011 | Personal
work

One of the European Knight chariots in a
Middle Ages world war

3 **Gold Radish**
Mamax | Mechanical tool | 2011 | Personal
work

A battling machine adapted and driven
by Goblins to confront forest trolls

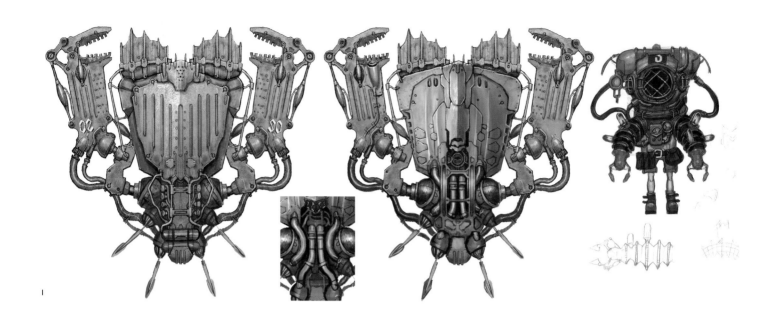

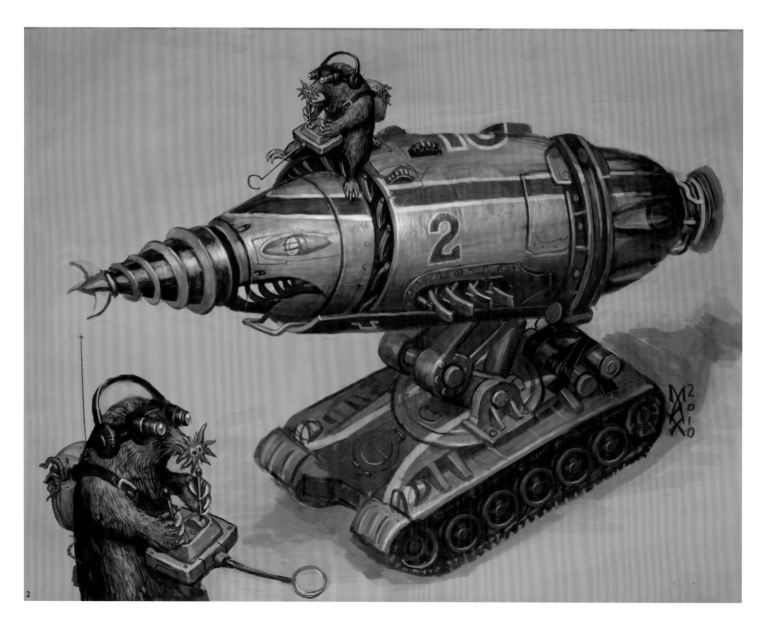

1. **Clawed Crabs**
 Mamax | Mechanical tool | 2009 |
 Personal work

 A machine constructed underwater by Eurasian countries which can work on land with the addition of legs to the base plate

2. **Mole Digger**
 Mamax | Mechanical tool | 2011 |
 Personal work

 A digger for tunnel construction and underground transportation controlled by star-nosed moles

3. **Automatic Bridge**
 Saturnian | Mechanical tool | 2011 |
 Personal work

 Automatic Bridge is a bridging machine with deployment capacity. When folded, it can walk on two feet, which makes it easy to adjust gestures in the construction process. It is such a giant that it cannot be accommodated by common roads. Therefore, it must be transported over long distance by large helicopters

3

4. **Wooden Oxes and Gliding Horses**
 Saturnian | Mechanical tool | 2011 |
 Personal work

 Wooden oxes and gliding horses are four-legged automatic walking vehicles used for medium-distance or long-distance transport. They can act as energy-saving SUVs. These two vehicles are deliberately narrow in width so they can move easily in narrow paths

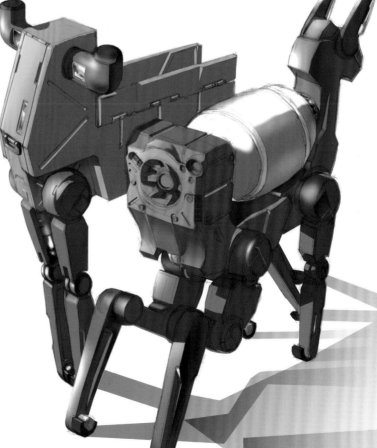

4

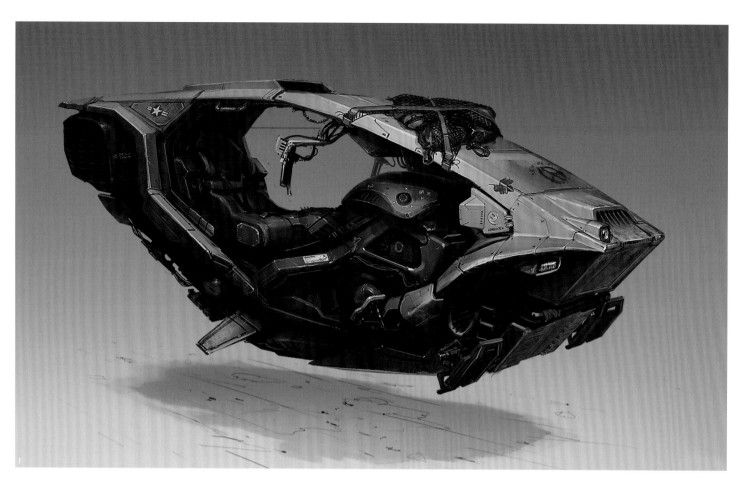

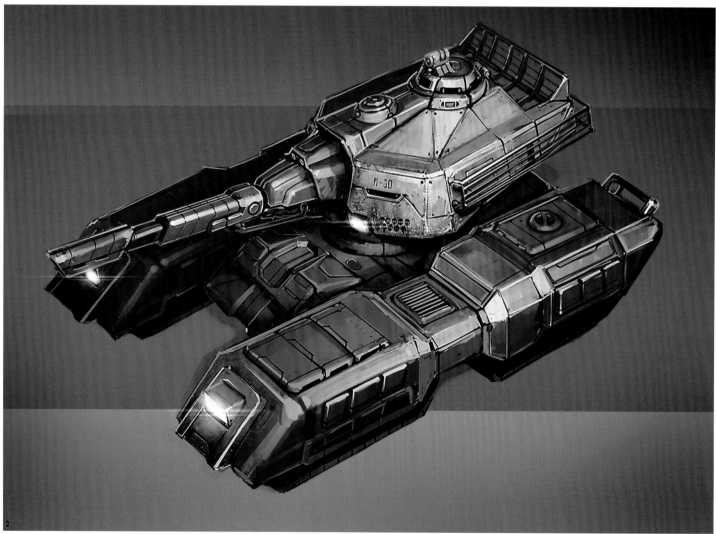

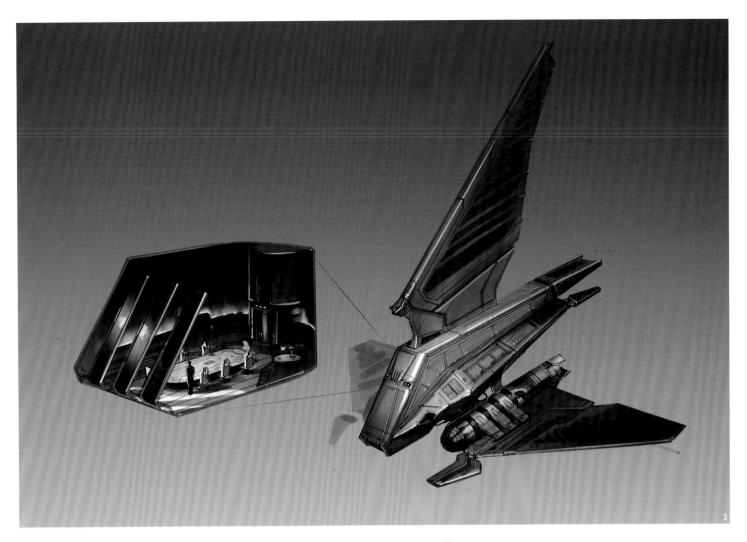

① Wasteland Skiff

Aaron Whitehead | Vehicle | 2012 | Personal work

The luggage strapped on top of the roof, the obsolete front window, the crude display, and the camera fed on the nose add a lot of character and richness to the design

② MBT-80 Titan Tank

Aaron Whitehead | Vehicle | 2011 | Personal work

I've always loved Zhu Feng's artwork, and I have watched pretty much every tutorial video he has ever produced. I think this tank was the product of a very FZD tutorial heavy weekend

③ Imperial Senator's Vessel

Aaron Whitehead | Vehicle | 2012 | Personal work

The brief with this particular piece was to design a Star Wars vehicle. I chose to do an imperial senator's personal vessel, before the Emperor purged the Senate. I wanted it be immediately recognizable as something that belonged in the Star Wars universe, but with a unique twist

1. **A Brave New World**

 Alex Figini | Vehicle | 2012 | Personal work

 I wanted to create a scene at sunset as I wanted to have both warm and cool tones. It was fun playing about with the industrial elements in the foreground as well as the more abstract floating structures in the distance

2. **Spider Mech**

 Alex Figini | Vehicle | 2009 | Personal work

 This is a lunchtime speed painting. It is of a dusty Arabic market street with the looming spider mech as a focal point

3. **Police Mech Standoff**

 Alex Figini | Vehicle | 2011 | Personal work

 This is also a speed painting I did at lunchtime. Due to the time constraints, this is partly an experiment in using photos to quickly create a convincing mecha

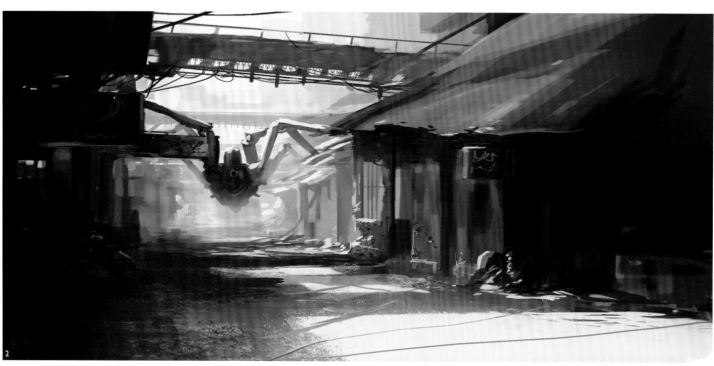

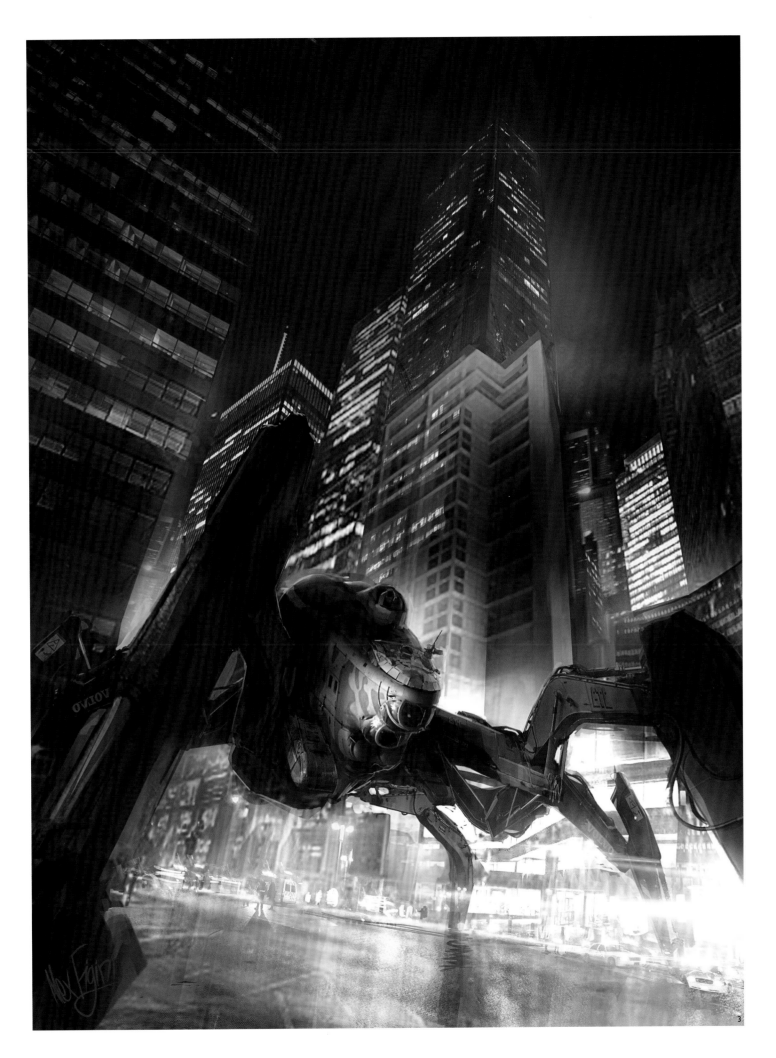

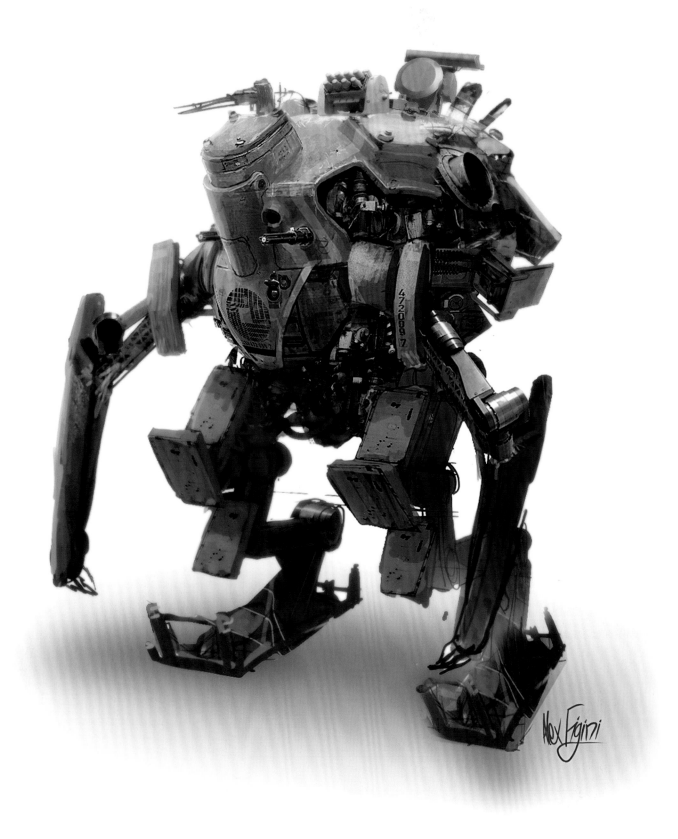

① **Rusty Mecha**

Alex Figini | Robot | 2011 | Personal work

This is another speed painting that goes a little further. It is an experiment in using images of machinery to introduce believable elements to a mechanical design

② **Hopper Bot**

Ben Mauro | Vehicle | 2011 | Personal work

This is some sort of vehicle that I imagined being used in some sort of post-apocalyptic setting. I imagined the vehicle could jump and glide long distances with its large robotic legs and its thruster engines located in the back

③ **Processor Bot**

Ben Mauro | Vehicle | 2011 | Personal work

This vehicle belongs to the same series with the Hopper Bot, though I imagined this vehicle's function was mainly collecting and processing trash and junk in the lower sector of some post-apocalyptic future city

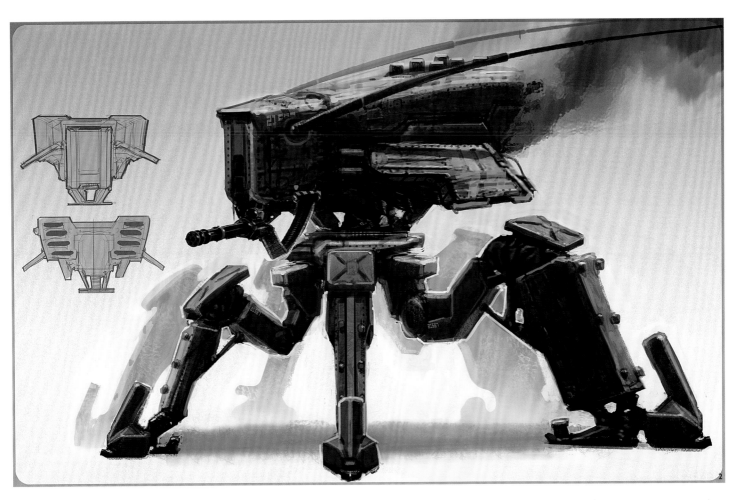

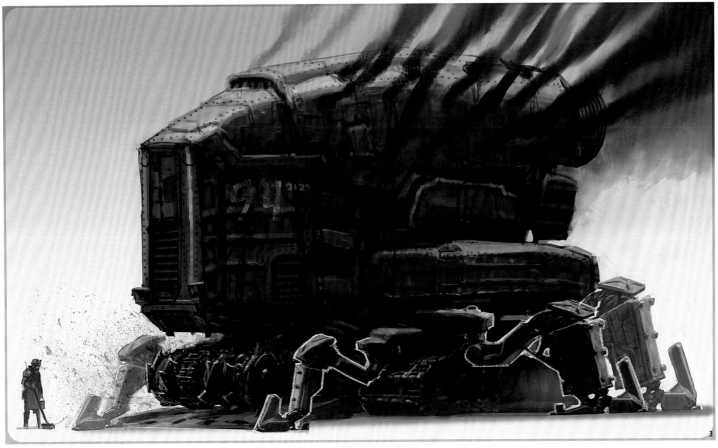

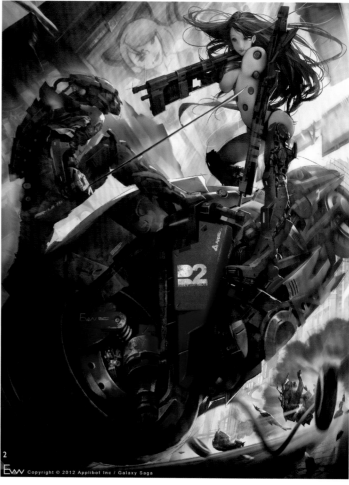

Copyright © 2012 Applibot Inc / Galaxy Saga

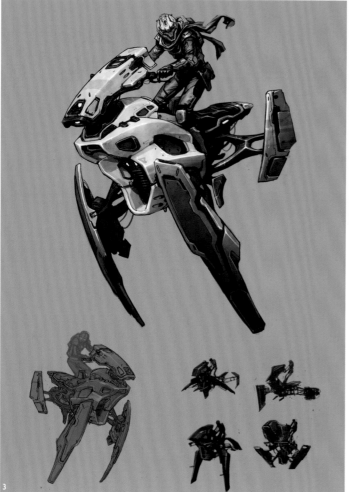

Copyright © 2012 Applibot Inc / Galaxy Saga

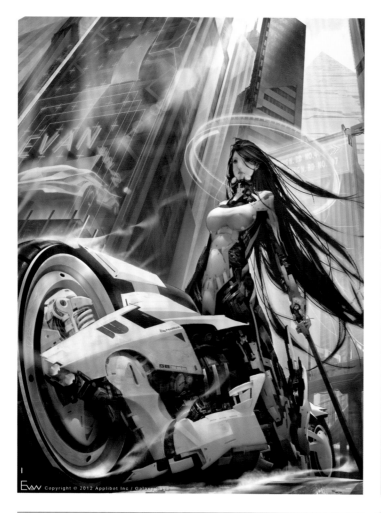

① **Swift Sleipnir**

Evan Lee | Vehicle | 2013 | Personal work

This primitive version of Swift Sleipnir employs a sharp contrast in perspective to highlight the explosive power of this heavy-duty mobile. White smoke around the wheels and axles capture the moment the vehicle comes to a halt from high-speed

② **Swift Sleipnir (advanced version)**

Evan Lee | Vehicle | 2013 | Personal work

This advanced version of Swift Sleipnir depicts a battle with a soldier armed with a samurai sword on an expressway in an outer city. An explosion from the rear throws the machine into the air, producing a vertical drawing space to capture the whole picture of the vehicle

③ **Arctic Speeder**

Kory Lynn Hubbell | Vehicle | 2012 | Personal work

The speeder is intended for use on frozen environments, including those lacking atmosphere. The thrusters can also fold down to form skis depending on the needs of the pilot. This particular rig is suitable for exploration on the moon Europa

④ **Rocha Exo-suit 02**

⑤ **Matthew Burke | Vechicle | 2012 | Personal work**

Manned combat exo-suit designed to leap a distance of five to eight miles. The Rocha Exo-suit is equipped with four stabilizing engines to navigate while airborne so each landing is level

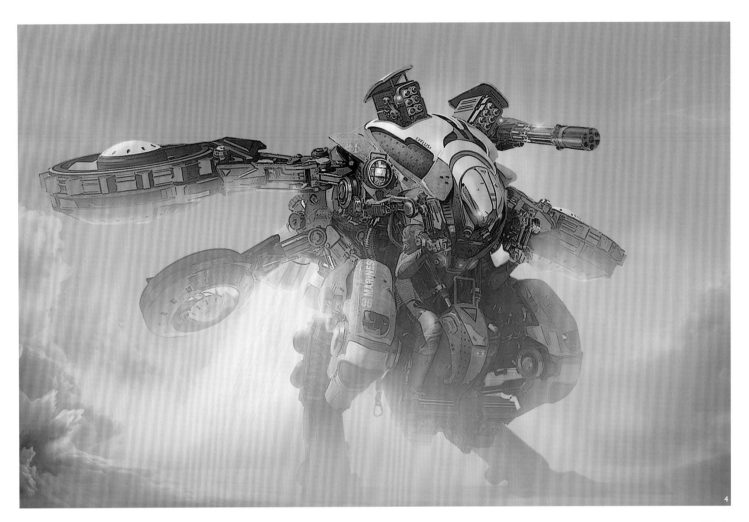

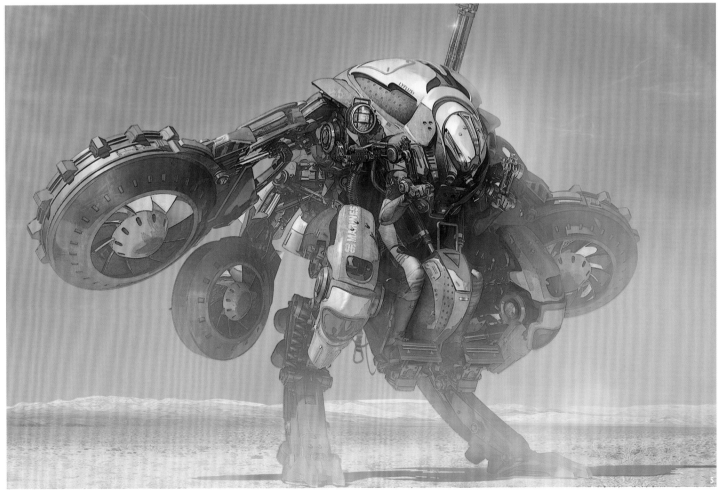

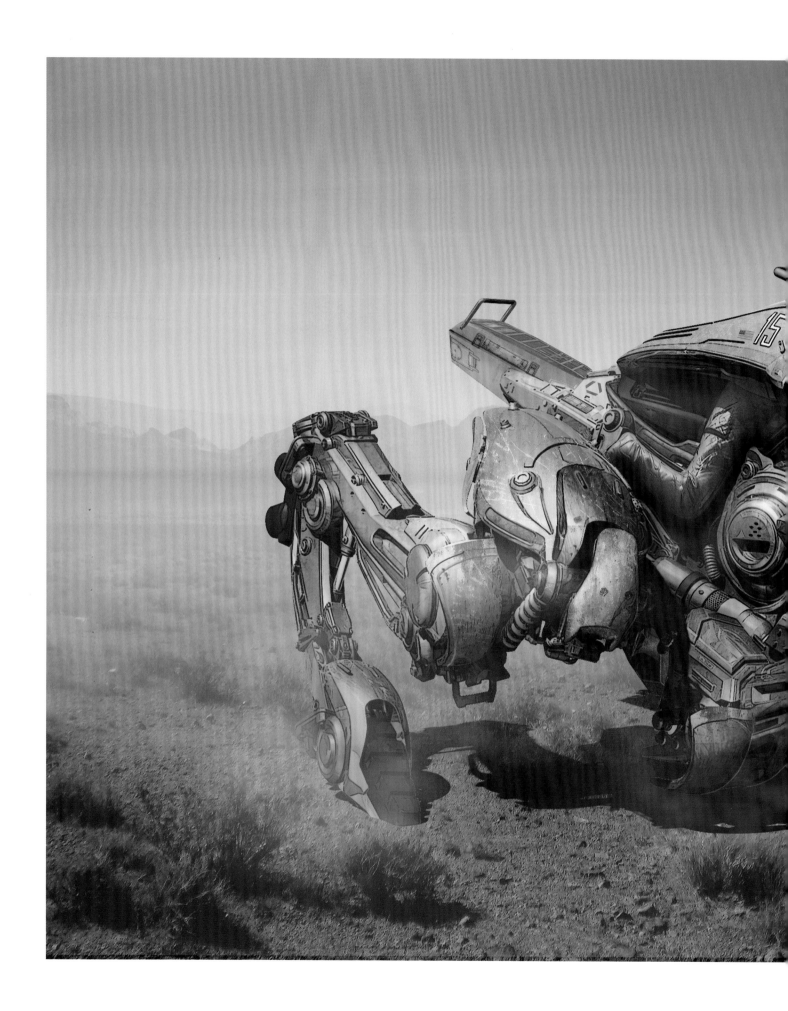

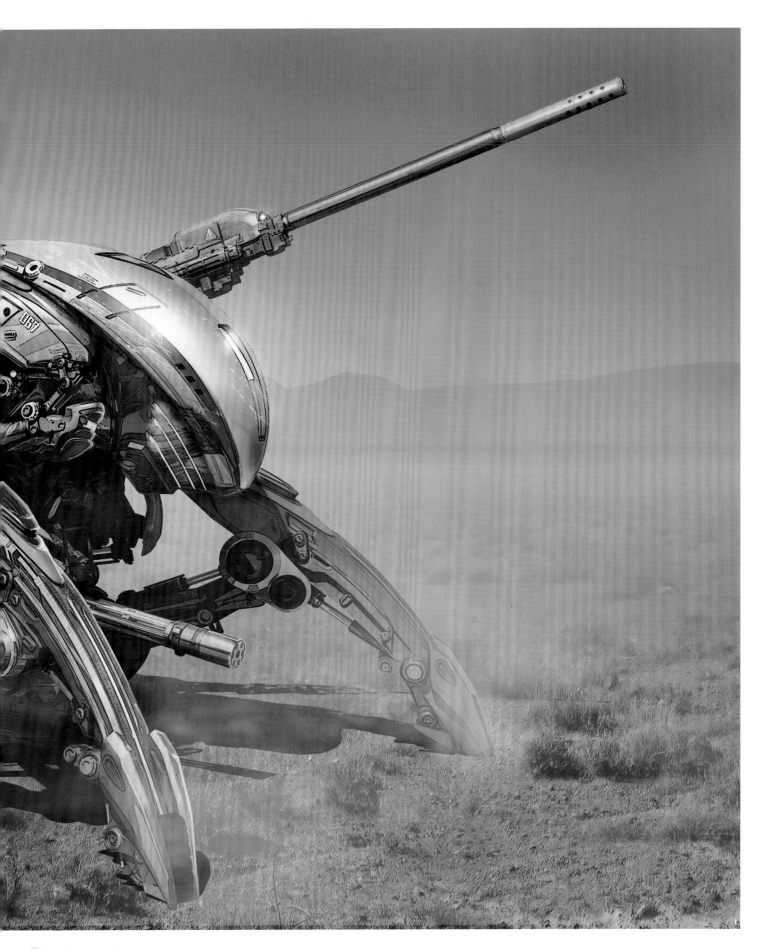

ⓘ **Cricket Exo-suit**

Matthew Burke | Mechanical tool | 2012 | Personal work

It is designed to be a fast quadruped runner. What it lacks in armoured defense, it makes up for speed and versatility. Its massive sniper cannon can hit the target several miles away with pinpoint accuracy. A combination of limited leaping ability and the flexibility to climb makes the Cricket Exo-suit a valuable asset on any battlefield

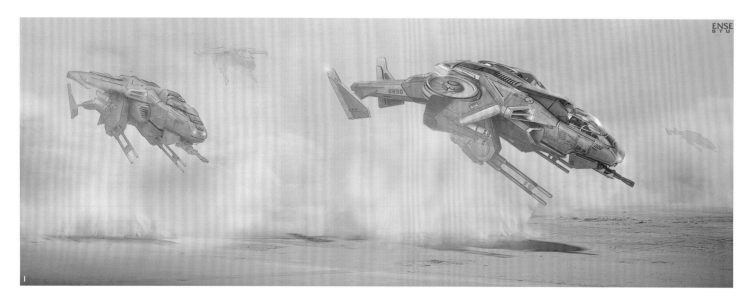

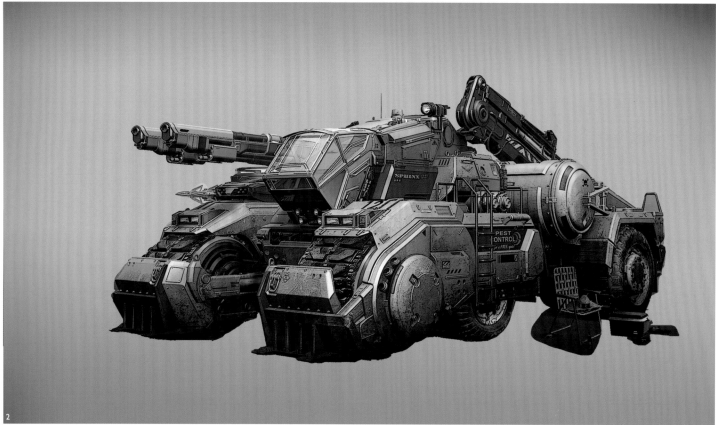

① **Halo Sparrowhawk**
Matthew Burke | Vehicle | 2008 |
Commercial work

The image depicts a squadron of UNSC Sparrowhawks flying low over the desert. This image was also released as featured wallpaper for the game "Halo Wars"

② **Infestation Vehicle**
Matthew Burke | Vehicle | 2011 |
Personal work

This work features an interplanetary pest control vehicle equipped with an arsenal of weapons to deal with a variety of alien pests that have overrun outposts on several worlds

③ **Infantry Chariot: Foxy Monkey**
Stephen | Vehicle | 2009 | Personal work

The Foxy Monkey is a transformative, mobile fortress, providing soldiers better protection. Multiple behavioral modes can be switched on in response to various environments and for different purposes

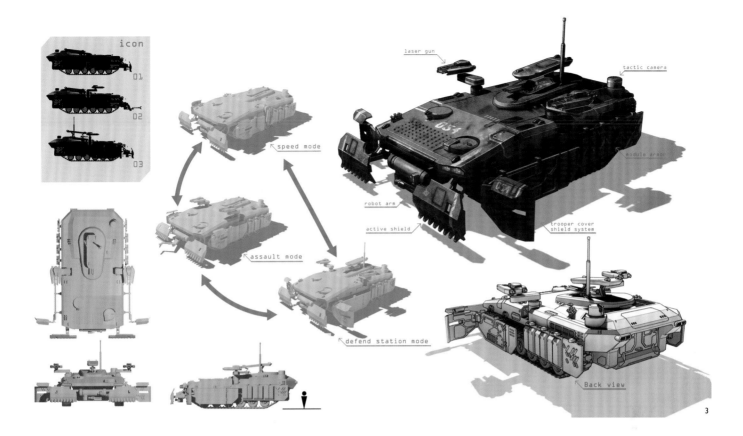

speed mode

laser gun

tactic camera

robot arm

active shield

module armor

assault mode

trooper cover
shield system

defend station mode

Back view

3

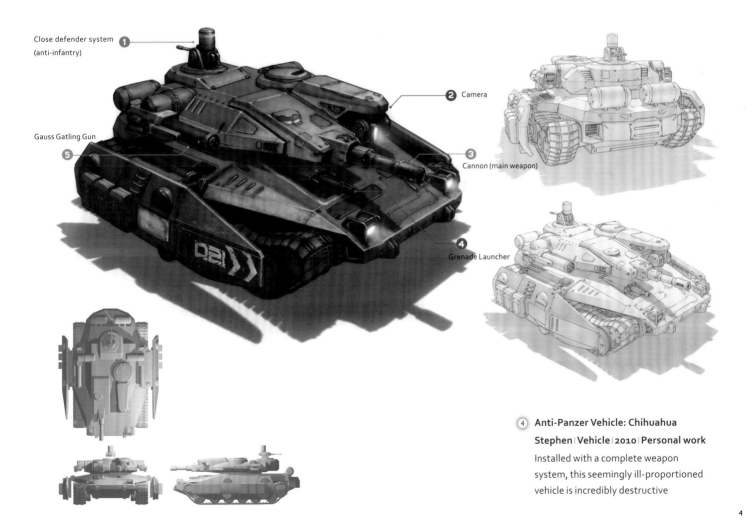

Close defender system
(anti-infantry)

1

2 Camera

Gauss Gatling Gun

5

3

Cannon (main weapon)

4

Grenade Launcher

4 **Anti-Panzer Vehicle: Chihuahua**
Stephen | Vehicle | 2010 | Personal work
Installed with a complete weapon
system, this seemingly ill-proportioned
vehicle is incredibly destructive

4

① **PF Guard Station**
Michal Lisowski | Vehicle | 2010 |
Personal work

This work features Station of Bay
Guardians somewhere in the near future,
with office, ramp, dry-dock and technical
office

② **XBOOT Wunderwaffe**
Michal Lisowski | Weapon | 2010 |
Personal work

Vision of the Nazi's wunderwaffe,
some kind of U-boat redesigned into a
spaceship

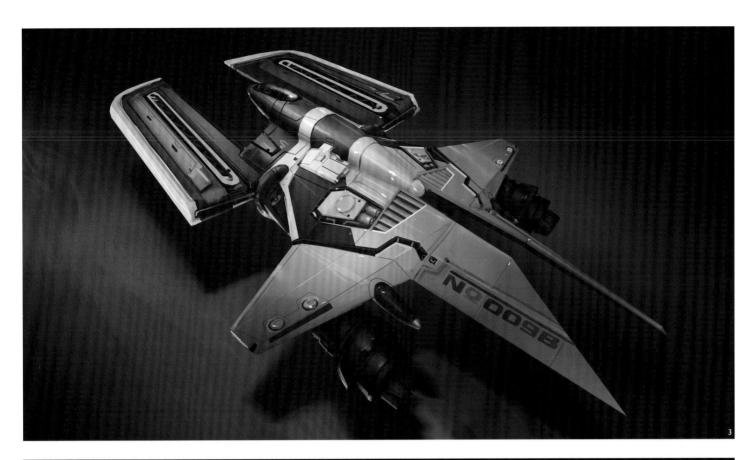

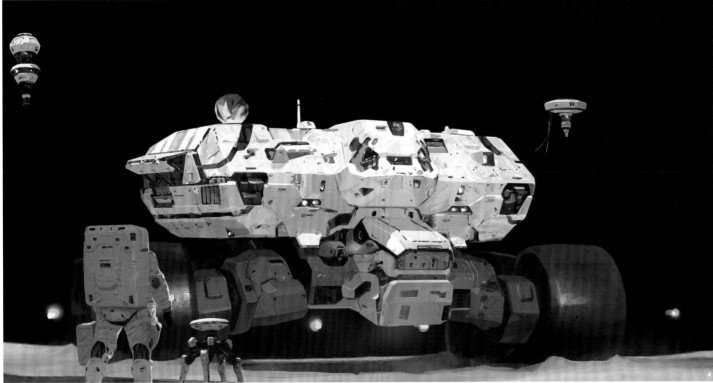

③ **Spaceship**
Michal Lisowski | Vehicle | 2010 |
Personal work
Ship fighter concept from my "Spaceships" series; a small two-seat offensive fighter

④ **Lunar Ranger**
RD | Vehicle | 2012 | Personal work
Illustration for an individual comic

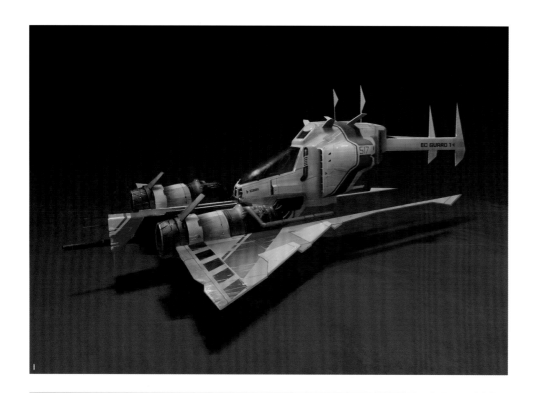

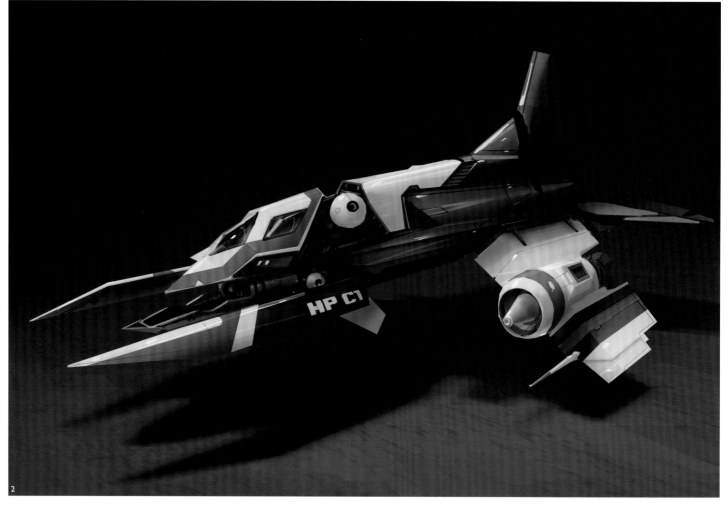

① **Repair Unit**
Michal Lisowski | Vehicle | 2010 |
Personal work

Ship concept from my "Spaceships" series; a two-seat supporting repair unit. The inspirtion came from today's helicopters' design

② **Heavy Fighter**
Michal Lisowski | Vehicle | 2010 |
Personal work

Heavy fighter concept from my "Spaceships" series; a one-seat heavy unit

③ **Capital Tank**
④ **Stephen | Vehicle | 2010 |**
Personal work

The sample capital tank from the Antodora Lab is installed with an unmanned turret and a self-defense system

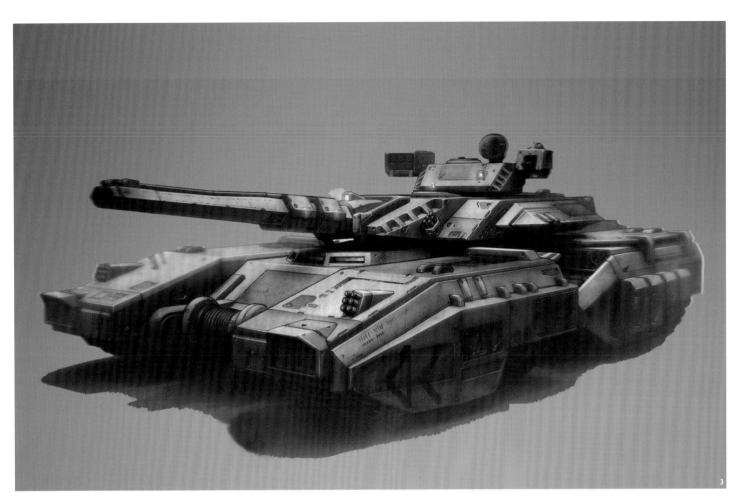

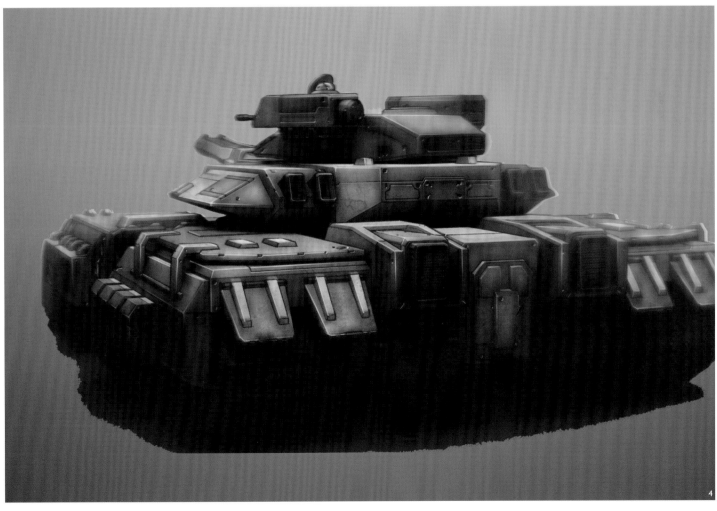

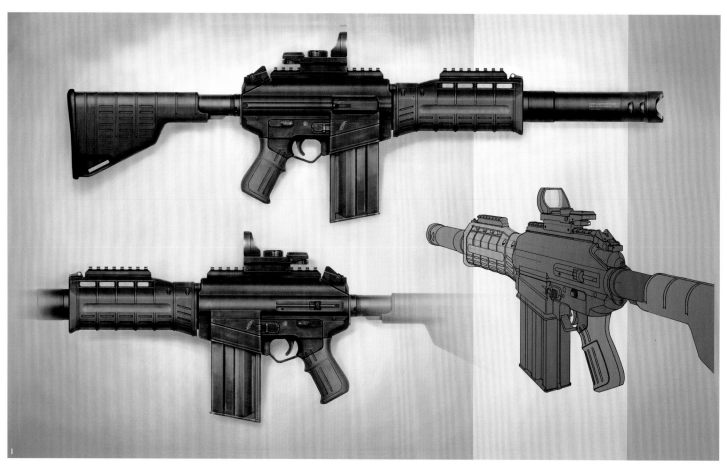

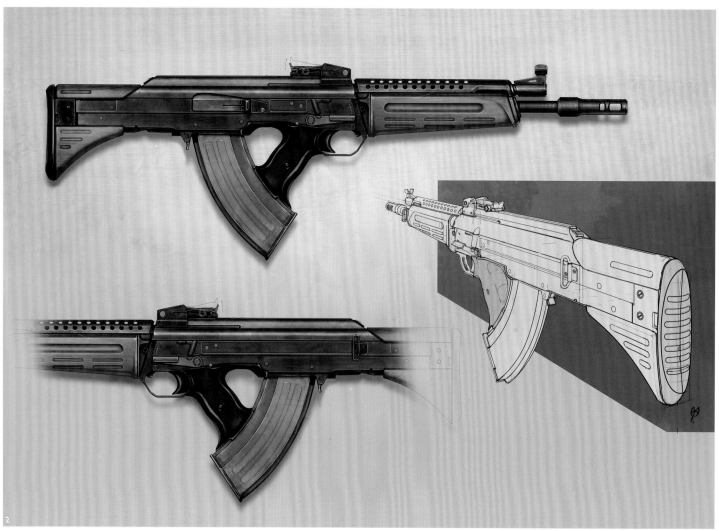

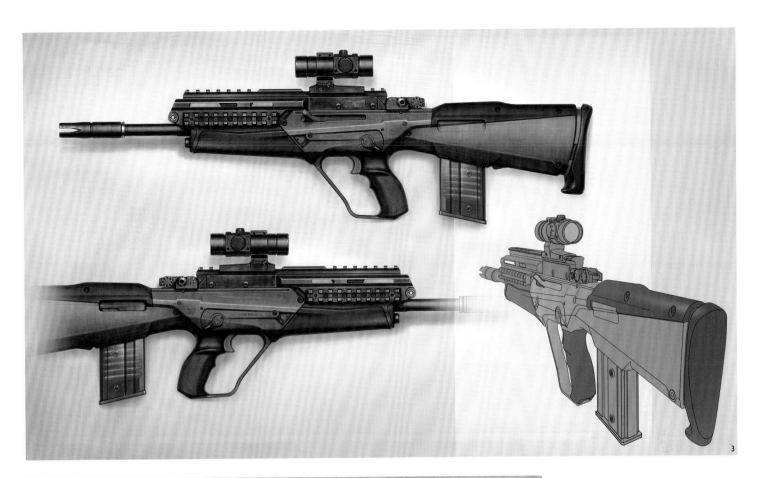

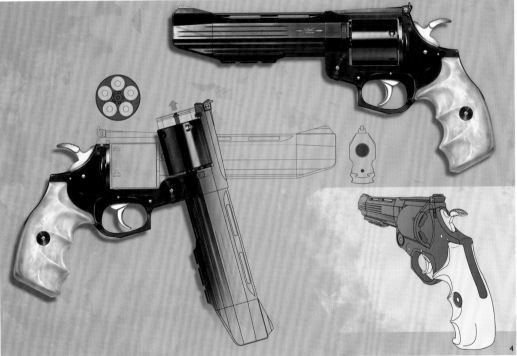

① **Auto Shotgun**
 Timur Mutsaev | Weapon | 2007 |
 Commercial work
 Automatic shotgun for the "Redemption"
 game project

② **RBP**
 Timur Mutsaev | Weapon | 2007 |
 Commercial work
 Automatic rifle, bullpup layout; for the
 "Redemption" game project

③ **SKP ELRifle**
 Timur Mutsaev | Weapon | 2007 |
 Commercial work
 Automatic rifle, bullpup layout; for the
 "Redemption" game project

④ **BMRevolver**
 Timur Mutsaev | Weapon | 2007 |
 Commercial work
 Five-shot revolver, for the "Redemption"
 game project

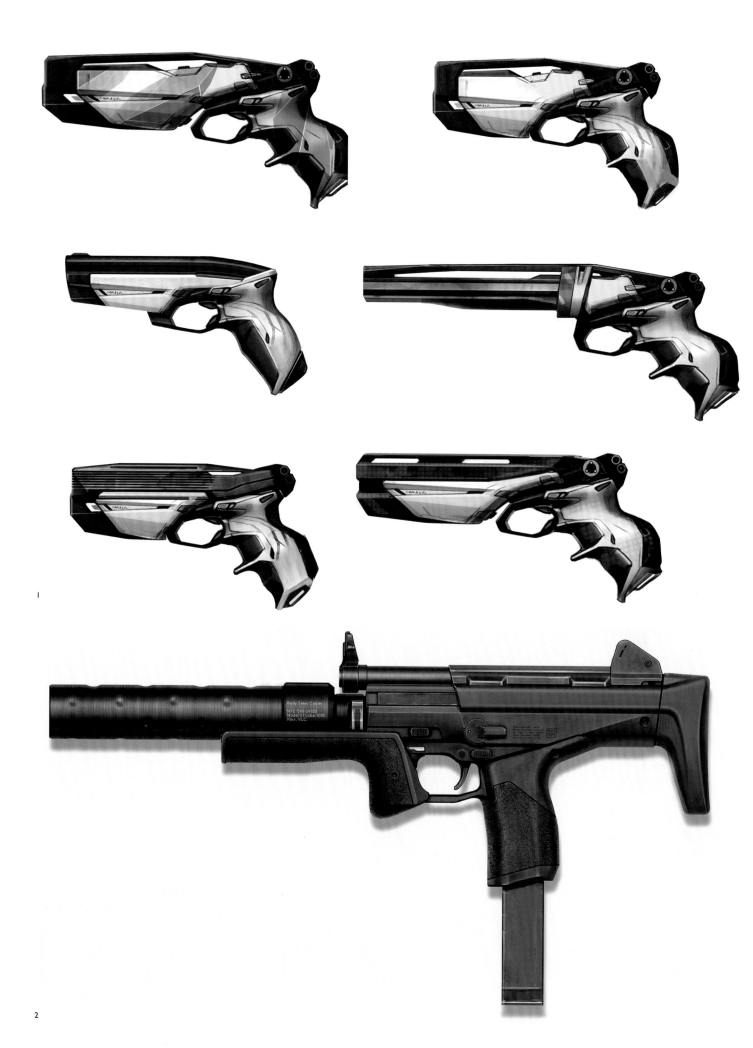

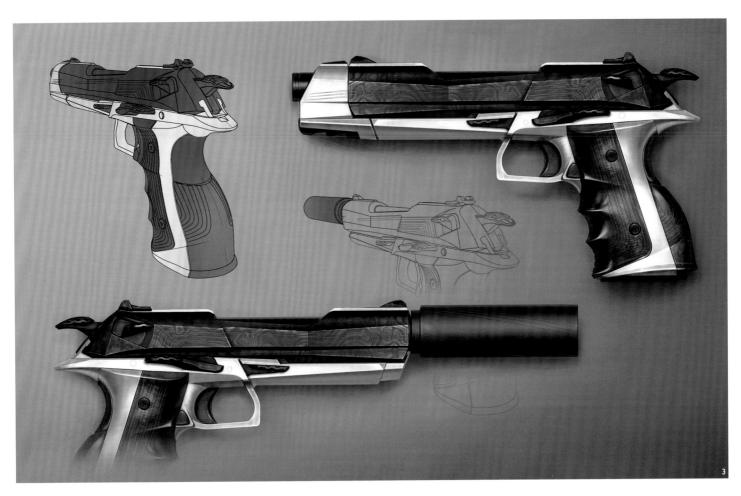

① Pistol C20

Timur Mutsaev | Weapon | 2012 | Personal work

It is a small plasma gun, so one of the characters could carry it around and shoot things

② ELSMG

Timur Mutsaev | Weapon | 2007 | Commercial work

Machine gun, SMG class with a silencer; for the "Redemption" game project

③ Rand's Signature Pistol

Timur Mutsaev | Weapon | 2007 | Commercial work

It is for the "Redemption" game project; it is a very powerful gun for the main character of the game

④ Police Pistol

Timur Mutsaev | Weapon | 2007 | Commercial work

Police gun for the "Redemption" game project

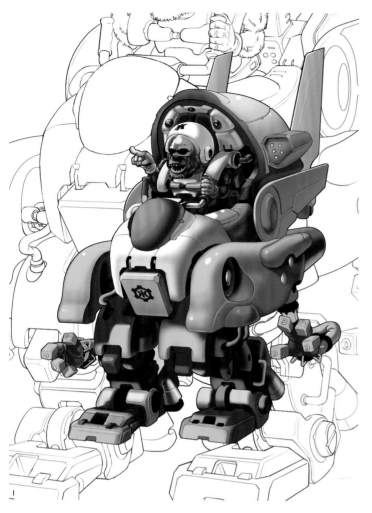

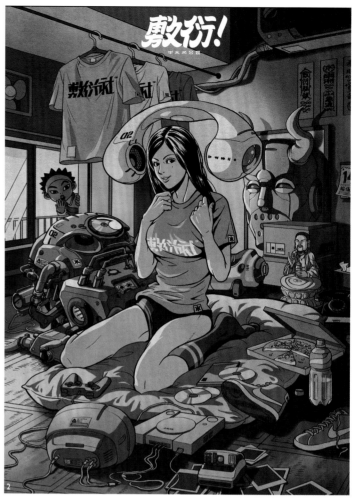

① **Waterborne Robot**

Nico | Vehicle | 2010 | Personal work

A vehicle capable of transforming into a small-sized submarine

② **House Girl**

Nico | Mechanical device | 2009 | Personal work

An experiment with a new coloring style, and an incidental integration with machinery

③ **A House-warming Gift**

X2R | Mechanical device | 2011 | Personal work

This illustration adopts the ancient comic style, and incorporates the Heavenly Stems, Earthly Branches and the twelve zodiac signs

④ **West-bound Machinery**

⑤ X2R | Mechanical device | 2011 | Personal

⑥ work

A sci-fi version of *Journey to the West*

⑦ **Mechanical Soul**

X2R | Mechanical device | 2011 | Personal work

A mechanical rendering

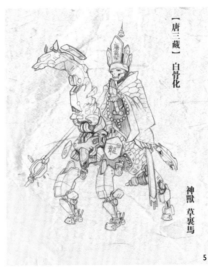

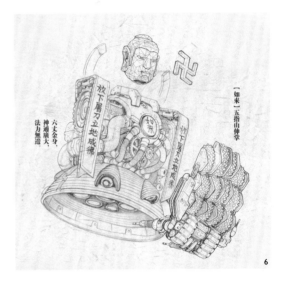

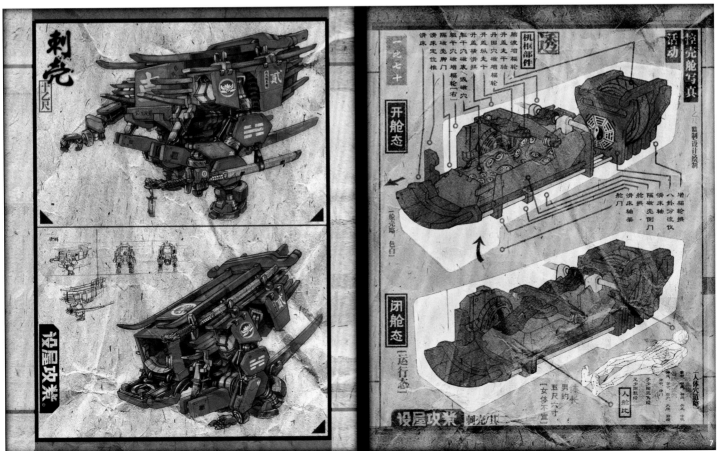

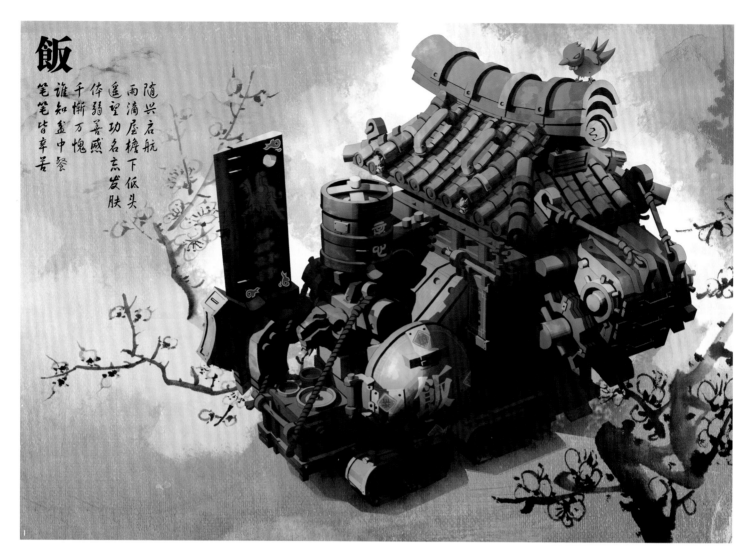

飯

随兴启航
雨滴屋檐下低头
遥望功名忘发肤
体弱善感
千惭万愧
谁知盏中餐
笔笔皆辛苦

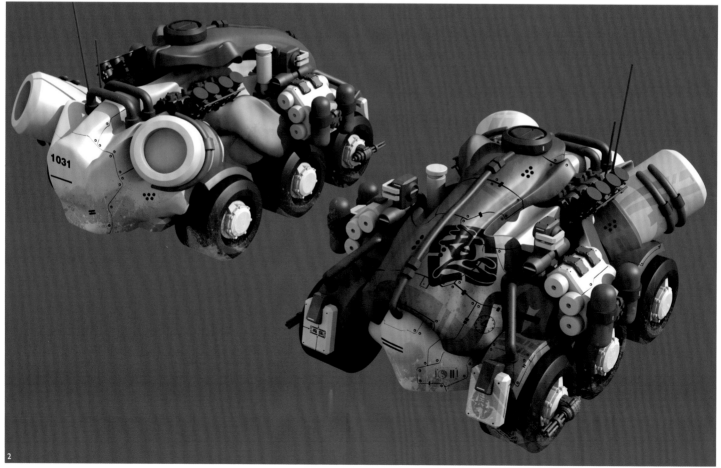

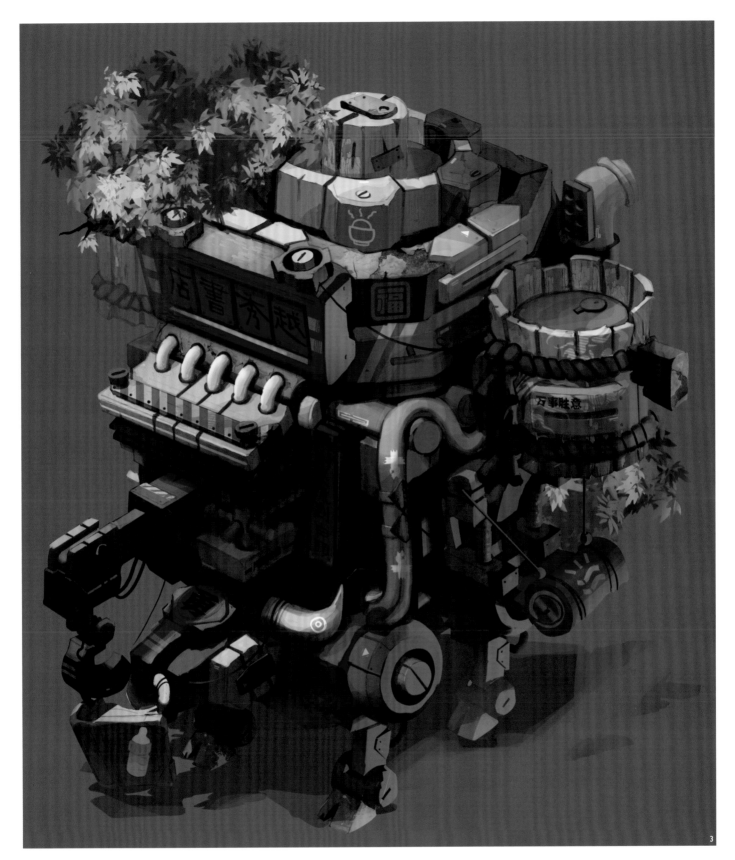

① **Dragon Gate Restaurant**
Lao De | Vehicle | 2011 | Personal work
An advanced version of a roadside stand

② **Fatty Ben**
Lao De | Vehicle | 2010 | Personal work
A troop crawler imitating Kow Yokoyama's style

③ **A Farmer's Store**
Lao De | Vehicle | 2011 | Personal work
Users of this mobile residence & store do not need to settle down somewhere for work

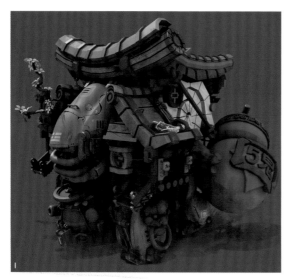

1. **A Traveling Orangutan**
2. **Lao De | Vehicle | 2010 | Personal work**
 A doctor's residence and clinic

3. **Defensive Armour**
 Wang Chao | Robot | 2012 | Personal work
 The artist references some modern military equipment for color palette and detail to produce this quasi-futuristic machine rendering

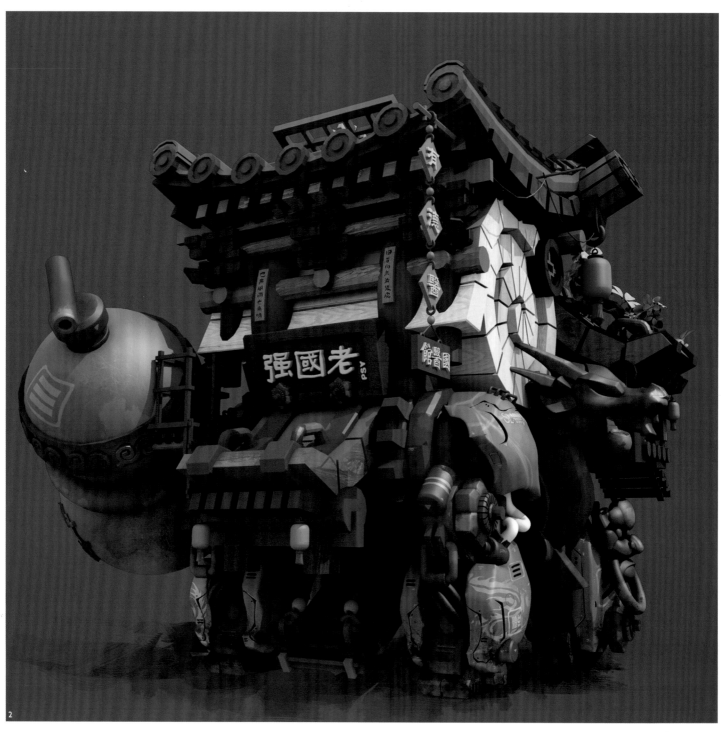

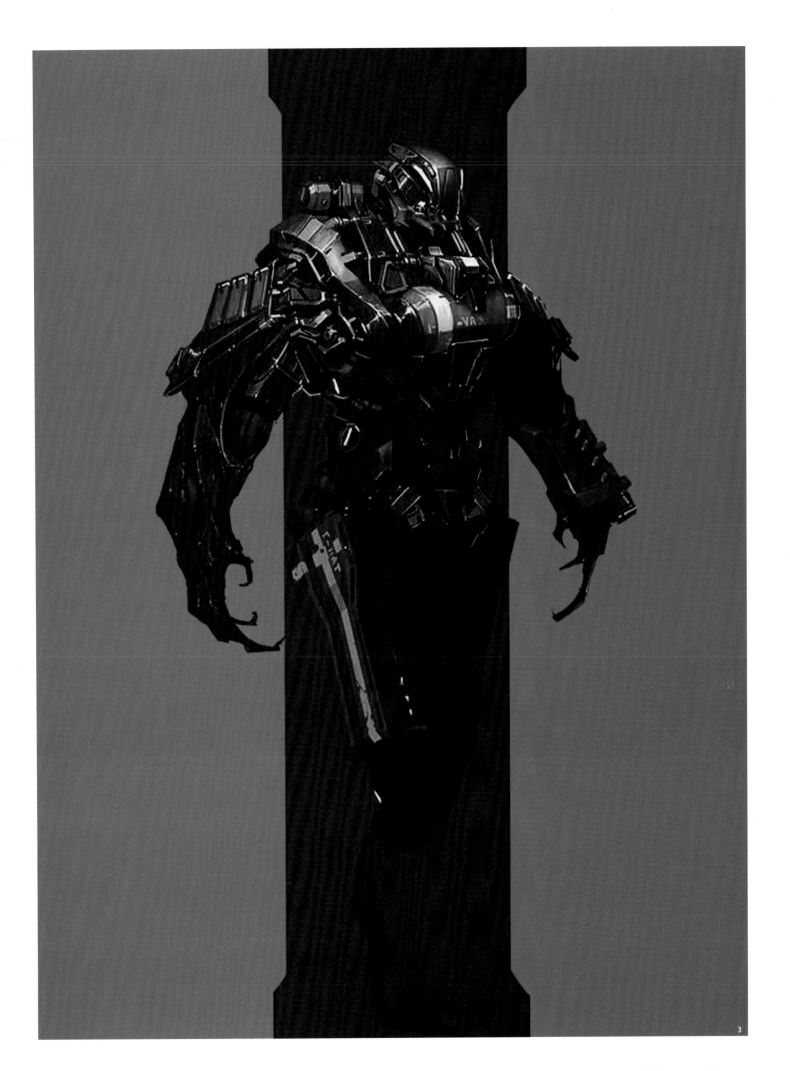

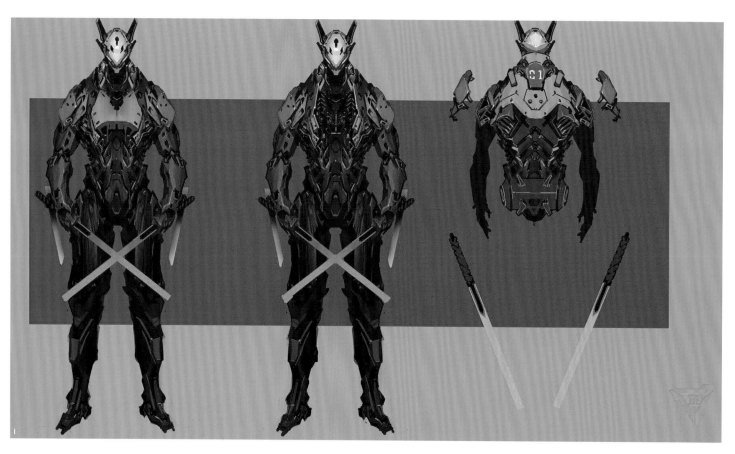

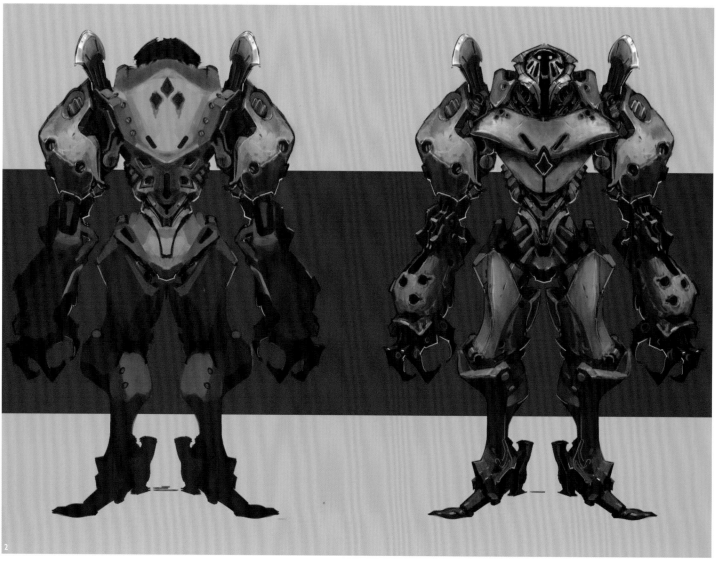

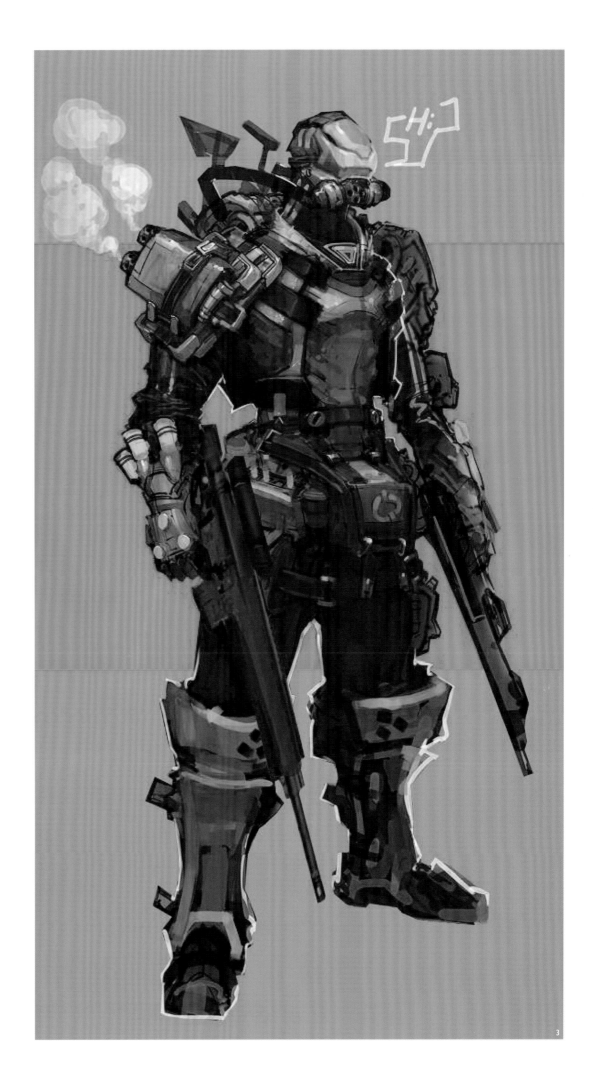

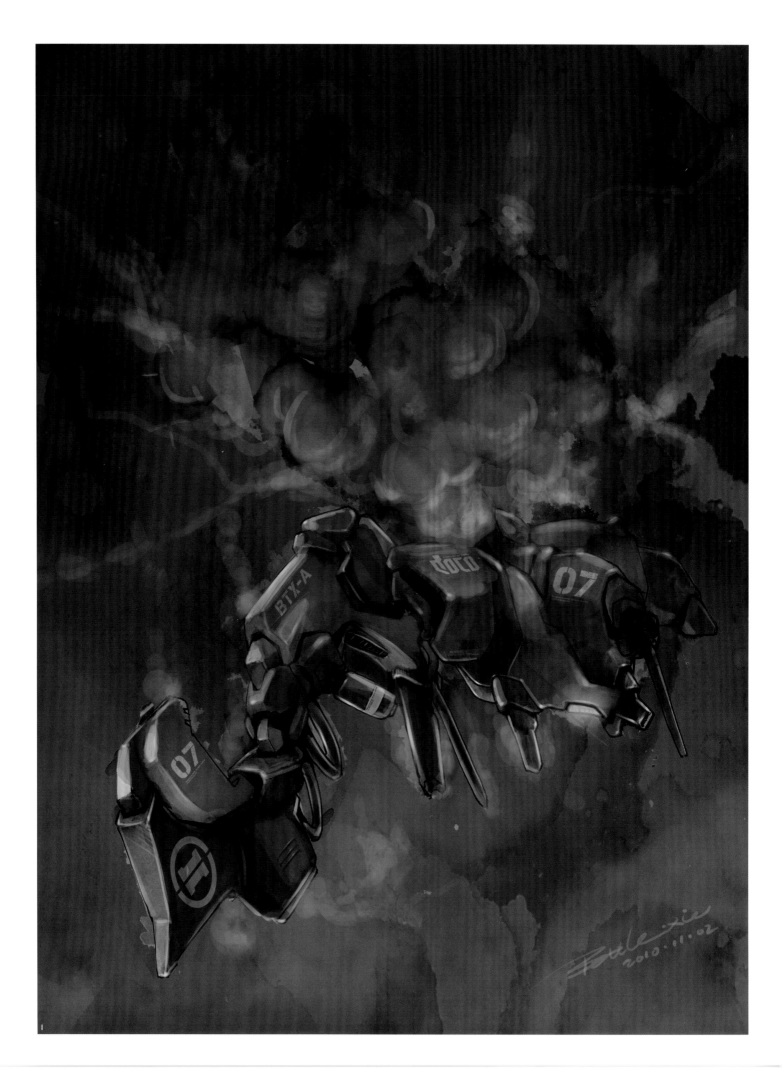

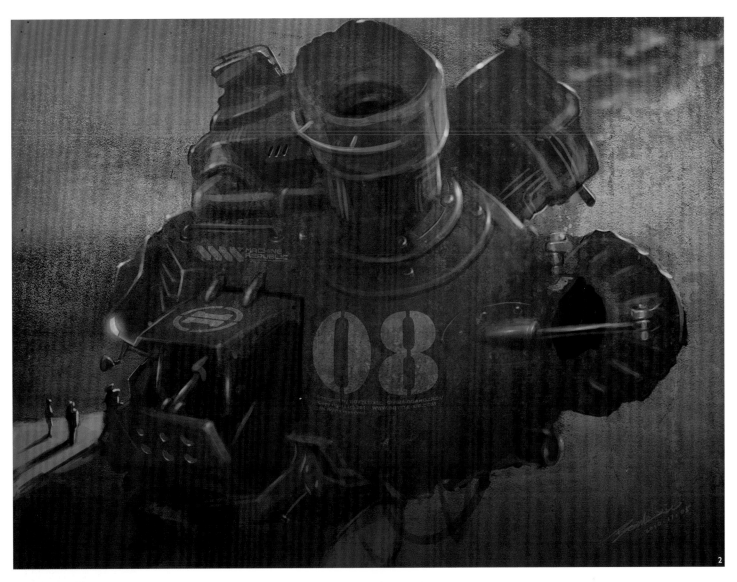

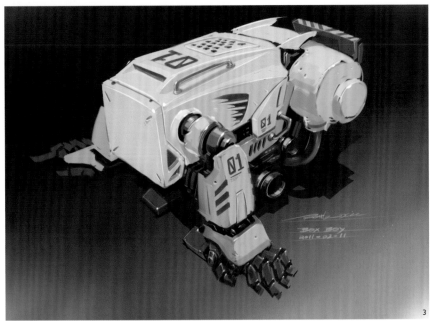

1. **Explosion**

 Xie Yunzhang｜Robot｜2010｜Personal work

 Before the production process, I first applied ink on paper to generate natural spread to obtain an organic shape, out of which this illustration has been developed

2. **No. 8 Airship**

 Xie Yunzhang｜Robot｜2010｜Personal work

 No. 8 Airship is based on rust stains from photos, with details added out of imagination

3. **Box Boy**

 Xie Yunzhang｜Robot｜2011｜Personal work

 A cooperative project with mechanical renderer C9, intended as an interesting mechanical form with more industrial elements

① Iron Cock

② Xie Yunzhang | Mechanical model | 2011 | Personal work

This work was finished for a shoe transformation project hosted by Royal Elastics, an Australian sneaker brand

③ Arcade Mover

Xie Yunzhang | Mechanical model | 2012 | Personal work

At the invitation of the Guangzhou Ancient Arcade Protection Team, I participated in the creation of this 3.0 arcade protection exhibition. This is my work for this exhibition

④ Arm

⑤ Xie Yunzhang | Mechanical model | 2008 | Personal work

This work features a combination of photography and machine rendering. The original intention was to produce a tool for photography which can be worn on the wrist. Distinct from industrial sculpture cluttered with wasted and worn parts, my work is more about dynamic design and demonstrates the range of joint movement and subjectivity to force

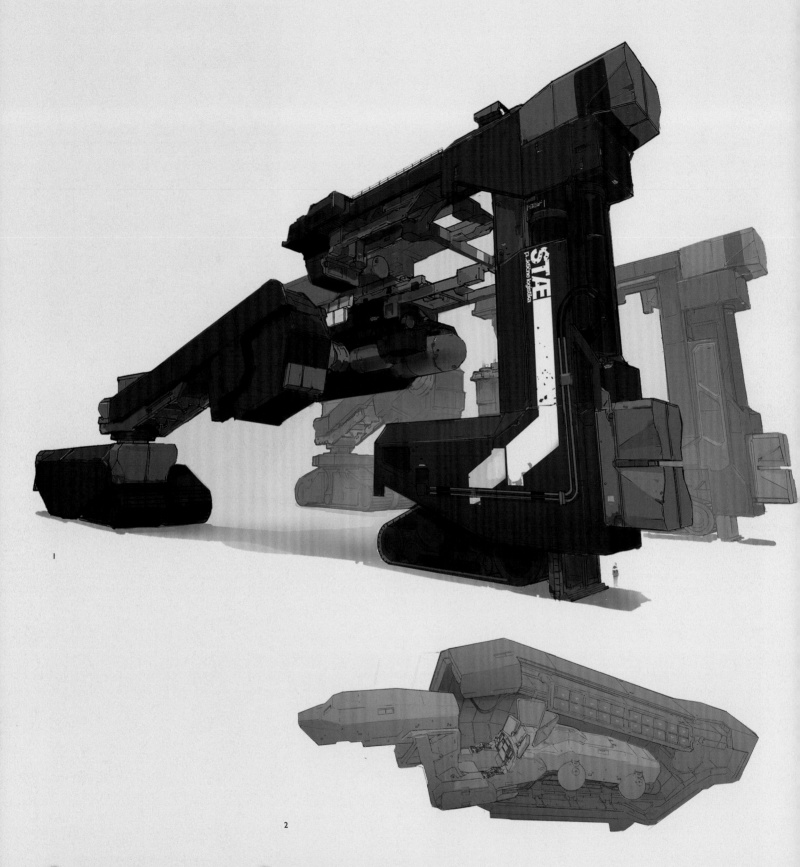

1

2

① **Heavy Loader**

 Al Crutchley | Vehicle | 2012 | Personal work

A design for an off-world loader, built
for moving ultra-heavy cargo to and
from spacecraft or even moving smaller
spacecraft themselves

② **Mech Cockpit**

 Al Crutchley | Vehicle | 2012 | Personal work

In this design I tried to imagine the layers
of armour needed to protect the pilot of
a mech. I liked the idea of the pilot sealed
in, relying on cameras and sensors to
navigate

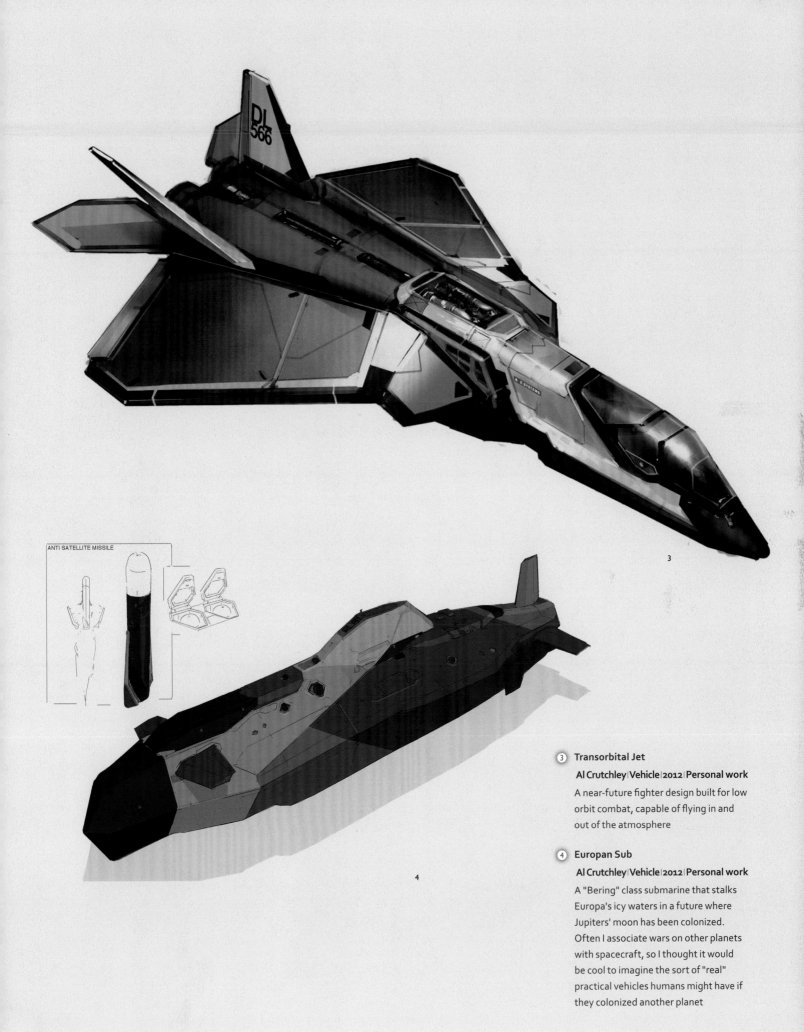

ANTI SATELLITE MISSILE

3 Transorbital Jet
Al Crutchley | Vehicle | 2012 | Personal work
A near-future fighter design built for low orbit combat, capable of flying in and out of the atmosphere

4 Europan Sub
Al Crutchley | Vehicle | 2012 | Personal work
A "Bering" class submarine that stalks Europa's icy waters in a future where Jupiters' moon has been colonized. Often I associate wars on other planets with spacecraft, so I thought it would be cool to imagine the sort of "real" practical vehicles humans might have if they colonized another planet

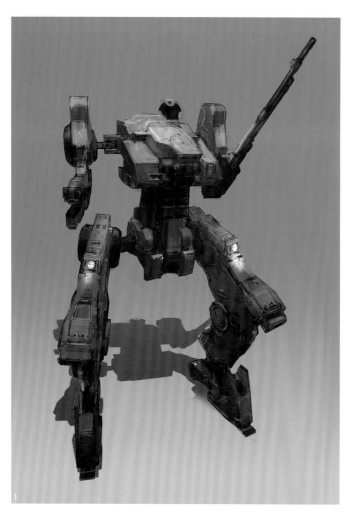

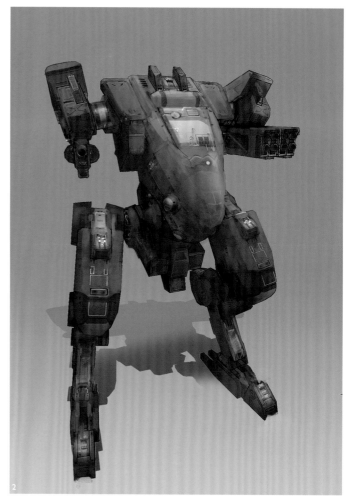

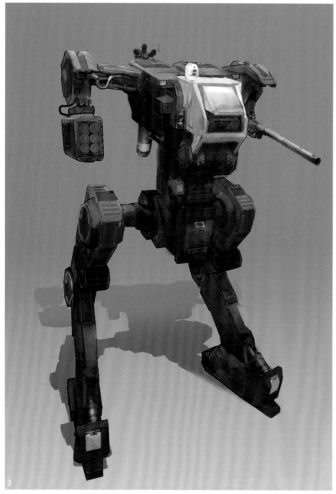

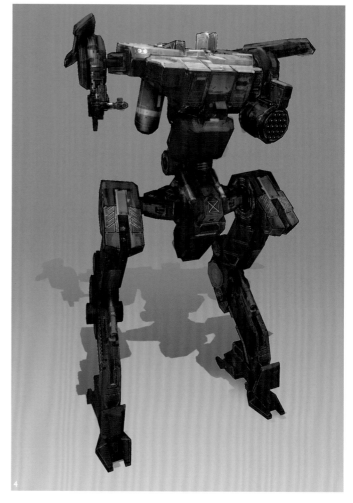

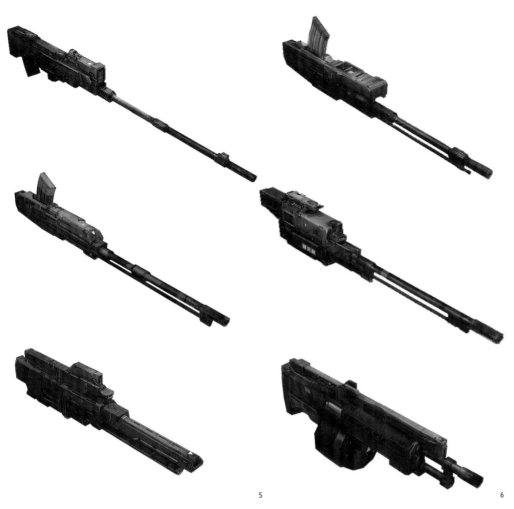

Here are two heavy mechas for a mobile project. The focus of the heavy mechas was for them to be unstoppable, with lots of forward-facing armour

Two light mechas; the reverse joint legs helped reinforce their agility; giving them less armour was also key to making them seem fragile and unable to tackle bigger mechas head on

An assortment of rifles; based on older WWII anti-tank weapons, with a grounded, heavy look to appear more convincing

This is a promotional image, showing how pilots could be "hot-dropped" into a warzone from a dropship

5 6

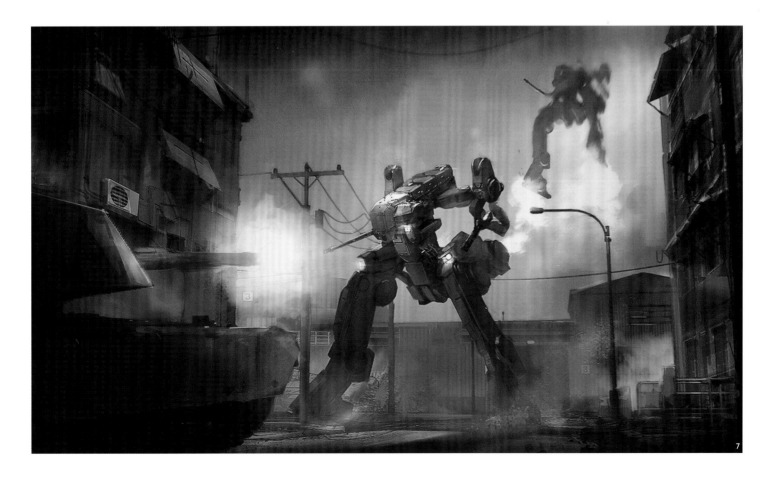

7

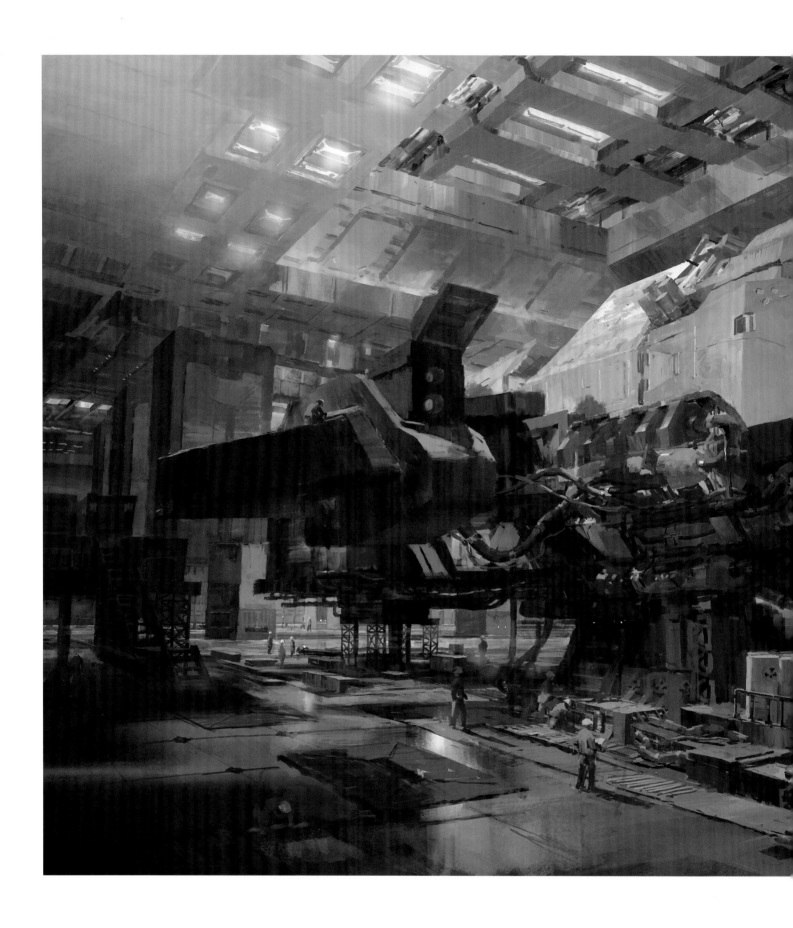

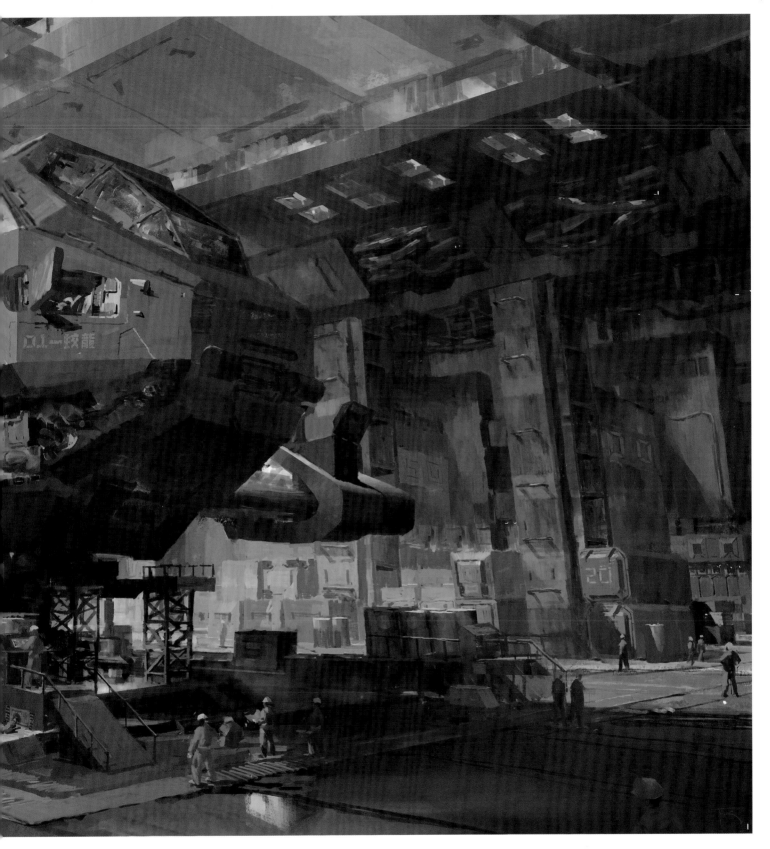

○ **Dragon Warship**
Ruan Jia | Vehicle | 2012 | Personal work
A group of workers are mapping out and
repairing the Dragon Warship

ARTISTS

Aaron Whitehead
aaronw28@hotmail.com
hazzard65.deviantart.com/

Agentwalker
124726397@qq.com
www.zcool.com.cn/u/406250

Al Crutchley
al.crutchley@googlemail.com
crrrutch.blogspot.com/

Alejandro Martinez
alejandrillo_martinez@hotmail.com
alexmartinez.deviantart.com/

Alex Figini
sundragon82@hotmail.com
alexf.cghub.com/

Ben Mauro
Benmauro@gmail.com
www.artofben.com

Benjamin Parry
benjamin.e.parry@gmail.com
xidon.cgsociety.org/

Brad Wright
bwconcept@hotmail.co.uk
bradleywright.daportfolio.com/

C9
exs01@tom.com
hao.lab.blog.163.com/

Dave Bolton
daveboltonart@gmail.com
daveboltonart.blogspot.com/

Evan Lee
evan082@gmail.com
www.evanartweb.com/

Guo Feng
georgeguo@foxmail.com
georgeguo.cghub.com

Iwo Widuliński
iwo.widulinski@gmail.com
sec.vc/iwo/

Kory Lynn Hubbell
kory.illustrator@gmail.com
www.koryhubbell.blogspot.com

Lao De
154310603@qq.com
user.qzone.qq.com/154310603

Lorenz Hideyoshi Ruwwe
lorenzruwwe@freenet.de
hideyoshi.deviantart.com/

LYK
442498237@qq.com
lyksuper.blog.163.com/

Mamax
mamax_ling@sina.cn
weibo.com/mamax

Matthew Burke
mburkeartwork@gmail.com
mburke.cghub.com/

Michal Lisowski
maykmail@tlen.pl
michallisowski.com/

Mike Majestic
vulnepro@gmail.com
nidaram.deviantart.com/

Nicholas Maradin
nickmaradin@gmail.com
nidaram.deviantart.com/

Nico
xnico@qq.com
weibo.com/monsternico

Nicolas Crombez
nicolas@dehollander.net
blam.cghub.com/

Nicotine
nicotine1986@yahoo.cn
nicotine.cghub.com/

RD
s4gr@live.cn
rd7.cghub.com/

Reza Ilyasa
onemanarmy_88@yahoo.com
ahbiasaaja.cghub.com/

Ruan Jia
ruan_jia@163.com
www.ruanjia.com

Sam Brown
sambrown36@gmail.com
sambrown36.blogspot.com/

Søren Bendt
soerenbendt@gmail.com
artofsorenbendt.com

Stephen
muta0079@yahoo.com.cn
nidaram.deviantart.com/

Tham Hoi Mun
thamhoimun@gmail.com
numioh.deviantart.com/

Timur Mutsaev
imutsaev@gmail.com
www.mutsaev.com/

Valentin Yovchev
spybg@abv.bg
spybg.cghub.com/

Wang Chao
hunter722@163.com
hunter722.blog.163.com/

Xie Yunzhang
mgky_2001@163.com
www.bottle-xie.com

X2R
X2_ROOM@MSN.com
x2r.cn/

Machine Rendering

Author: Vincent Zhao
Project Editors: Guo Guang, Mang Yu, Freja Foo
English Editors: Jenny Qiu, Vera Pan
Translator: Coral Yee
Copy Editor: Lee Perkins
Book Designer: Zhang Xuxing

First published in the United Kingdom in 2013 by CYPI PRESS

Add: 79 College Road, Harrow Middlesex, HA1 1BD, UK
Tel: +44 (0) 20 3178 7279
Fax: +44 (0) 19 2345 0465
E-mail: sales@cypi.net editor@cypi.net
Website: www.cypi.co.uk
ISBN: 978-1-908175-07-6
Printed in China